CINEMAS
OF
NEWCASTLE

A comprehensive history of the cinemas of Newcastle upon Tyne

For Greta

ISBN 0 902653 90 3

C O N T E N T S

Note: Prices referred to in the text relate to pre-decimal days when there were 240 pennies and twenty shillings in every £1.

 BEFORE THE CINEMAS

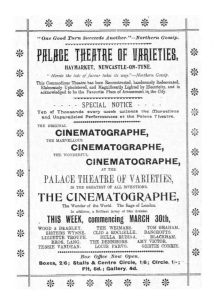

Advertisement for the first cinematograph show at the Palace Theatre, March 1896 (Newcastle City Libraries & Arts)

"THE CINEMATOGRAPHE. What in the world is it?" asked *Northern Gossip* on 28 March 1896. The reply: "A series of instant snapshot photographs of a living scene are taken with such rapidity ... that all the varying successive phases of the movement of a crowd, the actions of men at work, the restless motion of the sea, &c., &c., are faithfully recorded for all time. Photographs taken at the rate of 900 per minute. As taken they are thrown on the screen by electric light. Everything perfectly natural. The latest and greatest triumph in photography." A rather more coherent account had appeared in the *Newcastle Daily Chronicle* two days earlier: "The photographs, in their proper order, are made into a long band, which is passed rapidly through a lantern, the pictures being thrown in quick succession upon a screen. Owing to the circumstance that the retina of the eye retains its impressions of images, the rapid passage of the pictures gives the appearance of continuity, so that one sees the motions reproduced with life-like vividness."

What these two reviewers had seen and were trying to explain was the first showing of motion pictures in Newcastle, at the Palace Theatre of Varieties in the Haymarket, on Thursday 26 March 1896. Performances were given for the rest of the week and for the whole of the following week. The Palace's main rival, the Empire Theatre of Varieties in Newgate Street, also advertised the cinematograph for Saturday 28 March and the next week. This was unusual because according to most histories of the cinema, neither theatre should have had the facilities to show films at all.

On 20 February, five weeks earlier, the first public exhibitions of the cinematograph had been given in London, by the Lumière Brothers at the Polytechnic Hall, Regent Street and by Robert W. Paul at Finsbury Technical College.

Both shows transferred to variety theatres in the capital a few weeks later. The point about these performances is that they were exclusive to the two theatres and additional projectors were not manufactured for sale. How then could two Newcastle theatres show films days later? Neither Lumière nor Paul was involved. The historian of the early cinema in Britain, John Barnes, offers two possible solutions, neither of which can be confirmed from local evidence.

One possibility is that one of the machines used was the French-made Kinetographe de Bedts, patented there in January 1896 and in Britain in March. The Palace, alerted by the Empire advertisements, stole a march on its rival, and may have used a projector invented by a Newcastle man, William Routledge, an engineer with premises in Low Friar Street.

This was later marketed as the Rosenberg Cinematograph but was not patented until July 1896: would Routledge have risked a public exhibition without the protection of a patent? Or did the Palace management make him an offer he could not refuse? All that can be said at the present stage of research is that the first provincial showing of the cinematograph was in Newcastle.

The films that were shown at the Palace and the Empire are less of a mystery: most can be identified as Edison Kinetoscopes (originally made for peep-show machines), with titles such as *Cats Dancing* and *Acrobat Turning Somersaults*. Each film, only about fifty feet long, lasted a few seconds. The *Newcastle Daily Journal* hoped that the cinematograph would be "worked to better advantage shortly, for the vibration noticed in all the scenes ... was somewhat unpleasant to the eyes."

Consequently, apart from the press comments quoted earlier, there seems to have been little public reaction to this new form of entertainment and no apparent realisation that this was the beginning of

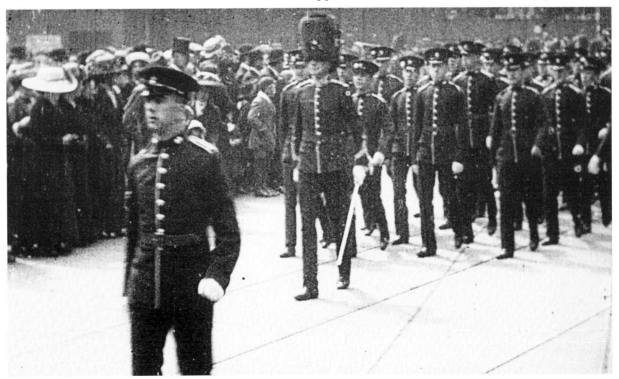

Frame still from Military Parade in Newcastle, *about 1900 (British Film Institute)*

something that would revolutionise the use of leisure time.

Later in 1896 Newcastle audiences saw the best moving pictures then available. First came the original Cinématographe Lumière from the Empire, London, under the direction of Monsieur Trewey, a stage illusionist who handled the brothers' English interests. This headed the bill at the Empire Theatre in the week commencing 15 June. According to *Northern Gossip*, the pictures "... made quite a sensation. Chiefly through Mr Thornborrow's splendid arrangements, all the figures were perfectly clear and distinct. The whole 'show' was a touch of realism that interested and delighted. A boat rowed over sea breakers was exceedingly natural in all its movements, as also was the scene of workmen taking down a building. Everyone who has not seen this wonderful instrument should make an effort to do so this week."

On 2 November 1896 it was the turn of the English inventor, Robert Paul; the Empire Theatre was again the venue. Paul had the idea, followed by most proprietors of travelling picture shows, of filming locally. So, in addition to the famous film of the Prince of Wales' horse 'Persimmon' winning the Derby, Newcastle audiences saw *Newcastle United Football Team at Play*, *Grainger Street at Noon*, and *Call Out of the Newcastle Fire Brigade*. The Palace Theatre riposted with J. J. and F. Downey's "Living Photographs", the "Greatest Invention of the Nineteenth Century."

From 1896 on, though moving pictures headed variety theatre bills, they drew decreasing attention from reviewers and were seen by some as a gimmick or passing fad. Even the first exhibitions in Newcastle of colour films, at H. Engel's Electrical Exhibition in the Art Gallery Theatre (Central Arcade) on 1 March 1897 and at the Palace Theatre on 3 May, with the new French invention, the Heliochromoscope, aroused relatively little attention.

Although in the next few years various moving picture shows – the Edison Vitagraphe, the Biograph, the Royal Vitascope, Gibbons' Bio-tableaux – continued to appear at the Empire and Palace Theatres, enthusiasm had clearly waned. Experiments were tried of incorporating the bioscope in regular attractions: the Vitagraph was used in the Palace Theatre's 1898 pantomime *Babes in the Wood* "in place of the obsolete Harlequinade."

With theatres losing interest, moving pictures were kept in the public eye by the travelling showmen; in Newcastle, those pioneers who hired public halls to give their entertainment were the most significant. The first of these was Charles W. Poole whose Myriorama shows had been travelling the country since the 1860s. The Myriorama was a series of huge painted canvases which, backlit, were moved across the stage between vertical rollers, while music played and lecturers interpreted the travel or historical scenes. In Poole's Christmas show at Olympia in 1897-98 there was an innovation, the "Eventographe", which was a true moving picture, the "finest and steadiest" yet seen in the city.

In June 1897 the Modern Marvel Company's Analyticon (or stereoscopic projection) – the stereoscopic items were in fact slides, not films – visited the Grand Assembly Rooms, Barras Bridge. The Town Hall was also hired (by Livermore's Living Pictures in 1904 and New Century Pictures in 1905) as was the Exhibition Hall in St Mary's Place (by the New Bioscope Company, 1907).

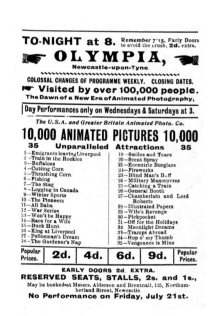

Advertisement for a cinematograph show at Olympia, July 1905
(Newcastle City Libraries & Arts)

The atmosphere of some of these travelling shows was described in *Northern Lights* in February 1920:

"I well remember visiting a show of this kind when the pictures were the latest novelty out. The showman had ... the hall fitted up with beautiful wooden forms, as hard as proverbial bricks, there was no operating box, no electric light, and no fine organ or orchestral accompaniment. The illuminant for this special performance was limelight, as used in the oldest form of picture entertainment, the magic lantern. The show started about 8 p.m., and as animated pictures were the latest boom the hall was packed at 1s. to 3s. a seat ...

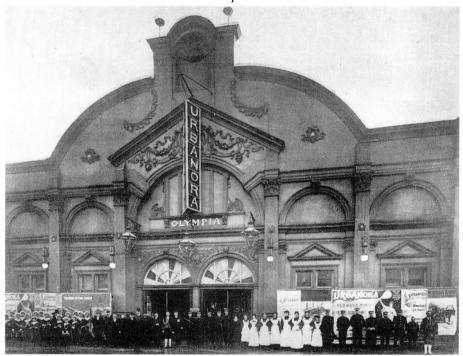

"Urbanora" at Olympia, December 1905
(Newcastle City Libraries & Arts)

"The company composing this particular entertainment I am thinking of was as follows: the showman, who was also the manager, operator, advertising manager, fly-poster, elocutionist and ventriloquist and anything else he could find time to do. His wife, who was also soprano vocalist, soubrette, and dancer, cashier and occasionally worked the lantern. These two together, with the lantern, the accompanist, and two local check-takers, gave an excellent programme, and it was worked after this manner.

"First item, picture; second, illustrated song by the soprano vocalist ... third, another picture; fourth, a recitation to slides by the operator ... next item, another picture, and then ten minutes interval ... the show finishes on a comic picture, and everyone in those old days goes home pleased."

The home of the best travelling shows, a far cry from that just described, was Olympia in Northumberland Road. Opened in December 1893 as a general purpose hall, its promoters included H. E. Moss and Richard Thornton, who ran a chain of variety theatres. The hall was of corrugated sheeting on an iron framework, with an ornate plaster frontage. There were seats for 3,500.

Olympia was frequently the venue for bioscope shows between 1897 and 1901. Its owners used it as a replacement while their new Empire Theatre was built in 1902-03 and when the latter opened, Moss and Thornton leased Olympia to Ralph Pringle, on condition that no variety acts would be staged there. Pringle's North American Animated Picture Company began a season at Olympia on 14 September 1903. The programme contained ten items, including colour films, with interludes by a military band and the band of the Wellesley Training Ship. There was one evening performance at 8p.m., with matinées on Wednesday and Saturday; prices were 3d. to 2s.

Pringle was followed by Walter Jeffs' New Century Pictures: "The pictures are certainly admirable,

being the steadiest and best selected ever seen in Newcastle, those of local interest being exceptionally well received ... while those showing various incidents in a voyage across the Atlantic ... with sports on deck, and a most realistic representation of a storm in mid-ocean, were responsible for a tremendous outburst of applause."

In March 1904 the agreement not to stage variety was broken by Thornton himself and Sidney Bacon who opened Olympia as a variety theatre with Lindon Travers as manager. Thus the claim made for Olympia that it was the first permanent cinema in the provinces is ill-founded. The bioscope was soon back, however: in June 1905 the USA and Greater Britain Animated Pictures began a long season until September. One of this company's programmes contained thirty-five items, an indication of the abbreviated length of pictures at this period.

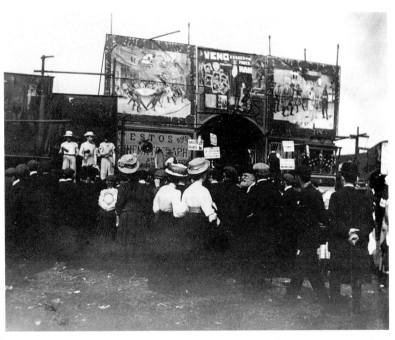

Testo's Royal Cinematograph booth at the Town Moor Hoppings, June 1908 (Newcastle City Libraries & Arts)

The greatest bioscope show at Olympia was undoubtedly the long season, beginning on 16 October 1905, of cinema pioneer Charles Urban's 'Urbanora'. "There have been many exhibitions of animated pictures, but those presented by Mr. Urban stand entirely on a different footing to anything yet shown here. The entire absence of flicker and the clearness of the pictures are two of their distinguishing features..." Also in the programme were "chatty lecturettes" by Lindon Travers. It was Urbanora which staged the Blonde and Brunette Beauty Show in December, thought to be the first beauty contest in the country. The Urbanora season ended on 6 January 1906.

Olympia reverted to variety until the USA and Greater Britain Company returned for a season from May to July 1906; it now advertised as "The Home of Pictures". In the early hours of 2 December 1907 it was totally destroyed by fire, the plaster frontage crashing into the street. But it had ensured that the moving picture had a future in Newcastle.

In contrast, the fairground showmen were of less importance. The first appearance of the bioscope on a Newcastle fairground seems to have been at Leazes in April 1898. Manders' Royal Waxworks and American Museum, open from 7 to 16 April, included "the great cinematograph living pictures – the rage of the world". The same show returned the next year from 30 March, advertising "The freak museum of peculiar people and, just added, London's Latest Rage, the only Electric Cinematograph living pictures all worked by Electricity by means of a magnificent Engine". Up to the first World War, many travelling bioscope shows visited the Town Moor for the Hoppings, until put out of business by the permanent cinemas.

 GOING TO THE PICTURES

GOING TO THE PICTURES

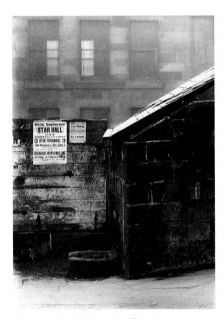

Fly-poster for the Star, Prudhoe Street, on a pant off Market Street, 1909 (Newcastle City Libraries & Arts)

Between 1908 and the outbreak of the First World War thirty cinemas opened in Newcastle and a further six in areas later incorporated into the city. From a lowly position on a variety theatre bill, moving pictures had advanced to the extent that buildings were now being devoted to them. The main reason for this was the films themselves: they could now tell a story and their technical quality was improving all the time. While some among early cinema audiences had transferred their allegiance from the music hall and the variety theatre, "in the main the vast majority of picture house patrons were not in the habit of attending other places of entertainment. The cheapness of this form of amusement has created what is really a new type of audience ..." The picture halls were small, intimate and above all local; there was now no need to travel to the city centre for a night out. For music hall audiences, the transfer of loyalty to films was eased by the inclusion of variety acts in the programmes of suburban cinemas.

Early cinemas were broadly of two types: the suburban hall, often characterised by the trade as 'industrial' (which was a polite way of describing their exclusively working-class audiences) and the more opulent city centre venues which hoped to attract a better class of patron.

The very first cinemas in Newcastle were of the first type: despite their owners' pretensions, with much use in cinema names of 'Grand' and 'Palace', they were very basic. Of the six cinemas opened in 1908, three were former churches, two former circuses and one a former shop. Any enterprising man or woman could open a picture hall: the leasing of an empty building, the purchase of a second-hand projector, the purchase or hire of wooden forms or chairs (which was all that was required), could be done for less than £100. Family members provided additional labour; advertising was by fly-posting or agreements with local shopkeepers.

A single projector only was common – the King's, Marlborough Crescent, acquired a second in 1910 and thought the fact worthy of mention – while the much-vaunted tip-up chairs were usually not upholstered and were only one small step removed from the wooden bench. In fact, some cinemas ripped out their tip-up seats and substituted benches so that more people could be packed in.

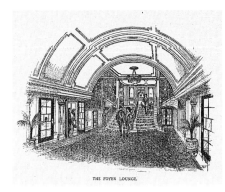

THE FOYER LOUNGE.

The Foyer Lounge at the Newcastle Picture House, 1914
(Newcastle City Libraries & Arts)

Suburban or 'industrial' halls were distinguished by their low seat prices (usually 2*d.* to 6*d.*) and the fact that they opened in the evenings only, when their potential audience had finished work. The type of film shown also categorised them: in the words of *Northern Lights*, "heavy melodrama, knock about comedy or ultra sentimental dramas."

At times, the 'industrial' hall must have been bedlam, with children running about, constant chattering, the eating of fish and chips. *Northern Lights*, in a rather cruel article in January 1920, gave a series of descriptions of 'typical' picture theatre patrons, among whom was: "... the lady with an awful yell, who will scream out just at the most exciting part of the picture, 'Hit 'em, knock 'em doon, eh, man, look at that now. Well yer, well I divvent knaw. Would yer believe?' Somebody behind shouts out, 'Shut up, wummon', and the lady gets on her dignity and off her seat, and expresses her opinion of the person who had the audacity to tell her to shut up. 'We wast telled me to shut up? 'Twas ye, ye greet big lump o' nowt, if I wasn't howding this ere bairn aad come acrost there and knock lumps off ye, mind ah wad an' all. What d'ye call yersel, anyhow, yer greet big bubbly beast, eh? Here'a a penny, gan and get yersel run ower...'."

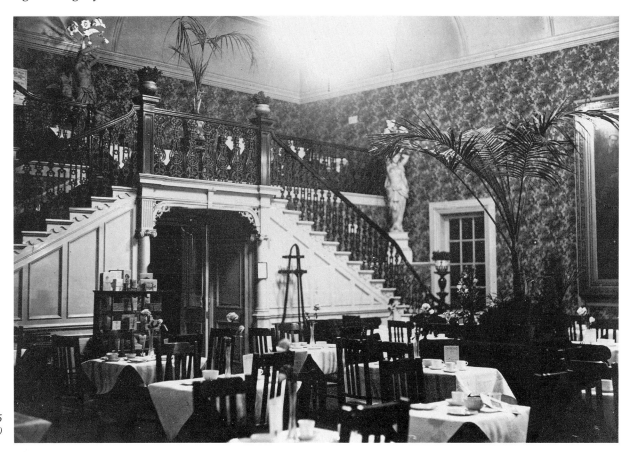

The Stoll's Winter Garden Tea Rooms, 1925
(British Film Institute)

Some cinemas used lecturers to explain the pictures and to point up moral lessons: Lindon Travers was an early exponent of this art. F. W. Morrison, chairman of the Northern Branch of the Cinema Exhibitors' Association, claimed in August 1926 that "...the lecturing was a farce and was soon dispensed with. There was an idea that people could not understand the picture."

Despite this, lecturer J. C. Padden was still advertising his services in 1920. Morrison was defending the north east against a charge made by film financier C. M. Woolf that cinemas employed people to read titles aloud, as some of the audience could not read while others could not read quickly enough. Despite Morrison's rebuttal of this 'libel', both Edward Davison, writing about the Raby and Agnes Smurthwaite on the Minerva mention that members of the audience were constantly asking their neighbours to read titles for them. This is confirmed by the *Northern Lights* article part-quoted above.

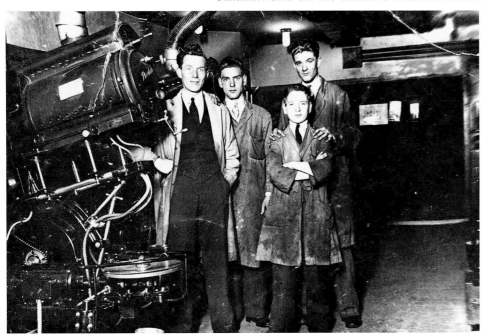

Operating staff at the Queen's, 1932. Ernest Brown, chief operator at left; below the projector is the sound-on-disc player (Mrs W. Huggins)

The musicians struggled against all the noise. Initially, musical accompaniment to films was provided by a single pianist who attempted to improvise to match the action on the screen. Most cinema owners tried to gather together sufficient musicians to dignify with the name 'orchestra', though this often meant a trio or a quartet. The orchestra brought its own problems: with little or no time for rehearsal, any improvement in sound quality was often nullified by the inability of the players to improvise effectively while remaining a musical unit. After the war, pipe organs were installed in the larger cinemas to give more 'body' to the sound; these were church organs with a minimal effects capability.

Naturally, the cinema-going experience was rather different in the A-class houses in the city centre. These were the 'picture palaces', built by the serious money which came into the exhibiting side of the business after 1912. The intention of this new breed of cinema owner (most operating as limited companies) was to drive the business up-market, catching what was known as the 'ton patron' rather than the exclusively working-class audience which had hitherto been attracted by the cinema. Ladies, after a morning shopping in town, were invited to pop into a cinema to enjoy the film and relax in the 'dainty cafés' which most city centre venues offered. The Newcastle Picture House offered all the facilities of a ladies' or gentlemen's club. Here, as in the Queen's Hall and the Westgate, there was much emphasis on good taste, refinement and opulent decoration, features unknown to the 'industrial' halls.

As the *Evening Mail* put it in December 1913: "We enter the marble portals of a lustrous and palatial building, pass by a pillar of politeness in uniform and brass buttons, receive a perforated disc of metal in exchange for a coin of the realm, tread the steps of thickly carpeted stairs, sip a 'café noir' in a

A page -boy at Black's Regal, about 1935 (Mrs E. Hodges)

luxurious lounge, and adjourn to a dim region of dreamy music and softly diffused ruby lights."

The clear distinction between these two types of cinema was recognised both by the trade and the public. The city centre cinemas showed first-run films in good condition, accompanied by an orchestra of ten or more players. Uniformed doormen, page-boys selling sweets and chocolates, and 'girl attendants' made cinema-going an event. Prices were naturally much higher for this superior fare, from 6*d*. to 2*s*. 4*d*. Afternoon as well as evening performances were normal.

The suburban cinema was part of its community, very much a social centre where everyone knew everyone else. People could, and did, turn up in aprons and carpet slippers. Going to a cinema like the Queen's meant dressing up for the occasion; it was something special.

In 1913 the trade was concerned that there were too many cinemas in the city with a consequent danger that profits might be spread too thinly. F. W. Morrison multiplied the seating capacity of Newcastle's four theatres, three music halls and twenty one cinemas by the number of performances to demonstrate that there were 380,000 seats for a population of 277,000. On the basis of this dubious calculation, the city council was asked to refuse all future applications for cinema licences; this was not agreed, but the problem (if it was a problem) was soon solved by the outbreak of the world war, which halted all cinema building.

In the cinema's early years much concern was expressed throughout the country about its possible effect on morality: it was reasoned by those who appointed themselves guardians of public behaviour that crowding people together in semi-darkness could only lead to indecencies of various kinds. Very little of this concern surfaces in Newcastle. The Rev. Stanley Parker, writing on "Newcastle morals" in May 1910, believed that "impurity occurred under cover of darkness in places of amusement" in isolated cases, but the only instance he gave had taken place during a cinema show at a place of worship in the city. One may feel confident that had evidence been available of sexual misbehaviour in commercial cinemas in the city, it would have been used.

In fact, the cinema was seen by many as the salvation of the people from a much greater evil: drink. Such sentiments were expressed by Sir Francis Blake at the opening of the Newcastle Picture House in May 1914: "The coming of the picture house was one of the most notable features in modern life. The popularity of the cinematograph was a sign of the change in the condition of the people, of their ... determination to use some of the increased leisure which they enjoyed ... in harmless amusement and pleasure."

John Grantham stated in 1926: "I had in mind when I first entered the kinema business fifteen years ago the need for the provision of a counter-attraction to the public-house, and I was very gratified to learn afterwards from the Chief of the Police that there had been a diminution of drunkenness since the kinema hall had opened in that district [Benwell]."

Only a handful of new cinemas opened in the city in the twenties: as early as December 1919 the *Newcastle Daily Chronicle* noticed that the wartime boom had ended, which it believed was accounted

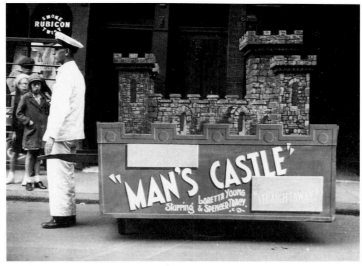

for by the longer opening of public houses, "the tightening of money, and the fact that people, and especially the women folk, no longer have need to seek relief from anguishing thoughts occasioned by the war." There was also, just after the war, a shortage of building materials. Only the Jesmond, Prince of Wales, Scotswood, Plaza and Welbeck were opened.

The coming of sound transformed cinema-going habits. Visits to the cinema became almost an obsession for most of the population. A correspondent to the *Evening Chronicle* in 1970 remembered: "Our programme was: Monday, Hippodrome Theatre, Tuesday, Brighton, Wednesday, Plaza; then when the programme changed ... Thursday, Brighton and on Friday to the Plaza." Cinema-going of this intensity was far from uncommon. Many people had their 'own' cinema seats which they occupied with clockwork regularity whatever was showing. The more dedicated planned their outings with the help of magazines like *Picturegoer*.

Advertising stunts: (Above) **Man's Castle** *at the Stoll, August 1934 and (below)*
My Old Dutch *at the New Westgate, November 1934*
(Both Newcastle City Libraries & Arts)

At first, it was by no means certain that talkies would be a success. For many, the sound film was not an advance on the silent picture, which had evolved its own international language. Two cinemas, the Grey Street and the West Jesmond, proclaimed their loyalty to the silents. The American accents of the early sound films were disliked by many and incomprehensible to some, although this was soon to change. By January 1930 the manager of the Queen's reported four capacity houses each day, compared with two and a half for silent films. His main problem was getting the audience to leave after each show. But as late as September 1930 the Brighton advertised the *The Bishop Murder Case* with "Basil Rathbone, the Star who speaks good English".

Small cinemas found the cost of adapting for sound a heavy burden and two, the Stanhope Grand and the Sun, closed. (The best American sound-on-film systems could cost £4,000, with an annual maintenance charge of £280). There was also confusion over sound systems. Most cinemas installed sound-on-disc equipment only to have to convert to sound-on-film. A film break with the former system was a disaster, as only the most skilful, or lucky, projectionist could successfully re-synchronise the two elements. At the Queen's, projectionists were paid a bonus if they got through a week without a film break.

Les Irwin remembers: "Talkies brought a vast difference. Prices went up for a start, our piano-player got sacked – a new kind of excitement prevailed. 'Talkies – whatever next?' 'They're just a passing fad' 'Can't make out a word they say' were some remarks people made. Deaf people hated them. Large notices ordered patrons: SILENCE PLEASE and offenders who disobeyed, tipped up their seats noisily or otherwise offended were silenced by loud 'Shsss' and murderous looks."

Once the sound era was firmly established, there was a rush to build reminiscent of that of 1910. The age of the super-cinema began in Newcastle with the Paramount. In the city centre, this was followed by the Haymarket and the Essoldo, along with two news theatres, News and Tatler. To the east came the Apollo, Black's Regal, Lyric and Gloria. To the west, the Regal (Fenham), Embassy, Rialto and Rex. Add to these the Royalty, Gosforth and the Lyric, Throckley: a total of fifteen new cinemas in eight years.

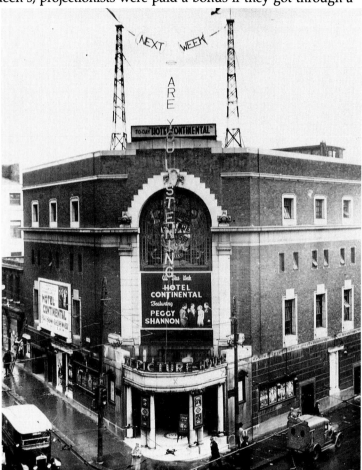

Advertising stunts: Are You Listening? *at the New Westgate, September 1932*
(Newcastle City Libraries & Arts)

Cinema owners must have thought that the good times would never end. Some cinemas in the suburbs introduced matinée performances. Other means of packing in more shows were less honest. In silent days, with no sound-track to worry about, films could be speeded up or 'rushed'. This was impossible with talkies, so films, usually the second feature, would be arbitrarily

cut to fit the time available.

The super-cinemas brought a greater standard of luxury to suburban cinema-going. New types of seating, often using the recently invented 'Dunlopillo', were matched by higher standards of projection. Waiting rooms replaced queuing in the rain and snow. Front-of-house staff, including in some cinemas page-boys employed solely to open doors for patrons, gave a new sense of style and occasion. At the same time, the older cinemas managed to keep their audiences with lower prices and by replacing wooden forms with tip-up seats.

The thirties was the great age of cinema advertising and 'stunting'. Stills boxes and newspaper publicity were considered far from adequate by the larger cinemas. Front of house displays, tie-ins with local shops, huge placards, sandwich-board men, motor cars and lorries, horses and donkeys were all pressed into service. Publicity could be taken to almost absurd lengths, as when in 1932 two 'radio masts' were erected on the roof of the New Westgate to promote an obscure film called *Are You Listening?*

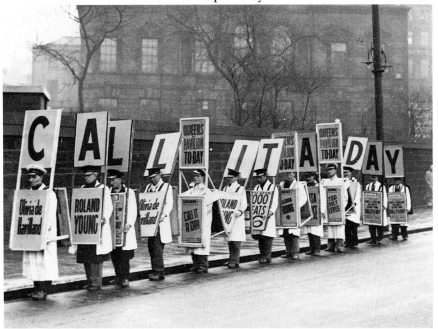

Advertising stunts: Call it a Day *at the Queen's and Pavilion, November 1937 (Newcastle City Libraries & Arts)*

The thirties also saw the rise to glory of the cinema organ. Unlike those of the previous decade, these were true theatre organs with full orchestral capabilities and sound effects. The city's first Wurlitzer was installed in the New Westgate in 1930. Initially used for background to advertisements and between shows, they became so popular that they were given solo spots and marquee billing. Organists at the Paramount were stars in their own right and frequently broadcast on radio.

On the outbreak of war on 3 September 1939 all cinemas were closed by government order. No one knew how long this would last and some cinemas laid off their staff. By 18 September most were open again and about to have their most profitable years. Only one cinema, the Apollo, was closed by enemy action, but all suffered from staff shortages and lack of maintenance.

Newcastle's cinemas emerged from the war grimy but playing to capacity: in these years queues formed for afternoon performances. The peak year for cinemas in Britain was 1946; in the following years there was a decline, initially slow, but then accelerating. The halcyon days had gone forever; cinema-goers replaced obsession with discrimination. Gradually through the fifties all sorts of factors worked against the cinemas. Living conditions improved so that the local cinema was no longer warmer or more comfortable than most homes. No cinema manager could now write, as had Hugh Le Mounier of the Essoldo in June 1939: "In winter few homes can offer so comfortable a warmth, free from draughts and with an atmosphere that is hygienically treated. In the Summer the superiority of

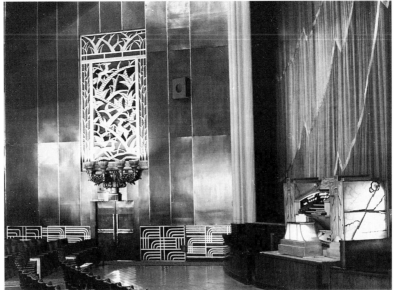

Above: The Compton organ at Black's Regal (John D. Sharp). Below: Elton Roberts at the Paramount's Wurlitzer (Tony Moss)

the Essoldo even over your own home is no less marked."

Various innovations of American origin such as 3-D and Cinemascope failed to halt the decline. The gimmicks could not disguise the fact that films of the fifties were generally of lower quality that those of the two previous decades. All agree, however, that the major reason for the decline of the cinemas – especially those in the suburbs – was the introduction of television, particularly commercial television by Tyne-Tees in January 1959. The statistics of cinema closures in the city bear this out: 1958, two; 1959, three; 1960, seven; 1961, seven. The suburban cinema audience was the first to switch allegiance to television.

The Betting and Gaming Act of 1960 dealt two more body blows in the form of bingo and nightclubs. Some cinemas, like the Crown on Scotswood Road, tried to combine films with bingo; it was usually bingo which survived, except at the Apollo and the Jesmond. The night clubs which opened in Newcastle in the sixties merely took away another part of the audience. For the surviving small cinemas, the youth culture explosion of the same decade often meant vandalism. Cars, foreign holidays and DIY in new homes mopped up surplus cash.

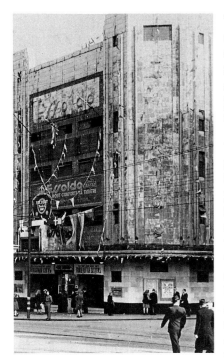

A grimy Essoldo celebrates V.E.-Day, May 1945 (J. Marsh)

The sixties also saw the decline of the Saturday children's matinée. From the earliest days, cinema owners and managers were firm adherents of the Proverb 'Train up a child in the way he should go: and when he is old, he will not depart from it'. Children were attracted into the cinemas by special shows at low prices, usually 1*d*. At some cinemas – the Scotswood and the Sun are examples – admission could be gained on production of clean jam-jars; the rate of exchange was 1 x 2lb. or 2 x 1lb. jars = one penny. In addition to the films, matinées offered gifts, competitions and prizes. A writer to the *Evening Chronicle* in 1970 remembered:

"... queuing for the Saturday afternoon show at the Brinkburn. It was one penny to get in; when you got your ticket, you got a comic called *Chips*, a stick of hanky-panky, which was all colours, and a ticket with different lettering on which you had to save until you got the word 'Brinkburn'. Of course you had to swap these tickets with your friends, because the letter 'k' was always the hardest to get. I remember very well when I collected the set I had to go on the stage and I received a fountain pen." A similar competition was run at the Raby and doubtless elsewhere. The presents offered to children were not always of the best: at the Vaudeville in the thirties the fruit was usually bruised and the cakes were firmly believed to be rejects from a Byker bakery. Matinées at the smaller cinemas were not all sweetness and light. Les Irwin remembers the Imperial, Newburn: " ... the well-off kids got into the balcony for tuppence and amused themselves by pelting orange-peel, banana skins, toffee wrappings at the less well-heeled kids in the pit. The noise of kids shouting, banging feet, fighting and creating a din was unbearable. No adults went to the matinées expecting to enjoy the film. [They] only went to chaperone small children unable to take care of themselves in the survival of the fittest conditions which existed."

The children's shows in the larger circuit-owned cinemas and in some independents like the Apollo were very different. At these, audiences sat in their seats more or less on their best behaviour, sang their club songs, entered competitions and occasionally performed on stage. The Gaumont British Clubs song was by Con Docherty:

> *We come along on Saturday morning*
> *Greeting everybody with a smile*
> *We come along on Saturday morning*
> *We know its well worth while*
> *Our parents know that when we're here*
> *We're in the best of care*
> *And we agree the shows we see*
> *Are best of anywhere*
> *We come along ...*

City centre cinemas, going to which was still something of an occasion, survived longer and succumbed as often to circuit restructuring as to declining audiences. An upturn in interest in cinema-going noticed by the local press in 1973 turned out to be something of a false dawn: of the three multi-screens opened in the early seventies, only one – the Odeon – remains, though it is quite possible that the others might have closed earlier had it not been for their subdivision. By 1984 only three

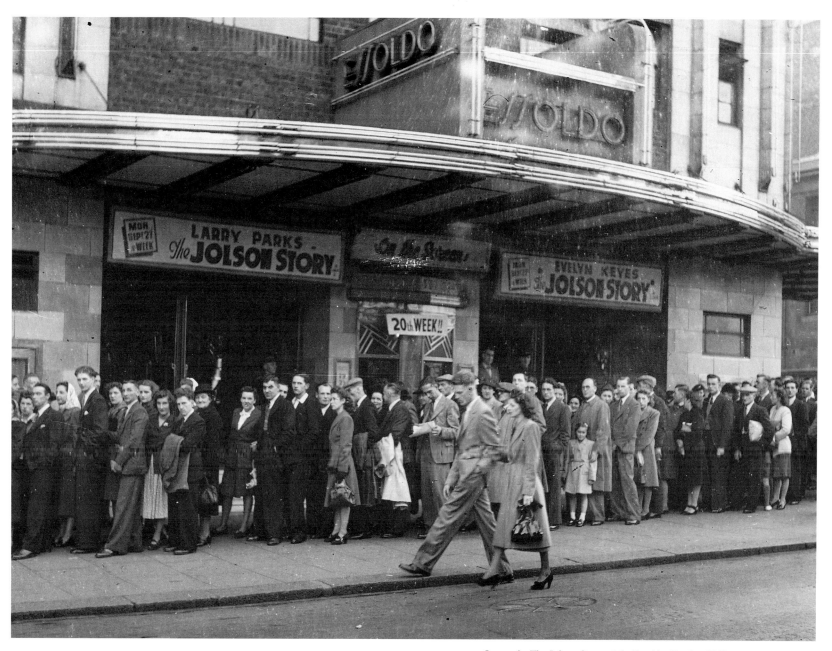

Queues for The Jolson Story *at the Essoldo, October 1948 (Turners Photography)*

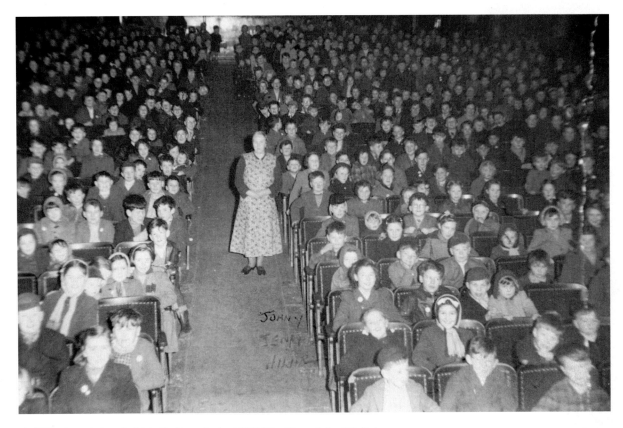

A children's matinée at the Majestic, Benwell, about 1955 (West Newcastle Local Studies)

commercial cinemas – ABC (ex-Essoldo), Jesmond and Odeon – remained in a city which in 1939 had boasted forty-one.

In 1984, British cinema audiences were at only 3% of their 1947 total; this turned out to be the last year of decline. A flood of films which were immensely popular began to appear for no apparent reason. Films like *E.T.* and *Crocodile Dundee* appealed across generations and brought back to cinemas people who had not gone for years. The spread of multiplexes also brought new audiences. The future of the cinema looks better than it has for some years, but only as long as films with a wide appeal continue to be made.

THE CINEMAS OF
NEWCASTLE UPON TYNE

ADELAIDE PICTURE HALL

Adelaide Terrace/Maria Street, Benwell

17 October 1910

Built by a local fishmonger, W. H. Rewcastle, the Adelaide was Benwell's first cinema. It seated 640 (504 stalls, 136 balcony); seat prices were 2*d.* to 6*d.* Shows were twice nightly with a Saturday afternoon matinée. There was usually a variety act in addition to the films: the stage was enlarged in 1911.

The Adelaide, ca 1937 (Keytone Publications)

Rewcastle made every effort to run a cinema which was a part of the community: something of this comes over in an advertisement from 1912: "When looking for enjoyment, combined with refinement, make a point of starting the New Year with being a regular patron of the ADELAIDE P.H., where you can find these features predominate. Our success has been attained by studying your requirements, and seeing that you get them. We have made thousands of friends, and are still friendly with them all. This alone speaks volumes for all of us."

For an unknown reason, Rewcastle disposed of the Adelaide to the Faith family in 1919. In March 1920 he advertised for a cinema managership in the local trade magazine *Northern Lights*, but does not seem to have been further involved with the cinema in Newcastle.

It was possibly when Charles Faith took over that a shallow, two-storey stone-faced annex was built to the right of the hall, forming a foyer with offices above.

Faith reportedly sold the Adelaide to two London cinema owners for about £10,000 in April 1928; under this management the cinema must have surprised the trade by becoming the third city cinema to install sound. This small cinema showed *Broadway Melody* (Bessie Love) from 14 October 1929.

In 1931 the Adelaide was taken over by Union Cinemas, initially under the name of Benwell Cinemas Ltd. Union was then a circuit of about eighteen halls widely spread throughout the country, but mainly in the south and east.

Advertising in the press ceased in January 1937, possibly a sign of declining management interest. There was strong competition from the Majestic (owned by the same company) and the Grand; the Adelaide seems to have come a poor third.

Despite this, some people remember that the cinema was closed for extensive redecoration, reopened in its new glamorous guise, only to close permanently a few weeks later. This oral information is in some conflict with the official date of closure, 1 February 1943; it is unlikely that redecoration would have been undertaken during the war. The building was used as a depot by Pathe for some years, then became a Woolworth's store. It is now a discount autoparts shop, recognisable as a former cinema from the side and rear.

Proscenium (above) and auditorium (below), ca 1937
(Tony Moss)

APOLLO

Prudhoe Street

13 April 1908

The Apollo after closure, ca 1914
(Northumberland Record Office)

When Olympia burned down in 1907, the city lost its premier venue for moving pictures. The owner of the USA Picture Company, Audrey Appleby, who had given the last shows at Olympia, submitted plans by architect W.H. Knowles on 31 January 1908 for the conversion of the former United Methodist Chapel in Prudhoe Street to a cinema, to be called the Star.

The building was altered very little inside or out; the horseshoe-shaped gallery was retained, though some sightlines must have been poor. Capacity was said to be 700. The projector stood on the floor of the hall, behind protective walls of three to four inch concrete.

The arrangements were approved by *Northern Gossip,* though it should be noted that this magazine invariably gave a good review to any theatre or cinema which paid for an advertisement: "The beautiful surroundings, perfect attention and the conveniently serried rows of tip-up chairs make a visit to this place quite a pleasure."

There were two shows, at 7 p.m. and 9 p.m., with matinées on Wednesday and Saturday. The Star had regular 'go-as-you-please' nights, amateur singing competitions and performances by local talent. On opening night, "Miss Cissie Noble sang acceptably, and her refrains were lustily taken up by the occupants of the gallery."

In the early years there was an emphasis on locally-filmed events, like the Newcastle v. Wolves Cup Final in April 1908 and the Gosforth Park Races in June. In January 1909, exclusive to the Star, were "Talking and Singing Animated Pictures: the Latest Novelty: first time of this new principle in Newcastle." Boxing films always appealed to early audiences: in March 1909 the Star had film, obtained at "enormous cost", of the Johnson-Burns fight, which was run three times a day for two weeks.

In March 1911 Sidney Bacon took over the Star; it was to be reconstructed and redecorated on a "lavish scale", with a new entrance from Northumberland Street (*The Bioscope*, 23 March 1911). This does not seem to have been done; Bacon let the hall to Edward Cant and John Grantham, who made minor alterations to the cinema in 1912-13 and replaced the tip-up chairs with forms. The Star, renamed the Apollo (possibly in May 1913), was allowed to decline; it was no competition for the purpose-built cinemas now opening throughout the city. The Apollo appears to have closed in 1914; certainly in October W. H. Bacon of Olympia proposed to use the building as a "Cinema Military Target Shooting Gallery", where potential soldiers could be trained. The hall was then used by Chapman's the furnishers.

APOLLO

Shields Road, Byker

28 December 1933

The Apollo was the first of two super-cinemas to be opened on Shields Road within a year. The site, formerly the Toll Bar House, had been selected by James MacHarg of Tyne Picture Houses Ltd. as early as 1920. Several times that year architect Pascal Stienlet submitted plans for a cinema, to be called La Scala, for MacHarg. The proposed auditorium was fan-shaped, with the screen across the apex. It was to seat 1,800 (1,150 stalls, 650 circle). The plans were rejected by the city council and the scheme

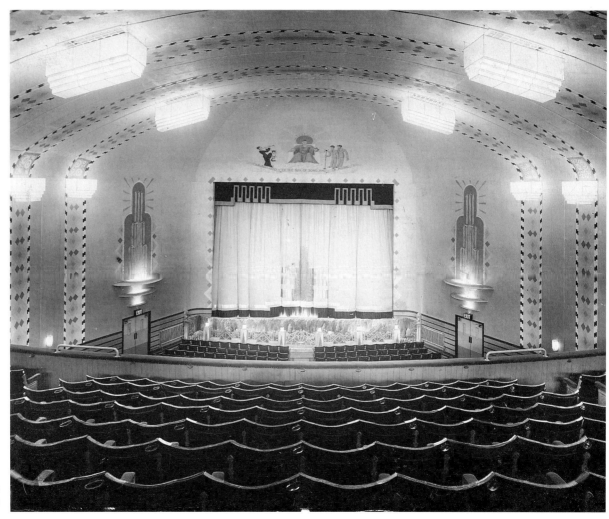

Auditorium of the original Apollo, 1933
(Mike Thomas)

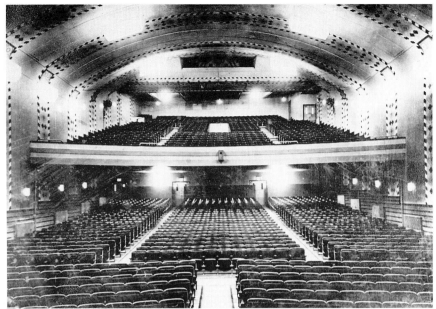

Above: Auditorium of the original Apollo, 1933 (Newcastle City Libraries & Arts)
Below: The new Apollo under construction, August 1955 (Newcastle City Libraries & Arts)

was not pursued, possibly because of post-war restrictions on building materials.

Thirteen years later, in May 1933, plans for the Apollo were approved; Stienlet was again the architect, this time of a more traditional building to seat 1,650. The main contractors were Davison, Eason and Harkness of Barrack Road.

Like the near-contemporary Haymarket, the front elevation of the Apollo was cement render finished in white. Above the electrically illuminated canopy were four large windows of amber glass, lit from the circle foyer. In the entrance hall were the payboxes and beyond these the stalls foyer, with walls shaded from flame orange to light cream, with geometric patterns in red and green on the beams. The stairs to the circle led off to the right.

"The decorative scheme of the auditorium has been designed to give a feeling of restful comfort ... Pilasters, 4ft. wide, with

slight projections, run up the walls above [the] dado, with an applied geometrical pattern in shades of orange, blue and cream, terminated by large, specially designed pilaster lights, which form a fitting cap to the pilasters. The geometric pattern of the pilasters is carried over the ceiling, to form ribs ... The walls are splayed into the rectangular proscenium opening ... Around the proscenium is a geometric pattern similar to [the] pilaster decoration ... and above the proscenium on the domed ceiling is the dominating feature of the modern Apollo on a modern throne with the Sun behind, with telephone and cocktail on the arms, on his left side the equivalent of song and on his right the equivalent of music."

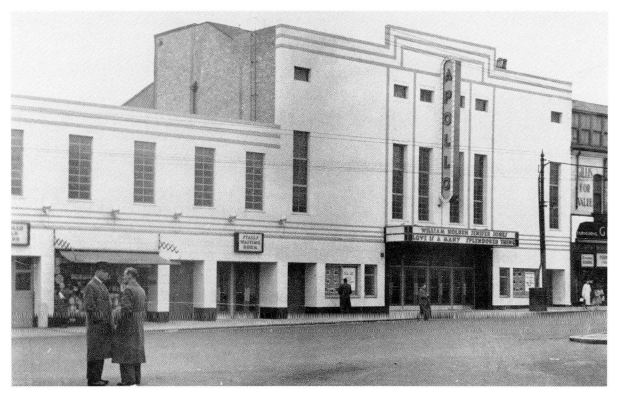

The Apollo, 1956 (Newcastle City Libraries & Arts)

This rather odd interpretation of Greek mythology was in keeping with the unusual decorative scheme. The stage had Holophane three-colour footlights and battens: the proscenium tabs were orange with appliqué work in gold. The screen curtain was a "Tapestry of Dreams", with changing lighting effects. The carpets and seating were blue. The projection room, behind the circle, was equipped with Kalee projectors and Western Electric sound equipment.

The Apollo was officially opened by the Lord Mayor on Thursday 28 December 1933, all proceeds

going to his Christmas Comforts Fund and the Byker Sun Ray Clinic. The opening film was *Moonlight and Melody* (Alexander Gray, Bernice Clare), with Gordon Richards in his own life story and an edition of the *Apollo Sound News*. There were two performances nightly (6.30 p.m. and 8.45 p.m.); seat prices were 6*d.* in the stalls and 9*d.* to 1*s.* in the circle. Initially all seats were bookable, at no extra charge, but this facility was soon limited to the front circle. "Get the Apollo habit" suggested early press advertisements: in one such, in February 1934, the cinema addressed its patrons:

"I, the Apollo, the Youngest Picture Theatre in the Newcastle area, hold over 1,600 people all comfortable and warm. I have heated waiting rooms for 1,000 people instead of queuing in the cold wet streets. My Western Electric Apparatus was acknowledged by everybody as the best in the district. It has been still further improved by adding Western Electric Wide Range, the latest sound invention. Note my prices ... " A free car park was opened at the side of the cinema, claiming to be the first in Newcastle, while in April 1935 an eighteen-table billiard hall was added.

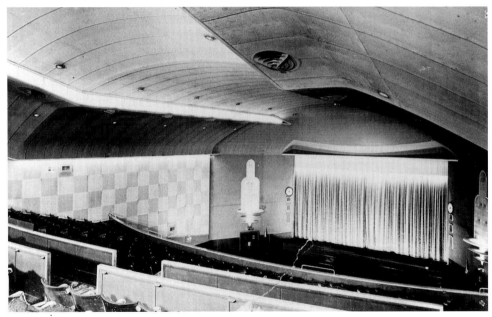

The Apollo auditorium
(E. Moorhouse)

Opening with evening shows only, in April 1934 the Apollo began to experiment with matinée performances, at first on Wednesday only but by 1937 every day. *Top Hat* (Astaire-Rogers) played four shows daily in February 1936 despite the fact that it had been shown at the Paramount only three weeks earlier. Reduced prices of 5*d.*, 6*d.* and 9*d.* were normally available at matinées.

Through the thirties, the Apollo was a considerable success. Morrison (Teddy) Fraser, manager from 1933, recalled for *Byker Phoenix*: "You must remember that they were the bad years, unemployment was rife, people hadn't very much money, and things were tough. The Apollo gave good entertainment, people budgeted for a twice weekly visit, it was comfortable, warm, you saw a good show with other people, and it helped them to survive until times were better. The Apollo was known in Westgate Road [where most film renting companies had their offices] as the 'Apollo Goldmine' – it just clicked. I had a wonderful staff, and you can't run a theatre or cinema without a good staff. The greatest business we did was with *Top Hat*. Approximately 30,000 people paid for admission during the week ..."

Morrison Fraser started children's matinées each Saturday at the Apollo and was known as "Uncle Teddy" – up to 1,000 children would pack the cinema every week to see cartoons, Shirley Temple, Laurel and Hardy and to sing the Apollo songs.

W. H. Whitehead, assistant manager 1935-41, remembers the showing in August 1938 of "the latest

The circle foyer, 1956
(Newcastle City Libraries & Arts)

screen novelty, Audioscopiks". These were short films in 3-D and two-colour Technicolor. The audience was supplied with cardboard eye-masks with apertures covered in red and green/blue gelatine. One of the films had a mouse on the end of a stick being thrust into the audience, resulting in screams of horror.

When Black's Regal opened, the Apollo "had a lady who used to go up to Black's to get the first tickets every Monday afternoon. She brought the ticket stubs back and we subtracted the [current] numbers from the [previous week's] numbers and found out how much the Regal had taken with their show that week. But I suppose Black's would have somebody who came down to the Apollo to get the first two tickets each week. We could have just rung each other up."

In the late thirties there were over thirty staff – five projectionists, six usherettes, four page boys, five cleaners, three cashiers, three doormen, one car park attendant, one kiosk girl, one shopkeeper and one billiard hall attendant, plus the management.

The good years at the Apollo came to an abrupt end at 1 a.m. on 6 May 1941 when the cinema took a direct hit from a German bomb. Jack Ritson, chief projectionist 1933-41 remembered: "I was firewatching that night; I'd just finished the show, gone home for a snack and was back for the firewatch. There was myself, the billiard hall attendant and the father of one of the doormen. We went up onto the roof to see what was going on, of course there was a blackout, and fortunately when things got a bit heated we went downstairs into the foyer.

"We hadn't sat there ten minutes before we heard one drop. We were dead lucky really. It came through the roof and hit the dress circle main girder and exploded. We were half out of the glass main doors when the canopy came down in front of us ... When I got up I looked towards the cinema and flames were starting up in the stalls..."

Arriving for work that morning, W. H. Whitehead "saw a crowd round the front and when I pushed through, there was no roof on the Apollo, there was a blue sky above, the radiators were hanging on the side walls with the water running out of them, a few tatters hanging where the screen had been..."

For years after the war the remains of the Apollo were a vast advertising hoarding. The billiard hall was not affected by the bombing and continued as such until after the war; it then became successively a soft furnishing factory and a clothing factory. In June 1947 Tyne Picture Houses Ltd. submitted plans for rebuilding but steel framing was not available. Further attempts were made in 1950 and 1953, the latter being stopped when the city council declared that the site was required for a new link between Shields Road and Tynemouth Road. Finally, in 1955, permission was given to rebuild the Apollo to its 1933 plan, as required by the War Damage Commission.

The main facade of the building was virtually unaltered from the original. A novelty was a vertical sign of 'chasing' pygmy sign lamps. Inside, the foyer walls had a vertical pattern treatment in tones of grey with off-white and red ornamentation. In the circle foyer were two large murals depicting scenes from the film industry. As in the old Apollo, there were large waiting rooms and a covered car park.

The Apollo projection room with Westars (E. Moorhouse)

The auditorium seated 1,576 (936 stalls, 640 circle): "Contemporary colouring is a main feature of the decorative scheme. A rich warm red is used on the splay walls flanking the proscenium opening, and this colour also extends over the main ceiling. On the splay walls, framed within panel shapes, are motifs consisting of conventionalised fountains which spring from three-tier illuminated half-bowls. The colours are cream, white and metallic gold, a combination which silhouettes their shapes against the rich red background..." The main side walls were finished in a light-reflecting chequerboard pattern. The screen was forty feet wide; in the projection suite were two Westars with Zeiss anamorphic lenses.

The new Apollo opened on 19 March 1956 with *Geordie* (Bill Travers). Admission prices ranged from 1s. 6d. (front stalls) to 2s. 6d. (Royal circle); pensioners paid 9d. Still an independent cinema, the Apollo played films from the National (formerly Gaumont) and ABC releases a few weeks after the city centre. There were also revivals, *Quo Vadis?* (Robert Taylor), a 1951 film, showing in 1960. In 1962, although the cinema was trading successfully, its owners decided that bingo would be more profitable and closed it. The final film, on 15 September, was *Escape from Zahrain* (Yul Brynner).

The chief projectionist, Mannie Moorhouse, stayed on to maintain the bingo equipment and the bandits, meanwhile keeping the projectors cleaned and oiled. His foresight was rewarded when in June 1964 the Apollo was taken over by Arnold Sheckman, who reopened it as a cinema on 2 August with *The Nutty Professor* (Jerry Lewis). Although revivals were shown as before, the usual programme was the ABC release.

The cinema was bought by the Classic Group in January 1972 and closed for tripling on 1 October. Cinema 1 opened to the general public on 30 October with *Mary, Queen of Scots* (Vanessa Redgrave). Late shows, commencing at 10.45p.m., were begun. The triplets were born (as the advertising put it) on Friday 22 December as the Apollo Entertainment Centre. Cinema 1 was the former circle; 2 and 3 were created from the stalls area. They opened with *Dumbo, Where Eagles Dare* (Richard Burton) and *Virgin Witch* respectively.

Seating capacities were 534, 180 and 169; all seating was new with greater leg-room and better sightlines. A licensed bar was added; total cost was reported as £100,000.

On 5 February 1973 a fourth screen (eighty-seven seats) was opened in what had been the stalls waiting area. Cinemas 2, 3, and 4 had a single projection suite.

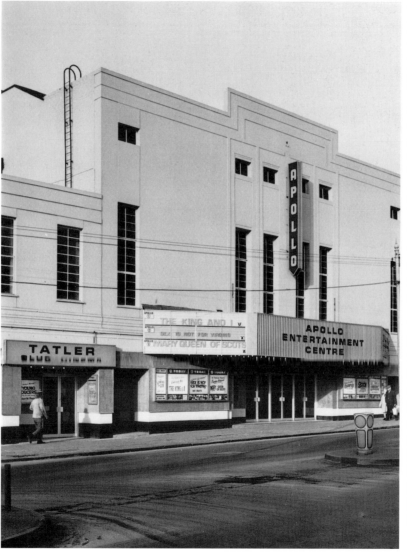

The Apollo Entertainment Centre, 1973
(Tom Oxley, courtesy of E. Moorhouse)

The fourth screen did not last long. It started as a club cinema, was then opened to the general public and ended as a skateboard centre; it was empty by 1980. In 1975 a bingo licence for Cinema 1 was refused; a slow decline began. By the early eighties shows were evenings only, with the cinema closed on Tuesdays. There was one projectionist, with part-time help.

Various ideas to save the Apollo were discussed, such as closing Cinema 1 and operating only the two minis, but head office decided the end had come.

The Apollo Entertainment Centre closed on 1 October 1983; the final film in Cinema 1 was *Friday 13th Part III*. The building was offered for sale until September 1989, when it was opened by Autospray as a car maintenance centre. The foyer has been attractively redesigned, but the most eye-catching feature of the building is the rear half of a red mini car protruding from the facade.

BAMBOROUGH (BAMBORO')

Union Road, Byker

?16 July 1913

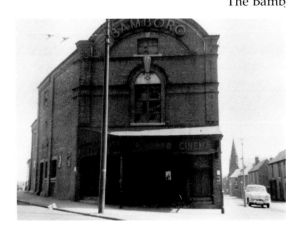

The Bamborough was at the top of Shields Road, at the junction of Union Road, Thornborough Street and Bamborough Street. It was owned for all its existence by the Renwick family. The early years of this cinema are something of a mystery; no plan survives and there was no press report of its opening. Various sources offer hugely different figures for its seating capacity. *Kine Year Book* gives 666 for 1914 and 1,000 for 1918; 675 is claimed in 1922 in an official source, while the cinema was licensed for 750 (500 stalls, 250 circle) in 1930.

The plans for the Bamborough were passed by the city council on 5 February 1913 despite a motion that the proposed cinema was redundant (i.e. superfluous). The hall had its projection room at stalls level. The circle was reached by stairs on the left hand side of the foyer, while there was no false ceiling – the roof trusses were clearly visible. By the 1950s a ceiling of building board had been added.

In 1919-20 there were two shows nightly, two changes weekly, with a children's matinée on Saturday; seat prices were 3*d.* to 9*d.* Major pictures however, such as *Tarzan of the Apes*

The Bamboro' after closure, above, ca 1963 (Newcastle City Libraries & Arts) and below, 1964 (S. N. Wood)

(Elmo Lincoln) and its sequel, could run for a full week. The cinema orchestra was highly recommended in the trade press.

Sound films came to the Bamborough on 20 January 1930 – earlier than some city centre cinemas – with *Broadway Melody* (Bessie Love). For *The Desert Song* (John Boles) shown from 10 March 1930 and said to be exclusive to the Bamborough, a special programme was issued, four performances daily were given, seats could be booked and no half price seats were available. About 1933 the cinema was redecorated in the 'atmospheric style'; unfortunately no details of this are available.

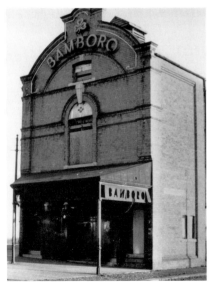

The Bamboro' (as it usually advertised and as it was called on its canopy) could show films only a month after the city centre: an impressive feat for a small cinema outside any circuit. A Thursday programme change had become standard in the late twenties although films of special appeal such as *Dr Jekyll and Mr Hyde* (Frederic March) and *Shanghai Express* (Marlene Dietrich) played a full week, with matinées. When Black's Regal opened nearby in 1934, the Bamboro' advertised even more aggressively.

In the fifties, programmes at the Bamboro' became more routine. It closed on 11 April 1959 with *God's Little Acre* (Robert Ryan). The building remained empty for some years and was demolished after a fire in January 1965.

BRIGHTON

Westgate Road/Lynnwood Terrace

10 July 1911

The Brighton Electric Theatre was the first element in a three-phase 'leisure centre'. On 2 November 1911 the Brighton Assembly Hall was opened, seating 800 and available for dances and other functions. This was followed on 4 April 1912 by a nine-table billiard hall. The whole complex was similar in concept to the Heaton at the opposite end of the city. The architects were Marshall and Tweedy and the builder James McEwen. The controlling company was Newcastle Entertainments Ltd.

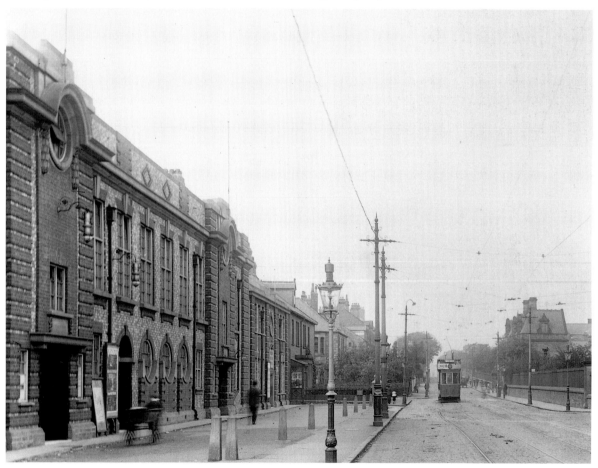

The Brighton, 1912 (Newcastle City Libraries & Arts)

John Coverdale Bell (Mr & Mrs Wilkinson)

The Brighton, opened on 10 July 1911, was licensed for 1,099: 767 stalls, 318 circle, fourteen in boxes and twenty standing. The four boxes were at the rear of the stalls and some were initially reserved for the directors of the company and their friends. The opening programme included the colour film *Aida*, an "Egyptian drama", suitably accompanied by the Cairo Trio, "Oriental musicians". "The building continually rang with expressions of appreciation". In the early years, films were accompanied by "Goffin's Bijou Orchestra (Finest in the North)". Family ticket books, offering a saving on normal seat prices, were available and there was a children's matinée every Saturday.

The general manager of the whole complex was John Coverdale Bell who stayed with the Brighton until his retirement in 1946. A founder of the local branch of the Cinematograph Exhibitors' Association, he was a close friend of Sidney Bacon and the latter's booking manager, Thomas France. The Brighton's films were booked by France until 1935; during the First World War they were identical to those shown at the Olympia in the city centre and a cut above the fare at the normal suburban cinema.

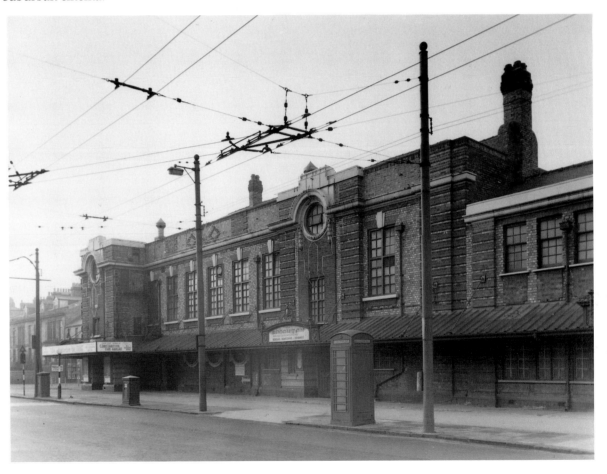

The Brighton, March 1963
(Turners Photography)

Bell had grand plans for the development of the Brighton which he revealed to *Northern Lights* in December 1919: "When completed the cinema will seat approximately 1,800, the dancing room will accommodate 400 on the floor and the billiard saloons will be equipped with twenty nine tables. This scheme will necessitate extensive structural alterations, and with the other internal improvements foreshadowed will, Mr Bell says, involve a sum of no less than £100,000."

This investment seems to have been too much for Newcastle Entertainments Ltd. to contemplate and the alterations were never made. The Sidney Bacon connection enabled the Brighton to stay in the front rank of suburban cinemas. Seat prices from 1931 of 6*d*. to 1*s*. 6*d*. indicated that superior fare was on offer. The first sound film at the Brighton was *Broadway Melody* (Bessie Love) from 20 January 1930. The cinema was reseated and redecorated in July 1934.

Like the Plaza, its nearest rival, the Brighton was taken over by W. J. Clavering, in this case in April 1947. It was the first suburban cinema and third in the city to equip for Cinemascope, showing *The Robe* (Richard Burton), from 1 March 1954 for three weeks, opening for matinée performances in the first week.

The Brighton survived longer than most suburban cinemas, closing on 20 April 1963 with *In Search of the Castaways* (Hayley Mills). It was converted into a ten-pin bowling alley, opened in November 1963 by Excel. It is still a bowling centre, operated by AMF.

BRINKBURN

14 Brinkburn Street, Byker

February 1910

The Brinkburn Picture Theatre is one of the least documented city cinemas: plans for the building do not survive and its opening, probably on 28 February 1910, attracted no reporters. It was a relatively large cinema for its time and location, seating about 930: 657 stalls and 265 circle, with forty standing places. The projection box was behind the stalls. It was James MacHarg's first, and for many years only, cinema in the city.

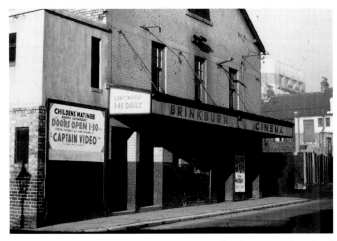

The Brinkburn, 1957
(Newcastle City Libraries & Arts)

The cinema was not without pretensions, advertising throughout 1910 as "The finest theatre and pictures in the North". Variety acts were prominent in the programme. There were the usual two shows nightly, prices ranging from 2*d.* to 6*d.* with half-price children's matinées every Saturday. Cycles, prams and go-carts were stored without charge. On some weeknights Boy Scouts in uniform were admitted free. On 27 November 1910 the Brinkburn promoted a concert under the chairmanship of James Lawrence of Newcastle United in aid of the East End Distress Fund.

The first manager, George Edminson, stayed for the unusually long time of twelve years. There is perhaps a touch of the backhanded compliment in *Northern Lights'* remark that "it says much for Mr Edminson's business acumen and forethought that he is still in the position where he started in 1910." In 1920 the hall was redecorated "in a very artistic manner" in cream and gold.

In the twenties the Brinkburn had the usual programme of cinemas of its type, either one main feature with support or a double feature of lesser films. Sound came late to the Brinkburn, on 29 September 1930, with *The Cohens and the Kellys in Scotland*; seat prices were raised to 6*d.* to 11*d.*

When the Apollo opened across Shields Road in 1933, the Brinkburn benefited from the crowds turned away when that cinema was full – both were under the same management. In 1937 seating was reduced to 646 by the replacement of the forms in the stalls and the cinema "beautifully redecorated".

In the forties and early fifties the Brinkburn was programmed concurrently with the Lyric, Heaton; the years up to 1956 were probably the cinema's best, as it was MacHarg's only outlet in the Byker area, in lieu of the bombed-out Apollo. When the Apollo reopened in 1956, the Brinkburn was dropped from MacHarg's display advertising in the press to the alphabetical listings for smaller cinemas. It is remembered as a very friendly cinema, strongly identified with the local community.

Programmes were now often X certificate horror with a leavening of westerns. The Brinkburn closed on 2 July 1960 with *Life is a Circus* (The Crazy Gang) and *Geordie* (Bill Travers). The building became a warehouse and has now been demolished.

CANNON

Westgate Road/Thornton Street

29 August 1938

The Cannon was built as the Essoldo by Sol Sheckman on the site of the old Westgate Police Station. It was the fourth cinema on a 100-yard stretch of Westgate Road, with the Stoll and Pavilion to the west and the Westgate to the east.

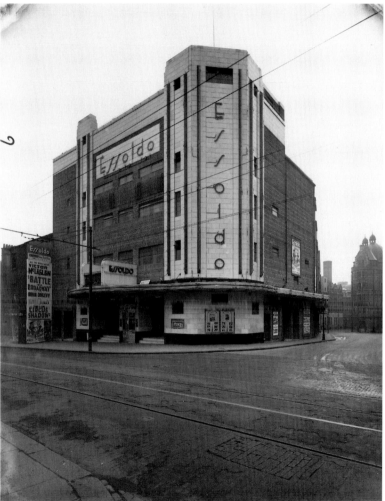

The Essoldo, November 1938 (Newcastle City Libraries & Arts)

Plans by North Shields architect William Stockdale for a cinema to seat 2,018 were first submitted to the city council in May 1936. Revised plans for 2,109 seats (1,144 stalls and 965 circle) were approved a year later.

The chosen site remained vacant: "Week after week passed, and still construction was held up by lack of steel and materials and it was not until February [1938] that building operations were started, and the gigantic steel framework of the new cinema began to take shape. Since that day, many setbacks have been encountered and overcome, and twice the date of opening has had to be put back." Rumour, less charitably, assigned the delays to Sheckman's problems in raising finance: a cinema of this size was certainly outside his experience. Part of the cost was raised from the sale of 2s. 6d. shares to the public.

"[The Essoldo is] both striking and original. Sandstone bricks and brilliant white facings give a startling effect, with the name Essoldo picked out in specially cast bright blue letters, built into the

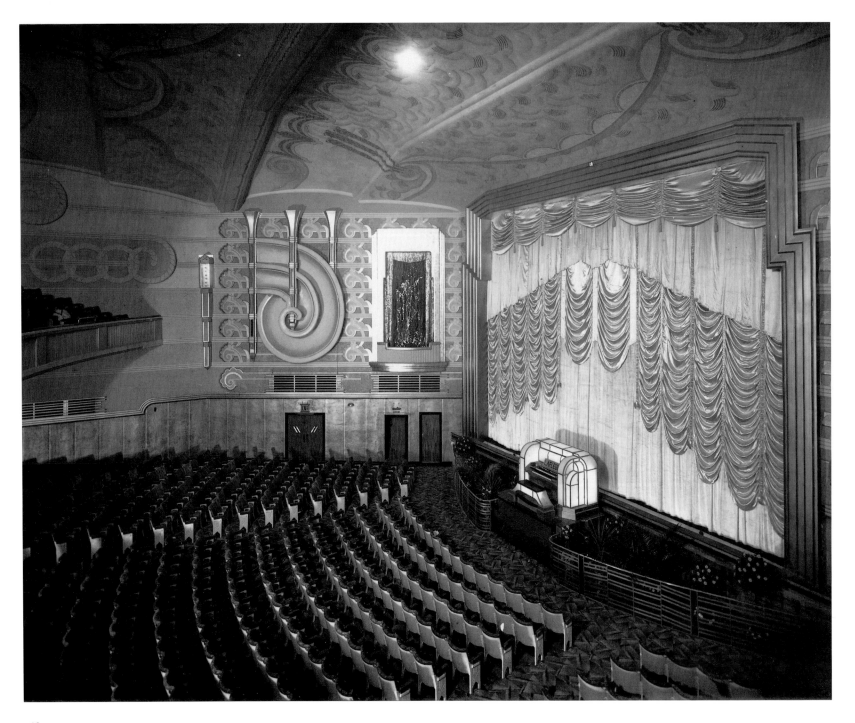

tower, on the front and at the side entrances. The unusually designed neon on the front of the building is arranged in a style never before seen in the provinces, and the amount of tubing used is the greatest in the North.

"Inside, the theatre is planned on the same striking lines. The main foyers and stairways are panelled throughout in Vitrolite glass ... The main colour scheme is jade and black, with engraved mirrors on every side. Brilliant effects are provided by several corner mirrors made of pillars of glass, embodying a clever concealed lighting effect. The upstairs foyers are panelled in contrasting shades of walnut.

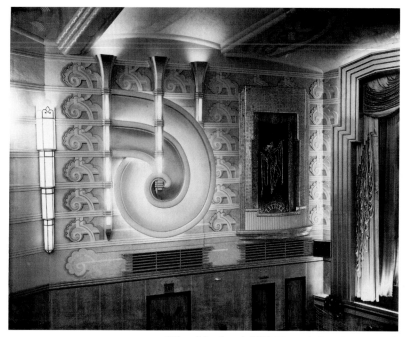

Sidewall treatment, 1938 (Newcastle City Libraries & Arts)

"From the circle seats a wonderful view of the unusual lighting effects on the walls and proscenium may be obtained. No actual lights are to be seen but the whole theatre is glowing with soft colours, which come from behind parts of the wall and ceiling, and show off the beautiful plaster work and plaster modellings.

"Most important for comfort are the seating arrangements ... It is expected that the Essoldo will hold 2,700 patrons in all." This figure is pure hype, chosen presumably because it was greater than the Paramount's capacity: the cinema was actually licensed for 2,099.

The projection box contained two Ross projectors, with a Super-Simplex as standby machine, occasionally used for shorts. There were seven projectionists. The cinema had the first all-metal screen in the North; the cinema organ was by Lafleur (Hammond) and was installed in the centre of the orchestra pit on a lift; it had an illuminated glass surround. It was unusual in that it was an electronic organ, of which only a few were installed in cinemas. The full-sized stage was equipped for large shows.

The first manager of the Essoldo was Hugh le Mounier who came to the cinema from a two-year stint as manager of the Palace Theatre for E. J. Hinge. He was an Australian who before the First World War had been the "greatest strong-man act in the Southern Hemisphere". Essoldo staff believed that he

Left: The auditorium, proscenium and Lafleur organ, 1938
(Newcastle City Libraries & Arts)

41

was the all-in wrestler 'The Blue Mask' as he was always absent on Saturday nights.

The Essoldo was officially opened on 29 August 1938 by the Lord Mayor who outlined his view of the attraction of the cinema: "To me its great value lies in the fact that it enables our womenfolk, without having to pay undue attention to their toilet[te] and with very little expenditure of money, to live in a world of fine dresses and luxurious motor-cars and for two short hours be away in the fairylands of romance." The women present "laughed and applauded."

The opening film was *The Hurricane* (Dorothy Lamour) which was also showing at the Paramount in that week. In fact the Essoldo had the same main feature as the Paramount for fifteen weeks of 1939. Otherwise the programmes were rarely first-rate, with second-rank Hollywood stars topping the bill.

In July 1939 Le Mounier admitted in the Essoldo's programme booklet that "... you may find names that are unfamiliar but please remember that it is the picture which is important, not the stars." Few thirties cinemagoers would have believed this.

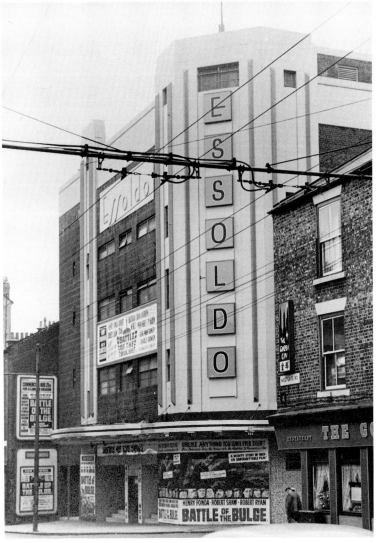

Essoldo, 1966 (Newcastle City Libraries & Arts)

The stage facilities were rarely used before the war. Gipsy Petulengro appeared in December 1938, there was a Czechoslovakian revue *Ma Vlast* in March 1939 and Younkmans and his Gipsy Czardas Band ("Thrilling! Barbaric! Exotic!") in April. There were, as in most large cinemas, Sunday band concerts. The regular organist was Ronald White.

Programming improved greatly on the outbreak of war. The Essoldo's greatest triumph of this period was the first Newcastle showing of *Gone with the Wind* (Clark Gable), which ran for four weeks from 29 July 1940. There were two showings each day at 2p.m. and 6p.m. with seat prices raised from 1*s*. and 2*s*. to 3*s*. 6*d*. and 4*s*. 6*d*. George Belshaw remembers collecting this landmark film from the Central Station. It came with a book of instructions on how it should be shown to best advantage. Essoldo staff spent hours covering any light-reflecting surface near the screen with matt-black paint, so that nothing should detract from the projection of the film. Coffee and biscuits were served in the lounges to waiting patrons.

The first Cinemascope film at the Essoldo was the Royal Tour documentary *Flight of the White Heron* from 7 June 1954. When Rank resisted Fox's insistence on the installation of full stereophonic sound in all its cinemas licensed for Cinemascope, the Essoldo gained the unexpected bonus of first-run films in this ratio, for example *The King and I* (Yul Brynner) for five weeks from 29 September 1956, *Carousel*, (Gordon MacRae), *A Farewell to Arms* (Rock Hudson) and *There's No Business Like Show Business* (Ethel Merman).

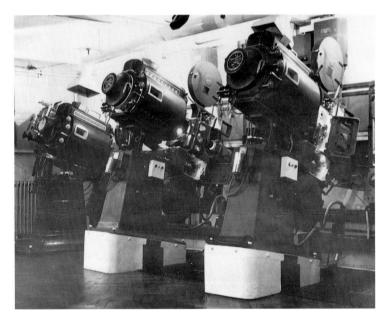

Essoldo projection room with Westars and a Super Simplex, ca 1963
(Newcastle City Libraries & Arts)

In the week beginning 7 December 1953, the full stage facilities had been used for probably the last time when the Essoldo staged the Latin-American revue *Braziliana*. At the end of 1960 the cinema was reseated, redecorated and given a new screen installation prior to a long run of *Ben Hur* (Charlton Heston). At special prices (circle 6*s*. to 10*s*. 6*d*.; stalls 4*s*. to 7*s*. 6*d*.), this epic film ran for twenty-one weeks from 9 January 1961. The Essoldo then went back to routine programmes with the occasional extended run.

In October 1965 the organ was dismantled and the entire proscenium rebuilt to take a larger screen for 70mm presentations. The proscenium arch was replaced by sweep-round curtains. In the box, two Cinemeccanica Victoria 8 projectors were installed alongside the existing Westars, which were retained for Pathe News and the advertisements.

The organ lift was used to elevate a "candy and coke bar". The organ was rescued and restored and now plays in a local private residence. Outside, the long 's's of Essoldo were replaced by new style box lettering. The cinema opened on 26 January 1966 with *My Fair Lady* (Rex Harrison).

On 23 January 1971 the Essoldo closed for conversion to twin cinemas, the region's first. The last film in the old cinema was *Tropic of Cancer* (Rip Torn). After work reported to have cost £170,000, the old stalls area (or most of it) became Essoldo 1, with a new projection box and seating 650. Essoldo 2, seating 390, was created from the former rear circle, using the original box, remotely controlled. Both cinemas were equipped with 70mm facilities and six-track stereo. *Love Story* (Ryan O'Neal) was the first film in Essoldo 1, opening on 29 July 1971.

A licensed bar was added in 1972; in the same year the cinema was bought by Classic.

In March 1974 it was rumoured that EMI had approached Classic with an offer for the twins. The transfer was announced on 3 April. The two cinemas were to be renamed ABC 1 and 2. Behind EMI's interest was the problem with the group's main outlet in Newcastle, the Haymarket, the lease of which was under review. It was rumoured that EMI had paid well over the odds for the cinema as insurance against the lease of the Haymarket being suddenly terminated.

The advantage of twinning can be seen, for example, in early 1975, when ABC 1 ran *Earthquake* (Charlton Heston) in 70mm and Sensurround for ten weeks, while ABC 2 had a varied programme. Later in the same year the re-released *Gone with the Wind* ran for a month, exactly the length of its run at this cinema thirty-five years earlier.

In 1986 the Thorn-EMI circuit was taken over by Cannon, beginning a period of uncertainty as the company, beset by financial problems, closed many of its cinemas. Added to this, Westgate Road was now something of a backwater, many of its buildings tatty and decaying. Alterations to the public transport system, particularly the downgrading of Marlborough Crescent bus station, had their effect. There was little car parking space in the vicinity and what there was, was not secure. On 18 September 1989 the cinema was offered for sale.

Two months later on 18 November, the closure of the Cannon was announced, along with the Cannons at Durham and West Monkseaton. Cannon management was clearly alarmed by the imminent opening of the Warner complex and was not willing to stay and fight. Ironically, the Newcastle Cannon had made an operating profit in its last year and had been refurbished. Business was reported to be back to the levels attained before the opening of the Metrocentre complex.

The Cannon closed on 11 January 1990; the last films being *Shirley Valentine* (Pauline Collins) and *Back to the Future II* (Michael J Fox). Thus the seventy-eight-year connection of the cinema industry with Westgate Road came to an end. The building was demolished in 1991.

CROWN

818-830 Scotswood Road

24 December 1910

The Crown Electric Theatre was built on the site of the Elswick Picture Palace (Queen's Theatre) by Joseph Dobson, an auctioneer and house agent. The plans do not survive, but there is a full description in *Kinematograph and Lantern Weekly* (5 January 1911):

The Crown, after fire damage in 1971 (Cityrepro)

"Two good attendances marked the inauguration of this large theatre at Newcastle. Situated immediately facing a section of the famous Elswick Works of Sir W. G. Armstrong, Whitworth & Co., Ltd., a populous neighbourhood is to be served. Twice nightly and Saturday matinées are to be the rule, first-class features with vaudeville to be featured. The fine building seats 2,000, all in comfortable tip-ups, at prices from 2*d.* to 6*d.* The whole of [the] seating forms a segment of a circle, and owing to great width and ample rake an excellent view is obtained from all parts ... The large stage is completely equipped for all classes of business, the proscenium opening being 26ft wide by 24ft high. A novel feature is the huge screen frame, aluminium coated, with curtain borders which automatically recede to the rear to allow for stage setting, all changes being worked with dark stage and powerful red lamps to face [the] audience. The operating box contains a Tyler-Ernemann ...

"A good orchestra accompanies, and a large staff is in attendance. Contractors for the building are Messrs W. T. Weir and Co., and architects Messrs. White and Stephenson also of Newcastle. The sole proprietor is Mr J. Dobson, a famous entrepreneur in several directions, having already two fine suites of Assembly Rooms in Newcastle and South Shields, besides owning over 100 billiard tables in the district. He is also adding, at the rear of this theatre, rooms to accommodate eight [billiard] tables, and three first class shop premises."

The *Newcastle Daily Chronicle* (24 December 1910) gives additional information: "The building, which has been constructed ... in the rapid time of seven weeks has accommodation for some 1,500 persons seated. The whole of the floor space is on an inclined plane, enabling every sitter to have a clear view of the stage. There is a circular gallery in the building ... The theatre is warmed on the most approved principles, and fitted throughout with electric light ..." The huge discrepancies in capacity given by these two sources is further complicated by a 1922 official source which gives only 1,190. Seating was further reduced over the years.

The Crown was opened by the Sheriff of Newcastle. Like most local cinemas, the Crown management ran special events for its patrons: in April 1912, for example, there was a seaside treat for the children of regulars.

The Crown abandoned variety acts by 1914, one of the first cinemas to do so. At one period in 1915 it had the lowest adult seat price I have seen – 1½d.. Occasionally a special picture, such as *The Rosary* in 1916, was accompanied by an improving lecture.

In January 1920 a *Northern Lights* correspondent visited the Crown for a performance of *Fabiola*, an Italian religious epic: "Mr Finch [the manager], a quartette of singers, and operators all seem to have been putting their heads together to make the picture a success, and if the night I was present is any criterion, it was a REMARKABLE success. The Pathé Gazette was the only [other] item screened, and after this the hall was put in absolute darkness while the quartette sang unaccompanied 'Shepherd of Souls' from *The Sign of the Cross*. Other items rendered during the screening of *Fabiola* by the quartette were 'The Stabat Mater', 'O Salutaris', and 'Adeste Fideles', these latter being sung in Latin. The picture closed as it began, by the singing of one verse of 'Shepherd of Souls'. The audience were so quiet that you might have heard the proverbial pin drop." A tribute to the emotional power of the silent film.

After the war, the orchestra was augmented, a third projector installed and double features introduced. Information on the Crown between the wars is hard to trace as it rarely advertised in the press. Sound came in 1931, when the programme organisation was continuous performances Tuesday, Wednesday, Thursday, with separate houses Monday, Friday, Saturday. Seat prices were unchanged from 1924 to 1939 at 4d. to 9d.

To judge from a letter in the *Evening Chronicle* on 26 June 1933 the Crown was a 'rough' house: "Scotswood Road, Newcastle is noted for many things, but the latest 'thrill' lies in listening to the 'rude' remarks about the following notice in the Elswick Labour Exchange window: 'Male Attendant wanted for local cinema; must be fairly well built, and able to take care of himself. Five shifts per week, includes one day off. Hours 5.45 to 10.45 daily, with Saturday matinée. Wage offered, 7s. per week'. The rumour is that the one appointed must provide his own uniform and arrange for a police 'escort' on receiving his wages." Later in the same year, the Crown management was fined for overcrowding gangways, so business must have been good, rough or not.

In 1935, though still owned by the Dobson family, the cinema began to be booked by the Hinge circuit. In February 1945 it was bought by Essoldo. Closure as a cinema came on 24 November 1962 (bingo had occupied five nights a week since October 1961). The building was badly damaged by fire and vandalism in 1971 and was demolished.

ELSWICK PICTURE PALACE

818-830 Scotswood Road

November 1908

The Elswick was one of the shortest-lived picture halls in the city. The building had a varied history, having opened in August 1900 as a circus. Apart from the many pubs, there were no other places of entertainment in the area. The New Tyne Circus, designed – if that is the word – by Newcastle architect Charles S. Errington, was a 'temporary' building with walls and roof of galvanised iron. The huge interior had at its centre a thirty-six feet diameter circus ring. Surrounding this on all sides was raked seating for 1,200. The proprietor was J. B. Davenport of Birmingham, but the circus seems to have been run by two Stockton men, John Batty and Henry Alvo.

The circus idea was soon seen to have been a failure as in October 1900 a plan was approved for the conversion of the building to a variety theatre for Frederick Bolam and Sidney Bacon who already ran the Queen's Theatre in Gateshead. A stage was built and the hall reseated as a conventional theatre.

On Monday 12 November the building opened as the Queen's Theatre. "Westenders have now got a variety theatre of their own, and are proud of the fact." The Queen's, renamed the Elswick Theatre in 1903, seems to have staggered along under various owners until 1906. In September of that year, it was planned to use the building for the Elswick Works Rifle Club, but it must have continued intermittently as a theatre until the city council refused to renew its licence in May 1907. The council also rejected, in March 1908, a plan by William Dobie of Sunderland to convert the building to a cinema.

Council officers must therefore have been surprised to read in the *Newcastle Daily Chronicle* of 9 November 1908 that the well-known publican and boxing promoter James 'Jimmy' Lowes had opened the theatre as the Newcastle Sporting Club and was running boxing contests and bioscope shows. The building must by now have been in a dilapidated state, but Lowes' patrons didn't seem to mind. By December 1908 the Newcastle Sporting Club was being advertised as the Elswick Picture Palace and "has met a felt want in that locality. The entertainments have been well patronised ..."

The city council was naturally disturbed that a building which had been refused a licence eighteen months earlier was still open and could hold 2,000 people. Correspondence ensued with Lowes in the course of which it transpired that "the firm that is running the pictures is from London ..." It was in fact the respected production company Walturdaw. As might be expected, the few available advertisements for the Elswick show a heavy emphasis on films of boxing matches. Beauty contests were also being staged: "First prize – Guinea Hat. Second prize – Half-guinea Hat."

Lowes finally agreed to close the Elswick Picture Palace on 16 January 1909. The Crown Electric Theatre was built on its site.

EMBASSY

Thorntree Drive, Denton

6 September 1937

The Embassy, like the earlier Plaza, was built as an integral part of a new housing estate by the developers. The *Sunday Sun* noted: "This is not the mere opening of an addition to the City's numerous places of entertainment. There is behind it romance, and innovation in a broader sense. Innovation, because here we have what is believed to be the first case in the area of two men who have devoted practically the whole of their partnership life to developing a given housing estate – the Thorntree Estate at Denton Bank – rounding off the job by themselves building and running its picture theatre. Romance, because Messrs. J. W. Longstaff and J. Bain are working lads, joiners to trade, who pooled their resources and comradeship in their own business venture."

The Embassy, 1937
(Newcastle Chronicle & Journal)

At the time the Embassy was opened, the firm had sold 600 houses on the estate (with mortgage repayments at 4½%) and were engaged on a second estate at Chapel House Farm. Plans for the cinema, by Newcastle architect Robert Burke, were passed by the city council in December 1936. The Embassy was designed on the stadium plan with 626 stalls and 362 circle seats. Actual seating when the cinema opened was 936.

"There will be seating for 936 people in roomy, luxuriously-upholstered tip-up seats, a proscenium arch which will be a masterpiece in lighting with a choice of three beautiful general colour-effects, an ample free car park, a projector for plain and coloured films which is the latest type, and a scheme of decoration which is quite novel. The latter is futuristic – but please do not get the idea that you will be confronted with daubs of red, yellow and blue in juxtaposition, representing goodness knows what."

The decoration was by Fred A. Foster of Nottingham and the lighting effects by Falk, Stadelmann. The projectors were Ross by Pathé Equipment, who also installed the carpets, seating and other furnishings. The sound equipment was RCA Photophone.

The Embassy was opened by the Lord Mayor, Alderman John Grantham, on 6 September 1937: the

opening film was *Pennies from Heaven* (Bing Crosby). There was a Thursday programme change, prices ranging from 6*d.* to 1*s*. Advertising as "Newcastle's Premier Suburban Cinema" with "Trolleybus to door", the Embassy in fact programmed for a captive audience. 'A' features reached it six months after their city centre showing. A May 1939 advertisement read: "Comfort, Courtesy, Cleanliness, plus a good show": not much confidence in the product being shown here! In 1954, while most main features shown were over a year old, it was occasionally possible to see films made before the war.

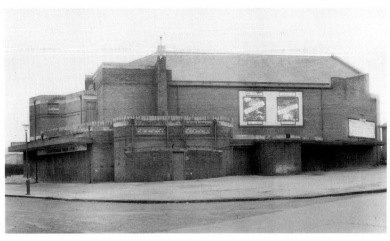

The Embassy after closure, January 1961 (Turners Photography)

This very attractive cinema closed on 25 June 1960 with *A Touch of Larceny* (James Mason). Plans to demolish it in favour of a bowling alley were not pursued; the building was empty and vandalised before opening in 1963 as a bingo club, which it remains.

EMPIRE CINEMA

10-12 Grainger Street West

2 April 1913

The Empire was a converted shop, formerly the premises of Dunn and Dick, jewellers. It was built by Moss Empires, who owned the adjacent Empire Theatre in Newgate Street. It may be a unique example of theatre proprietors building a cinema which was intended to operate as a unit with the original theatre.

The entrance was on Grainger Street West and up to first floor level had pillars of Hoptonwood stone, between which were mahogany doors and fittings. The foyer, with payboxes in the centre, was laid with marble slabs on floor and walls. "Sumptuous" tea rooms (run by Tilley's) were provided and access was made from all parts of the building to the Empire Theatre, "so that patrons wishing to spend an hour in the cinema, and then have a part of the evening in the theatre, can pass from one to the other without coming into the street, and special tickets will be issued and special facilities provided to enable them to do so."

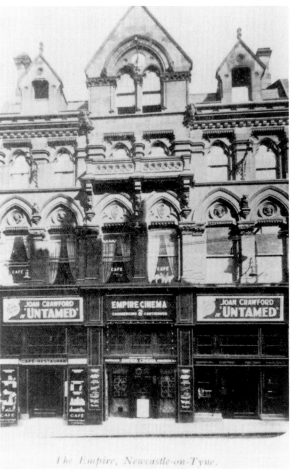

Empire, 1930
(Tony Moss)

The auditorium, sixty-eight by forty-two feet, was licensed for 614 (456 stalls, 158 circle, with fifteen standing); the circle was unusual in that it had a wide slip running along one wall towards the proscenium. Tip-up chairs in rose-pink were used throughout. The decoration was in the Adam style; the walls were panelled in mahogany with cedarwood carvings up to a height of seven feet. Above this were friezes and tapestries. The sixteen by fourteen feet screen was set in a fibrous plaster proscenium arch; projection was from the rear of the stalls.

The auditorium lighting was indirect, projected from the electric lamps on to the ceiling from which it was reflected, "a system which gives a most pleasing effect and avoids strain on the eyes". Much was made of the Ozonair ventilation system, which was said to remove all stuffiness from the atmosphere, dissolve smoke and dissipate any fog which might get into the

building.

On the first floor was a large tea room with a separate entrance from Grainger Street and access from the Empire Theatre. It was decorated in the Treillage style – " much in vogue in London, but which has not yet been introduced in the North of England". There was also a smokers' lounge and a further tea room on the second floor. The architects were W. and T. R. Milburn of Sunderland and the builder Stephen Easten Ltd. of Newcastle.

The Empire opened on Wednesday, 2 April 1913 at 6 p.m., with *A Strong Man's Love* (written for Clarendon Films by the Marchioness of Townsend), five other films and the Gaumont Graphic News. After opening night, performances were continuous 2 p.m. to 10 p.m. Incidental music was by the New Empire Cinema Orchestra supplemented, according to one account, by an organ, though this is unlikely.

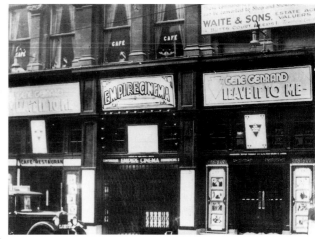

Empire, the week before closure, November 1933 (Mike Thomas)

The cinema's modest little press advertisements during its early years – "An excellent programme, with charming music" – contrast sharply with the more aggressive approach of the nearby Grainger to the marketing of its product. It is not known whether the proposed transfer tickets to the Empire Theatre were ever used, but if they were, the constant tramping to and fro must have been an irritation to the patrons of both places.

In 1927 the Empire was taken over by Favourite Cinemas Ltd. (later part of Associated British) and one of the cafés became a 'dance room' for a short period. Talkies came to the cinema on 3 February 1930 with *The Informer* (Lya de Putti) and from the same date films were shown in concurrency with the Grainger.

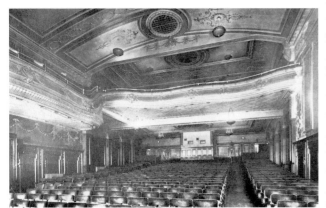

The Empire auditorium, 1926
(Stephen Easten Ltd.)

In October 1931 the cinema was reseated, recarpeted and redecorated but at the beginning of November 1933 its closure was announced. The lease on the building was due to expire and ABC was not interested in renewing it. The last show was on Armistice Night, 11 November 1933; the last film – shared, of course, with the Grainger – was *The Keyhole* (Kay Francis, George Brent). As the crowded cinema emptied, 'Swanee River' was played on the gramophone (the orchestra had long gone) and patrons said farewell to Bobby Cook, the commissionaire. Twelve staff were thrown out of work (though Bobby Cook went to the new Apollo).

The building became a furniture shop: its site is now the Grainger Street entrance to the Newgate Shopping Centre.

GAIETY

12 Nelson Street

29 March 1911

In 1838, as part of their development of central Newcastle, Grainger and Dobson built the Music Hall in Nelson Street. It was later known as the Lecture Room, where in 1861 Charles Dickens gave readings from his works.

In 1879 it became the New Tyne Concert Hall, then the Gaiety Music Hall in November 1884. This closed when the Empire Theatre opened in December 1890 and the hall was used by the temperance movement for meetings and lectures as the Central Hall.

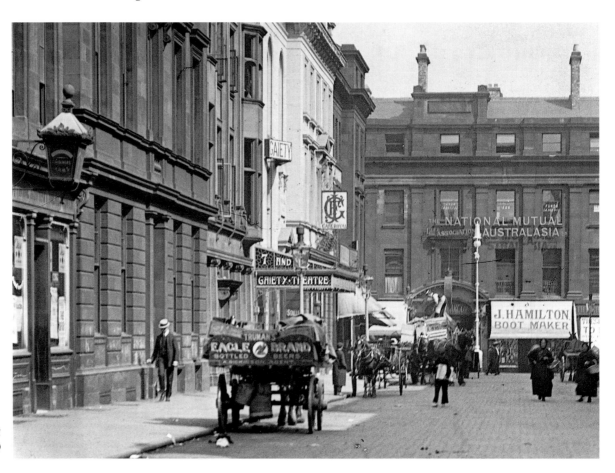

The Gaiety, 1912
(Newcastle City Libraries & Arts)

The early history of the building as a cinema is confused. The *Kinematograph and Lantern Weekly* (19 January 1911) reported that "some years ago a picture season was run here by Mr. J. Thompson [actually, John Henderson], afterwards of Royal Hall and Olympia, Newcastle, with a fair measure of success." Confirmation of this comes from the *Evening Chronicle* of 2 January 1908, in which the Royal Biograph Animated Picture Company advertised "The great picture, *Returning Good for Evil* [and] *Hunting in the Arctic Regions* " with prices at 3*d*. to 1*s*. On Saturday of the same week a temperance meeting was held at the Central Hall: "At the close of the usual programme a short EXHIBITION of CINEMATOGRAPHIC PICTURES will be given". It seems evident that the Royal Biograph Company had an arrangement with the temperance committee for the use of the hall during the week, in return for which they allowed their equipment to be used as an audience puller for the temperance meetings. The cinema company opened a full-time hall, the Royal, in the Groat Market, in June 1908.

There is no further record of cinema shows at the Central Hall until January 1911, when the issue of *KLW* quoted above mentions a kinematograph entertainment under the auspices of the Central Hall Temperance Concerts Committee, beginning on 14 January 1911. But as early as February 1910 R. & W. Baker had submitted plans to the city council to raise the floor of the Central Hall to give a rake, which suggests a cinema show. In December 1910 the Baker brothers, with architect Percy L. Browne, submitted further plans for the full conversion of the hall to a cinema, to seat 528 in the stalls and 402 in the gallery. These plans were refused, but revised plans of January 1911 were passed, though the council clearly had doubts about the suitability of the hall as a cinema. At the end of March the Gaiety Picture Hall opened. What seems to have happened is that the Baker brothers ran cinema shows for the temperance committee, saw the commercial potential and persuaded the temperance people to leave – they went to a hall in Westgate Road.

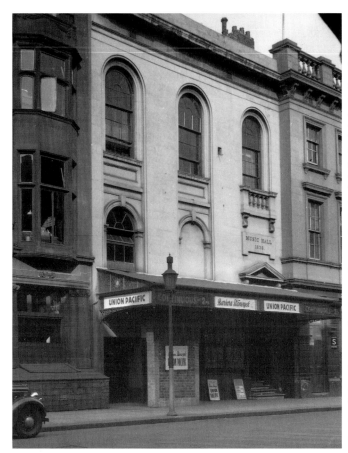

The Gaiety, December 1943
(National Monuments Record, RCHM)

The conversion was said to have cost several thousand pounds and the hall to seat 1,000 comfortably, but in fact it was licensed for only 885 and actually seated 830 (in 1922). The cinema retained its old music hall appearance. It was on the first floor, above a fruit wholesaler's, with a tiny stage twenty-five feet wide and only ten feet deep. The balcony extended along both side walls towards the proscenium arch.

The Gaiety offered "high class variety" and pictures at two performances nightly with matinées on Wednesday and Saturday. On opening night: "... two packed audiences showed evident appreciation of the programme put before them and the arrangements made for their comfort. The pictures are steady and clear, the comic element predominating. Two very fine dramatic films were shown, together with a long one describing a trip through Holland [that sounds exciting!] ... The Morellis

present this week a clever and enjoyable musical act, the other turn being provided by a dancer of no mean ability". On Friday of the opening week a film of the launch of HMS *Monarch* from Armstrong, Whitworth's Elswick yard was shown, "specially taken for Messrs Baker Bros." There was a Thursday change of programme and prices were 2*d*. to 6*d*. – all on tip-up seats. By 1912 there was a "Grand Orchestra" under the baton of Mr F. Young.

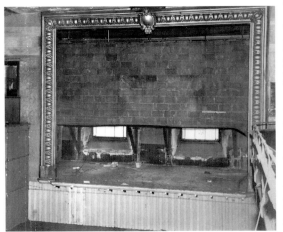

Variety performances ceased about 1915. Many of the films shown were British, from the Hepworth Studio, but there were also films from France and Norway – an indication of the international language of the silent film. At the Gaiety, as elsewhere during the war, serials like *The Broken Coin, Secret of the Submarine* and *Patria* were very popular.

After the war, the Gaiety turned to double-feature programmes, usually of American origin. From 1923 the cinema was part of the Stanley Rogers (later Hinge) circuit. It was the last city centre cinema to install sound, on 8 September 1930 with *High Society Blues*. According to report, through the thirties and early forties the Gaiety's main clientele was "market traders and prostitutes"; it is said that the latter occasionally plied their trade in the balcony and passages. Very low prices – 4*d*. to 6*d*. – were retained until the war. In the late forties it was an 'overflow' for the other city centre cinemas. When they put the 'house full' signs up, people went to the Gaiety rather than go home without seeing a film. It was a "little goldmine", with queues every Saturday night.

The Gaiety proscenium after closure, 1956
(Newcastle Chronicle & Journal)

It may have been these crowds which attracted the licensing authorities to the Gaiety. A renewal of its licence was deferred pending an inspection, which took place on 18 February 1949. The poor exit facilities were noted as well as the fact that inflammable material was stored in the warehouse below. The emergency exit is agreed by a former member of the Gaiety staff to have been dreadful, consisting of a rickety cast iron staircase to the alley below. But it had been so for years, and this seems to have been a case of a new broom sweeping clean (the Regal, Walker, was closed after an inspection on the same day).

The "Pie and Tatie" as it was nicknamed, closed on 26 February 1949 with *The Hidden Eye* (Edward Arnold). A deputation from Stanley Rogers Cinemas to the city council proposed substantial alterations but in May it was decided that these would be uneconomic. In 1951 King's College students held a cabaret night at the Gaiety during Rag Week, but the cinema stayed closed. A visiting *Evening Chronicle* reporter in 1956 found the seats removed and the "once magnificent ceiling" chipped and rotting. The Gaiety auditorium, along with the fruit warehouse below, was demolished in 1964, although the 1838 facade has been preserved.

GAUMONT

Westgate Road/ Clayton Street

12 February 1912

The Gaumont was originally the Picture House (occasionally known as the Cinematograph Picture House), the first up-market hall in the city centre, costing a reported £4,500. It was owned by the Newcastle Cinematograph Company; the architect was Arthur Stockwell and the builder Stephen Easten Ltd. The land, part of the Cross House site, was leased from the city council at £835 per annum. The cinema was opened before the builders had finished; the *Newcastle Daily Chronicle* reported:

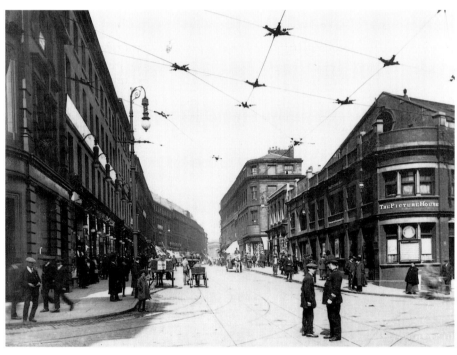

Clayton Street, with The Picture House at right, ca 1915
(Newcastle City Libraries & Arts)

"It is not yet complete, there is still the tower to be built at the angle of Clayton Street and Westgate Road [this was never done] and there is still an artistic scheme of mural and ceiling decoration to be carried out as soon as the plaster work is dry; but even in its present state visitors will be impressed by its handsome appearance. Except for the balcony at the Clayton Street end, there is nothing to break the four square walls of the building. The lights are all concealed within the cornice that runs round the four walls, and the one thing that attracts attention above all others is the screen, artistically enclosed as it is in a proscenium of Corinthian design. There is more than the usual rake in the floor, so that the occupants of the tip-up chairs can see without interruption every picture that is shown."

The projection room was at the rear of the circle. The hall was to be run "as a picture show purely and simply and to keep the entertainment going continuously from 2 till 11 p.m. Thus patrons may enter or leave at any time, and visitors to Newcastle who have trains to catch may, by the assistance of the electrically lit clock near the stage, time their departure to a minute." There were 850 seats.

The Picture House opened with a charity performance for the benefit of the Home for Destitute Crippled Children at Gosforth. Trading must have been successful, as in February 1913 a further part of the Cross House site was leased from the city. The cinema was extended to the rear, increasing capacity to 1,021 and permitting the addition of a tea room and a smokers' lounge. The decor was made considerably more opulent. Teas were served in all parts. These alterations were complete by November 1913.

In early 1914 the orchestra was said to be Viennese, led by the almost unpronounceable Herr Franz

The Picture House orchestra and staff, ca 1914
(Newcastle Chronicle & Journal)

Csavojacz. Also in that year, the cinema's name was amended to Westgate Road Picture House as a result of the opening of the Newcastle Picture House in Grey Street.

The programmes included many first runs and exclusives, including D. W. Griffith's *Judith of Bethulia*. No doubt tears flowed during showings in 1919 of *For the Love of a Child* – "A story of a tiny maid who melts an old man's stony heart."

The Westgate now had competition from the Stoll and the Pavilion and in about 1919 was taken into the Consolidated Cinematograph Theatres circuit. The new owners added a "splendid marble entrance" in February 1920. CCT leased yet more land in January 1922, presumably with the intention of enlarging the cinema again, but it was not until 1927 that a decision was taken to rebuild entirely. The Westgate closed on 5 March 1927.

The rebuilt cinema opened as the New Westgate on 31 October 1927 with *The Monkey Talks* (Olive Borden), hardly a distinguished picture or a famous star, in a week when the Grey Street was showing *Ben Hur* (Ramon Novarro).

"The exterior has been designed to provide a dignified colour harmony in varied materials. The lower storey is in stone finish, with numerous recesses in which various forms of posters will be placed. The entrance, as in the old building, is placed at the junction of Westgate Road and Clayton Street, and a magnificent marble porch fills the ground storey. The main staircase, which is noticeably easy in ascent, with massive ebony handrails, is also executed in Roman stone plaster, while at the first landing an illuminated fountain, attractively set off by dainty colour lighting effects, provides a striking decorative feature. [The fountain had gone by the late thirties]. From this staircase the parterre is reached, which accomodates about 1,200 persons, all with tip-up seats, and at the rear under the balcony, an illuminated dome adds to the impression of height and space. Continuing ascent of the main staircase, the spacious balcony foyer is reached, decorated in Roman stone and Italian furniture. From the other side of this, access is gained to the circle, which

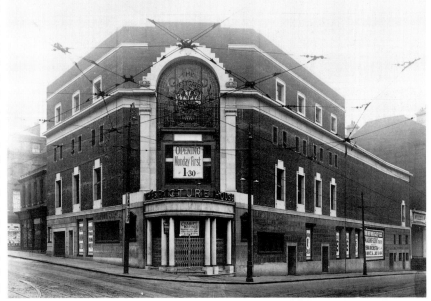

Above: The New Westgate, 1927
(Newcastle City Libraries & Arts)

Right: The New Westgate, September 1933
(Newcastle City Libraries & Arts)

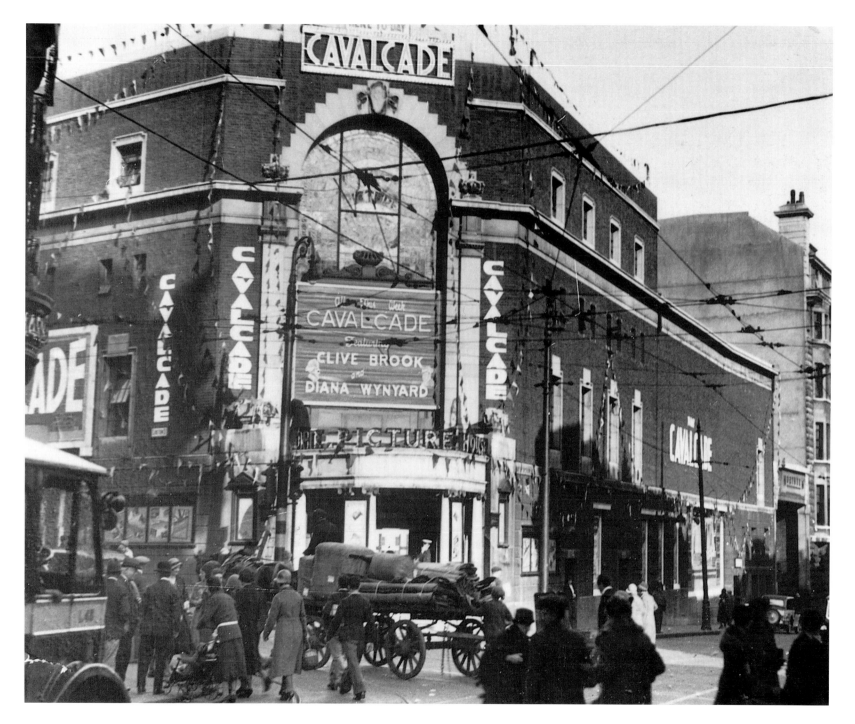

accomodates about 700 and is carefully graded so as to provide a clear view from every seat. In the interior of the house the general period of decoration is Italian Renaissance. The gilded proscenium with its graceful curves, frames a deep embroidered pelmet and curtains, which frame in turn the screen, while on either side decorative arcades with graceful projecting balconies flank the proscenium. To further improve the musical appeal, the proprietors have installed a lift for the orchestra, so that during interludes the performers will be raised to the level of the stage ... This electric lift is the first of its kind in this country." There is a persistent story that the new cinema was designed without a projection box, which had to be added at the last minute. This seems barely credible, but would account for the box (which still exists) being on the roof, with a very steep twenty-seven degree rake to the screen.

Seating was actually 1,870 (1,145 stalls, 725 circle), making it the city's largest cinema. A few months after the reopening, in February 1928, Gaumont bought the New Westgate for a reported £70,000. It was advertised as "the house of laughter and thrills" and much was made of the "Rising Orchestra". Talkies were introduced on 25 November 1929 with *King of the Khyber Rifles* (Victor McLaglen). The orchestra duly gave way to a 2-manual "mighty Wurlitzer" in August 1930; this was brought from the Castle Hill Theatre, Bronx, New York.

From the early thirties the New Westgate was subordinated to the Queen's (also a Gaumont theatre) in its programming, with many weeks of double features. On 8 February 1937 'New' was dropped from the cinema's name. From 1938, the Westgate was occasionally programmed concurrently with the Queen's, at other times showing popular films the week after they had played there. The Westgate continued to provide tea to patrons of matinées well into the forties; this tradition had ceased elsewhere. The cynical view is that had audiences been larger, the custom would have died out sooner. Throughout the war and after, Freddie Stebbings' twenty to thirty piece band played for Sunday concerts, with visiting guest artistes and organists.

From April 1941 the Westgate was twinned with the Queen's. Renamed Gaumont on 10 July 1950, the cinema's link with the Queen's lasted until closure, except when the Queen's had a long run or the Gaumont had a Cinemascope film. It was the second city cinema to equip for this process, showing *How to Marry a Millionaire* (Marilyn Monroe) from 1 February 1954.

The Gaumont was a victim of the rationalisation which accompanied the final merger of the Odeon and Gaumont theatre groups under Rank and closed on 29 November 1958 with *In Love and War* (Robert Wagner). The Wurlitzer organ was removed: almost all the pipework was destroyed, but the remainder has since been used to replace damaged or missing parts on other Wurlitzers throughout the country.

Rank then turned the building into the Majestic Ballroom, opening on 26 February 1959, but this failed to make any headway after the rival Mayfair opened. It became a bingo club, which it remains.

GEM CINEMA

Tindal Street

8 January 1934

St Paul's Church was built in 1841, became a Congregational church and shortly before conversion to cinema use was a recreation centre for the unemployed. Plans were submitted to the city council by Chester-le-Street architect Edwin M. Lawson on 16 December 1932, shortly after the opening of the Savoy and possibly inspired by it. Also, the nearby Stanhope Grand had recently closed.

Conversion was largely a matter of adding a brick and concrete annexe to the west end of the church, to contain a foyer with projection suite above. The original windows were bricked up but the bell-tower remained. The new cinema, called the Gem, continued to look very much like a church, particularly as it was surrounded by a graveyard complete with tombstones.

The Gem, 1963
(Newcastle City Libraries & Arts)

In the original plans of 1932 the seating was proposed at 630 (456 stalls and 174 balcony). There was an unexplained delay of almost a year before the plans were announced in the press (21 October 1933); the Gem finally opened in January 1934. The licensee was Sydney Millar of the Picturedrome, Gibson Street, although there is an opinion that the actual owner was a solicitor, J. Hamilton Grant. Mr McMahon remembers:

"My father J. C. McMahon retired from the army after twenty-one years' service in October 1933. When the Gem opened we – my father, mother, sister and I – all moved into a cottage in the grounds [the former vicarage] ... From that day we all became employees of the Gem with a joint wage at the beginning of £4 10s. Later it was increased ... "

Almost immediately after the opening, seating capacity was increased to 680, partly by the addition of twenty-four double seats in the balcony. The decorative scheme was in brown paint to a height of four feet with the remainder of the walls and ceiling cream. Stalls seating was tip-ups in red plush at 5d. In the balcony were about 200 red plush tip-ups with wooden armrests at 7d. and about fifty with plush armrests at 9d.

The staff was: manager, commissionaire/caretaker, cleaner, four usherettes, one usher, one cashier and one projectionist with an assistant. Mr McMahon continues: "As to myself, at fourteen years of age to start with, I was chocolate and ice cream sales person, but my other chores were: taking the night's takings to the bank the following morning, collecting the items sold in the kiosk from a shop opposite the Gem in Tindal Street and also selling the same items, also taking them around the cinema

on a lighted tray during the performances, helping with opening and closing the cinema, drawing the stage curtains and stoking the coke boilers, and in general assisting in doing all the odd jobs as it was a family effort."

The old church tower had horizontal blue neons at top and bottom with GEM in red neon between. Programme leaflets were hand-delivered each week to shops in the area, along with two complimentary tickets. Usherettes had to provide their own uniforms – black dress with white collar, black shoes and stockings, but the management supplied black berets with G.E.M. sewn in silver thread.

The Gem, shortly before closure, April 1967 (S. N. Wood)

Programmes were initially twice nightly but changed to continuous from 6 p.m. There were two children's matinées on Saturday, admission 2*d*. There were three programme changes each week. In 1934-5, in addition to films, Tuesday night was Variety Night. Later this was divided: Tuesday night became Adult Variety Night, Wednesday Juvenile Variety Night. Joe Ging remembers visits to the Gem just before the war:

"A lot of snobbery went on and many locals 'wouldn't be seen dead in that dump'. An average bill would be a big picture and possibly one other, even worse than the big one, or several shorts ... There were dreadful rudimentary commercials. A chorus of disapproval if – or rather when – the film snapped. By the time these films got to the Gem they were stretched to breaking point so, to a chorus of 'Missy oot!, Missy oot!' the projectionist would get on with his repair job.

"There was always a talent contest – they were always precocious children who got up. If their talent had matched their cheek it wouldn't have been so painful. A typical entrant [was] the local Shirley Temple, finger curls, bow in the hair, tap shoes – the lot! Their mothers kept them in a shoe box between contests – they were never seen on the streets."

The Gem closed on 29 October 1960 due to declining audiences. In April 1961 it reopened, with seating reduced to 540 , showing Asian films on Wednesday and Thursday of each week. On other nights it was a bingo club. It finally closed in August 1967 and was demolished.

GLOBE

Salters Road, Gosforth

19 December 1910

Gosforth's first cinema was built by a syndicate led by Joseph R. Collins, formerly of the King's, Marlborough Crescent.

"The building has been designed and erected on the most approved modern lines by Mr J. J. Hill, M.S.A., of Newcastle, and the interior is luxuriously appointed, comfortable accomodation being provided for about 1,000 persons ... A new feature, so far as picture theatres in the North is concerned, is the provision of several private boxes, and these are tastefully furnished in keeping with the remainder of the building ... [A] high-class cinematograph and vaudeville entertainment will be given twice each evening and on Saturday afternoons."

The original plans of April 1910 show two billiard rooms in a basement: a 'select' room with two tables and a general room with six tables. These had been eliminated in the final plans of May. The cinema

Globe, 1987
(Author)

was actually licensed for 883. The stalls, with tip-up seats, was priced from 2*d*. at the front to 6*d*. at the rear, each division separated by a moveable barrier; the balcony, seating 180, was 1*s*. at the front and 6*d*. at the rear; the operating box was behind it. The private boxes were at the rear of the stalls.

There was a very full programme on 6 January 1912: "*The Better Way* (A highly emotional picture playlet), *Thistles* (Beautifully coloured), *Ups and Downs* (A comedy abounding with droll incident), *The Horse Thief* (A sensational), the complete *Delhi Durbar*, fully depicted, and Effie White in her oriental Kaleidoscope dance. Beautiful orchestral music by the Globe Orchestra."

The success of the Globe is indicated by the fact that the manager was twice fined, in 1912 and 1913, for overcrowding. The cinema made a rather more dramatic appearance in the local press on 24 February 1913:

"Early on Saturday morning an outrage by Suffragists was committed at the Globe Electric Theatre, Gosforth. The theatre had been let for the purpose of a political gathering in the afternoon under the auspices of the Gosforth and Coxlodge Liberal Association ... The damage was discovered when the theatre was entered, and it was then ascertained that a plate-glass window in the foyer of the theatre, which was guarded by an iron gate, had been smashed. A hammer-head had been thrown through it, and this was found in the doorway. To the hammerhead was attached a label which bore the words 'Let fresh air into politics by votes for women'".

In February 1915 the Globe was taken over by Sidney Bamford who ran it almost to the end of the silent period, although the connection with J. R. Collins was retained. The programming during and after the First World War was good: the cinema was sufficiently far from the city centre to be able to present major features with comedy support and run them for a whole week. The variety acts were dispensed with during the war but reintroduced (on Tuesday and Thursday only) in the late twenties. Talkies came on 28 April 1930 with *Sunny Side Up* (Janet Gaynor).

In December 1928 the Globe became part of the large national circuit General Theatres Corporation, shortly to merge with Gaumont-British. The opening of the opulent new Royalty (with which Sidney Bamford was connected) less than a hundred yards away in 1934 hurt the Globe; it did not advertise in the press and G-B seemed unwilling to support this outpost of their empire. A year later, they were probably pleased to dispose of the Globe to E. J. Hinge, who already co-owned the Royalty. Effectively running both Gosforth cinemas, Hinge was able to offer totally contrasting programmes to suit all tastes. In a move which is now impossible to understand, he left the Royalty but retained the much smaller Globe, which by the end of the thirties was often showing a stronger programme than its grand rival.

In 1958 the Hinge circuit had sufficient faith in the future of the Globe to close it for a month for redecoration: it reopened on 11 August with *The Bridge on the River Kwai* (Alec Guinness). Closure came on 25 November 1961; the final film was *No My Darling Daughter* (Juliet Mills). The Globe became a bingo hall, which closed in 1990. It is the oldest surviving cinema building in the city, with its future now in doubt.

GLORIA

St Anthony's Road, Walker

11 April 1938

The Gloria was built for Albert Buglass, who had taken over the ailing Bensham Picture House in Gateshead in 1923 and made it a success. The name was chosen at a family meeting and was a deliberate attempt to avoid the more common cinema names. It was opened to take advantage of the large new housing estates in the area. Gateshead architect Albert Fennel designed one of the most attractive medium-sized cinemas in the city; the builder was Gordon Durham & Co. Seating was 762 in the stalls and 422 in the circle.

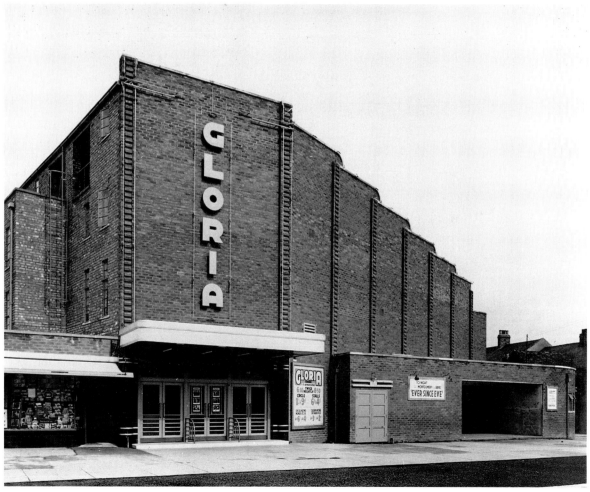

The Gloria, May 1938 (M. Aynsley & Sons Ltd.)

The entrance doors, flanked by black and gold pillars, gave onto a foyer panelled in oak with lime green stippled walls above. The floor was finished in cream and buff terrazzo. The unusual design of the auditorium was dictated by acoustical requirements. The side walls were splayed and the ceiling sloped towards the screen. It was claimed that this gave such a near-perfect result that sound-absorbent materials were only required at the rear of the hall. Above the dado the walls were decorated in a stippled hard plaster finished in autumn tints, with the fibrous relief picked out in gold, silver and turquoise. "The ceiling is lit by a two-way trough throwing light on a plaster cove, while the large central feature, designed by the architect, consists of fibrous plaster coves which take reflected light from long metal reflectors housing strip lamps."

The circle foyer was approached from a double curved staircase and had settees in alcoves. "Already many comments have been made on

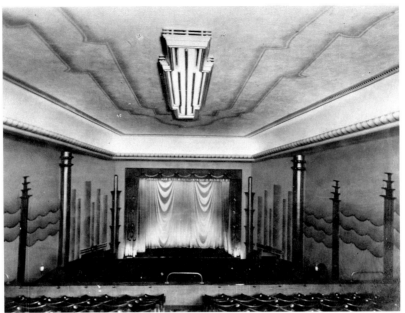

the advantage of entering the circle from the top back instead of entrances half way up which result in the screen view being interrupted every few minutes by passing patrons."

The proscenium had colour-change lighting, concealed behind pillars. The inner screen curtains were silver French festoons; the outer peach, with designs in turquoise, silver and gold. Seats were turquoise. The projectors were Ross and the sound system RCA Photophone.

Outside the building great trouble was taken to achieve a clean outline which could be effectively set off by tubular

Above: The auditorium, 1938 (D. Buglass). Below: The Gloria's neon display, 1938 (D. Buglass)

lighting. The stepped roof outline gave a 'waterfall' effect when the blue neons were lit at night.

The Gloria opened with *52nd Street* (Leo Carillo), with a revival of *The Garden of Allah* (Marlene Dietrich) in the second half of the week. Seat prices were 4*d.* to 1*s.*, with a special cheap matinée on Monday.

In the 1950s the Gloria specialised in science fiction, horror and western movies, and had the usual uneventful life of the suburban cinema until closure came on 4 March 1962; the last weekday film was *Babes in Toyland* (Ray Bolger).

A bingo club opened on 8 March 1962; the splendid thirties interior is virtually unchanged.

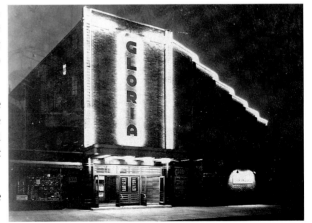

GRAINGER

26-28 Grainger Street

1 December 1913

The Grainger was built by a company controlled by Joseph R. Collins. It was a conversion from the business premises of Millings the drapers. The narrow entrance led to an **auditorium parallel to the street**.

This entrance, described in 1913 as "imposing", was flanked by granite columns and gave on to a marble-lined vestibule. The stairs and passages were of marble with mahogany panelling and led to the circle and to a café, which also had independent access from the street. The general style was very similar to the near-contemporary Empire.

The auditorium was in the neo-Classical style, by Newcastle architects Percy L.

The Grainger, 1930 (Newcastle City Libraries & Arts)

Browne and Glover. The ceiling was pierced by three domes; the walls featured massive columns and modelled figures. The proscenium arch was flanked by four columns and surmounted by "a magnificent group of sculpture".

The colour scheme – "the essence of good taste and refinement" – was designed to be restful. The Grainger was probably unique among Newcastle's cinemas in that it was claimed that all contractors were city-based: even the seats were by the Patent Automatic Seat and Engineering Co. of St James' Street. The cinema was licensed for 800; actual seating was 775 (566 stalls, 209 circle).

The Grainger achieved an initial coup, opening with the Edison Kinetophone, one of the early sound-on-disc systems: "The method by which the results are achieved is simple in explanation only. An attachment by wire operates a gramophone behind the screen at the same moment as the picture is released, and the projected photographs become, to all intents and purposes, live persons. They sing, perform on musical instruments, act plays, and do various other things, and if one is not self-deceived, he is at least wonderfully impressed with the absolute realism of the thing."

In fact, sound-on-disc systems were far from new, even in 1913, and the Edison system was far from

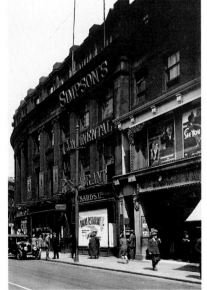

The Grainger's original entrance, 1927
(Newcastle City Libraries & Arts)

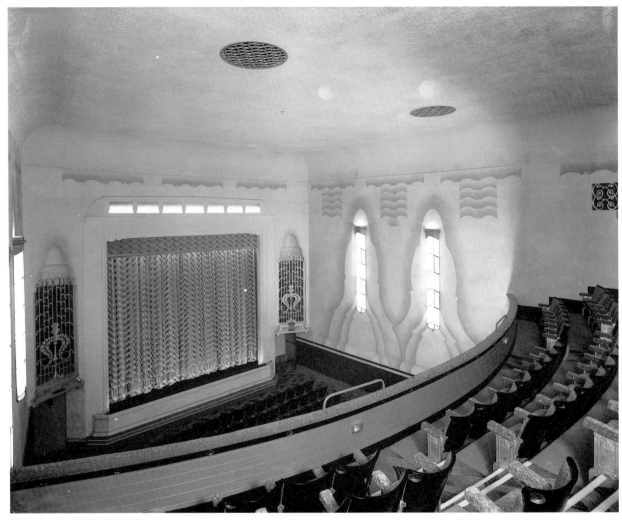

The redesigned auditorium, 1937 (Newcastle City Libraries & Arts)

perfect; there had been problems at the press show and the examples of sound films shown were very short. There were six altogether, in addition to the normal complement of silent films.

After the excitement of its opening, the Grainger settled down to become a fairly routine cinema: prices were 3*d.* to 1*s.* and the Wedgwood Café was much advertised, as was the orchestra conducted by Robert Smith. During the war, the Grainger management began eye-catching press advertisements, unafraid of the topical pun (although a serious note suitable for the time could intrude): "Munitions of amusement for the working millions of patriots during the few hours of rest and recreation. NO FUNERALS are ever shown at the Grainger." By 1916 the cinema's adverts were taking a whole

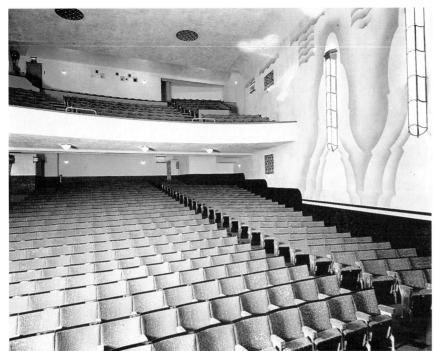

The redesigned auditorium, 1937 (Newcastle City Libraries & Arts)

column on the front page of the *Evening Chronicle*, which must have been expensive for a 775-seater and the enthusiastic manager seems to have been reined in.

In 1925 the Grainger was bought by Bernicia Ltd., a £1,000 company controlled by George Black; sound came on 30 December 1929 with *White Cargo*. The Grainger became an ABC cinema and from 3 February 1930 showed films concurrently with the Empire down the street until the latter closed in 1933. Next came a period of routine double-bills as an ABC outlet. When the enlarged and ABC-run Haymarket opened in 1936, the Grainger showed an identical programme until closure came on 31 July 1937.

After an expenditure of about £10,000 the building reopened on 2 December 1937 as the Grainger News Theatre, part of the MacHarg circuit. The cinema was totally reconstructed to the designs of Marshall and Tweedy. The entrance was re-faced in rough-cast pink glass with stainless steel straps. The new canopy was in coloured glass and neon; above it was a projecting sign, an inverted V in shape which was illuminated in turquoise and carried the announcement "News Theatre". The paybox was brought out almost to street level and the stairways altered to give easier access to the auditorium.

The proscenium was brought forward to allow space for the Western Electric sound horns and the ventilation system. Supporting pillars which had interfered with some sight-lines were removed and a new flat ceiling constructed. The most striking features of the re-design were sixteen foot vertical light fittings on each side wall and the concealed lighting effects above the proscenium. "The three-colour lighting system, in amber, cream and red, is in keeping with the colour ensemble of pastel shades, beige, orange, cream and red, the stone walls of the auditorium being gilt sprayed to tone."

The 515 stalls and 218 circle seats were scarlet and grey, with matching pile carpet. The projection room was equipped with Simplex machines; the sound system was Western Electric Mirrophonic type 35.

The Grainger set out in its new incarnation to show the usual news theatre programme of cartoons, travelogues and newsreels. Programmes were continuous 12.30 p.m. until 11 p.m.; seat prices were

The Grainger canopy, April 1950 (Turners Photography)

6d. and 1s. The whole idea was soon seen to have been a great mistake and lasted only until 26 March 1938. Perhaps it was found that 733 seats was too large for a news theatre: it certainly could not compete on price with the newly opened Tatler, where all seats were 6d.

On 28 March 1938 the Grainger reverted to a regular cinema programme with *Three Smart Girls* (Deanna Durbin). This was the first of a series of revivals and extended runs which were to sustain the cinema for the rest of its life. The best-known Grainger long run was probably *The Quiet Man* (John Wayne) which played for 15 weeks in early 1953, but *Genevieve* (Kenneth More) had the longest run – seventeen weeks – later in the same year.

The Grainger, 1956 (Newcastle City Libraries & Arts)

In January 1960 the closure of the Grainger was announced as Dunn's, hatters and outfitters, who occupied the premises next door, wished to expand. A much-loved cinema, with a very high standard of projection, it closed on 26 March 1960, the final film being *Expresso Bongo* (Cliff Richard).

GRAND

3 Condercum Road, Benwell

7 August 1911

The Grand Cinema Palace, to give it its original name, was one of the city cinemas whose opening was recorded in the national trade press. *Kinematograph and Lantern Weekly* (17 August 1911) reported:

The Grand, ca 1929
(West Newcastle Local Studies)

"The opening of this handsome new theatre, designed by the famous firm of local architects, Messrs. Gibson and Stienlet, who have now quite a number of theatres to their credit, took place on Bank Holiday, two crowded audiences attending. The decorative scheme in crimson, white and cream is further enhanced by the beautiful plaster work on ceiling, walls and proscenium in Louis Quinze style, with fruit and flower festoons, this work by Anderson's of South Shields. A full stage, with beautiful scenery by Albion Studios, Newcastle, calls for special comment, and is deservedly entitled to rank among the finest in the district; it is fully equipped for all vaudeville interludes, etc. The operating equipment is Kamm Universal ... Current for the entire building and arcs, etc., is supplied by a large Siemens dynamo driven by a 16 h.p. Crossley engine. The lessees are Messrs. Jack Grantham, late of Hartlepool and Newcastle theatres, and Eddie Cant, late of Star Picture House and Sidney Bacon's Pictures, men with a sound exhibiting and mechanical training, who will fully gauge the public tastes ... The building is being flanked on one side by a long verandah canopy for use of waiting visitors."

The Grand, on a stadium plan, seated 448 in the stalls and 192 in the circle. The following account, from *KLW* (9 November 1911), is probably not typical, but is an example of the excitement (and noise) which could be generated by the 'silent' film and of the ways used in the early years to promote the product:

"A series of packed houses marked the initial performances, under exclusive rights, of *Rob Roy* at the

Grand Cinema, Newcastle ... During the pictures, graphic Highland pipe effects were given by Pipe-Major Sutherland (late Seaforth Highlanders) and Sergeant Alec Marshall, drums also being employed in places. This alone aroused enthusiasm, but at the finale, when the screen disappeared and disclosed the famous Highland band of the Northumberland Veterans, under Drum-Major Bevan, the applause was greater still. Their fine display, with special lighting effects and stirring Scottish music, created a furore such as has never previously been witnessed in any local picture house. National dances by the smart Edina Troupe followed, to the great delight of the Scots present, then the grand finale by the full band closed what can only be classed as a really memorable performance."

A more typical vaudeville performance was advertised on 6 January 1912: "Amases, the Egyptian Man of Mystery in a Wonderful Exhibition of Eastern Magic, also Frederica's Wonderful Terriers and Cake-Walking Pony".

The Grand's power supply
(West Newcastle Local Studies)

In August 1930, John Grantham's Majestic Theatre, across the road from the Grand, went over to films: two years later the Grand became a theatre, opening as such on 5 September 1932 with the Denville Stock Company in *The Middle Watch*. The experiment lasted for a few weeks only and in April 1933 the Grand became part of the Stanley Rogers Cinemas circuit.

Under this management, the Grand continued through the thirties with long variety seasons each year, the rest of the time showing films. Douglas Gibson went to work at the Grand in 1937: "During the theatre period the screen and sound speakers were moved to the rear of the stage. I ceased to be a rewind lad but then became a general dogsbody for everyone who chose to boss me about. During the evening performances I used to work one of the limelights on the O.P. side. I never used to like this as it was really warm work ... and if I made a slight mistake I had to go to the [artist's] room and they would give me a right dressing down."

Actress Beryl Reid also remembers the Grand in 1937. In her autobiography she states that "... the orchestra pit was wired in – I mean, there was wire over the top of the orchestra because of all the things that the audience threw at the artists. Whenever a comic came on, there was a lady who walked about in the gallery saying, 'Razor blades, buy me razor blades – she does nowt but talk.' Quite a baptism!"

During the war the Grand slowly declined. Bill Rosser remembers that most seats had lost their fixings to the floor. The programmes were mainly aimed at children with Roy Rogers westerns and cliff-hanger serials. At quiet moments the thumping of the engine which still produced the cinema's power could be heard. The Grand did not even appear in the Hinge circuit press advertisements. From 1953, three-month licences were applied for and the cinema does not seem to have been licensed at all for most of 1954. It finally closed on 29 September 1956. The building became a warehouse for Ferodo; Presto's car park now occupies the site.

GRAND THEATRE

Wilfred Street, Byker

14 April 1930

No one can say that the various managements of the Grand did not make every effort to give the public what it appeared to want: it was at various times a theatre, a cinema, a variety theatre with films and a cinema with variety acts.

It was built by Weldon Watts (architect, William Hope) and opened on 27 July 1896 with F. R. Benson's Company in Shakespeare's *The Taming of the Shrew*. Like most theatres, the Grand experimented with bioscope performances: Downey's Living Pictures appeared in 1899, returning in 1907 as part of a Sunday series of sacred concerts with Lindon Travers. In December 1908 *The Bioscope* reported that "pictures were thrown on the screen before the usual show commences" and in 1909 there was a "picture season" ending in August. Variety and pictures seem to have become a feature by 1910, when the Grand took out a cinematograph licence, but there was no permanently constructed operating box until 1913, when part of the gallery was so used. The rest of the gallery was apparently closed, reducing capacity to 1,826.

In 1913 the Grand was taken over by George Black who continued the pictures and variety seasons. During the war, many of the pictures were accompanied by the lecturer J. C. Padden; Friday night was given over to a full variety programme. By 1915 variety only was featured, but films and variety were back by 1917. In 1920 the Grand became part of the Thompson and Collins circuit, but the cine-variety policy continued until 1928, when the theatre was bought by Gaumont-British; variety acts tailed off to one each show.

On 14 April 1930 the Grand showed its first talkie, *Honky Tonk* (Sophie Tucker): this spelled the end of variety with the Grand operating as a true cinema for a few years. Presumably unable to compete with both the Apollo and Black's Regal, G-B disposed of the Grand to E. J. Hinge in 1935. Hinge continued films for a few months, closing the Grand as a cinema in March 1936 with *Boys will be Boys* (Will Hay). On 9 March it became a theatre again, with variety, plays with such local luminaries as Sal Sturgeon and in 1936, a sixteen-week season by the Charles Denville Famous Players – it is of this season that Kenneth More writes so hilariously in his autobiography, his main recollection being of an encounter with an incontinent camel.

The Grand closed as a variety theatre on the day war was declared, opening again "with a full programme of talking pictures" (a curiously old-fashioned phrase) on 9 October 1939. The first film was *Pennies from Heaven* (Bing Crosby). Soon, however, Hinge's preference for the theatre over the cinema came to the fore. The last film was *The Singing Marine* (Dick Powell) for the week of 17 March 1941. The Grand became once again a variety theatre (with the gallery reopened) until final closure on 27 August 1954. The gutted theatre was used as a store by builders' suppliers Henry Moat until demolition in April 1964.

GREY STREET PICTURE HOUSE

10-12 Grey Street

6 May 1914

Provincial Cinematograph Theatres (PCT) was one of the first and largest cinema circuits, established in 1909. Its policy was to build imposing cinemas in major centres of population: a cinema was proposed for Northumberland Street in August 1910 but it was not until 1914 that Newcastle joined Birmingham, Bristol, Leeds, Manchester and twelve other cities in having a PCT outlet.

The new cinema was a conversion of an existing building, formerly the Victoria Music Hall and latterly a billiard saloon. The frontage was altered but the cinema blended reasonably well into the splendid Grey Street. It was PCT custom to name their cinemas simply 'The Picture House', but as there was already a cinema of that name in the city, it opened as the Newcastle Picture House.

When the cinema closed, a local newspaper referred to it as Tyneside's first super-cinema, "the leading picture house of the district at a time when all the others were run on very modest lines". PCT's cinemas were deliberately designed and operated to appeal to middle and upper class patrons – the 'carriage trade' or *ton patron* whose custom had so far eluded the business.

This philosophy is well expressed in the booklet produced for the opening of the cinema, in which the attempt to create the atmosphere of an exclusive club is very evident. This was picked up by the press:

"The vestibule from Grey Street is decorated in rich marbles with an original design of leaded glass comprising the arms of the city and counties of Northumberland and Durham. The entrance hall and Foyer are of striking beauty, carried out in white and grey marble with panels of delicate Breche rose marble ... There is an electric passenger lift for balcony patrons. On the right is the cloak room and telephone call office ... On the first and second floors are spacious Foyers panelled in oak and hung with tapestry and [they] are furnished with comfortable lounges where patrons may rest and meet their friends ... Leading from the Entrance Foyer is a cosy tea lounge, where refreshments are served, and where patrons may read papers and magazines ... Leading from the First Floor Foyer is a handsome smoke room and cafe in the late 17th century style. Situated on the balcony level and reached by the main staircase or lift is a large Wedgwood café ... For the convenience of patrons who are shopping, parcels may be addressed to the theatre to await their arrival or departure..."

Grey Street, Newcastle on Tyne.

Newcastle Picture House (left), ca 1914
(John Airey)

The architects were White and Stephenson. For its importance, the Newcastle Picture House had a rather modest capacity of 927 (719 stalls, 208 circle), with sixty-five allowed to stand. It was opened on 6 May 1914 by Sir Francis Blake. The opening programme was *Beauty and the Barge* (based on a W. W. Jacobs story and made by the London Film Company, with which PCT was vertically integrated), a version of Shakespeare's *A Winter's Tale* and two comedies, *Fatty's Flirtation* and *Polidor does the Hat Trick*.

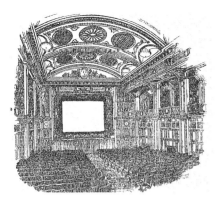

Auditorium, 1914
(Newcastle City Libraries & Arts)

The Newcastle Picture House became the Grey Street Picture House on 5 June 1922, after a brief period as 'Picture House, Grey Street'. It was a first-run cinema throughout the twenties, sharing prime billing in newspaper advertisements with the Queen's Hall, the Pavilion and the Stoll. It was owned in 1927 by George Black and went with him to General Theatres Corporation (later part of Gaumont-British) which seems to have made little effort to support it, concentrating instead on the Queen's.

Talkies were resisted at first: the Grey Street's advertising in late 1929 emphasising "peace, tranquillity and entertainment". It was the last major city centre cinema to take the plunge into sound, on 28 July 1930, with *His Glorious Night* (John Gilbert).

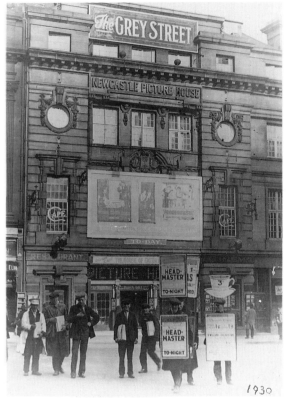

Grey Street Picture House, 1922 (Mike Thomas)

By this time sound was not enough to save the Grey Street, which closed on 14 May 1932 after a short life of almost exactly eighteen years. The last film was *Dance Team* (Sally Eilers) and the audience filed out to 'Auld Lang Syne'. Most of the staff went to other cinemas in the Gaumont circuit. The reasons for closure were given as the "depression, increased entertainment tax and competition". The last is likely to be the true reason: there was no way a rather old-fashioned cinema could survive against the opening of the massive new Paramount a hundred yards away.

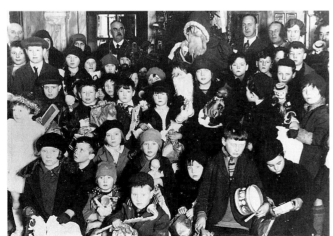

'Poor Children's Treat' at the Grey Street,
Christmas 1929
(Mrs W. Huggins)

In March 1933 the lease of the building was transferred to the London-based furniture dealers, Smarts. For many years the premises were occupied by Broadloom Mills; they are now Pizzaland (ground floor) and TSB (upper floors).

HAYMARKET

Percy Street/Haymarket Lane

21 December 1933

When the Haymarket opened, its owner, Dixon Scott, had twenty-five years experience in the business. The profits from his cinemas in Jarrow, Prudhoe and elsewhere enabled him to build it. Haymarket Theatre (Newcastle) Ltd. was formed in June 1933, capitalised at £50,000.

The plans for the cinema as built were for 1,280 seats (902 stalls, 378 circle). There was a box on each side wall level with the circle. The thirty-five feet wide stage had dressing rooms below. The architect was George Bell of the Newcastle practice of Dixon and Bell, the builder Thomas Clements and Son.

ABC Haymarket, 1964
(Tony Moss)

"Mr Bell has borne in mind the perfect comfort of its patrons in every respect. Although the building is large enough to seat 1,700 people, less than twelve hundred seats are installed. This sacrifice of seating accomodation has been made in order to give really ample space for each patron. Each floor has an adequate crush foyer ... there is no need to climb any stairs to reach the Circle, for a lift is provided to enter it at two levels. The Circle seats have been chosen for luxury without regard to expense. They are throughout of the very latest invention 'Dunlopillo', covered in velvet ... The seats in the stalls are almost as luxurious as those in the Circle. They, too, are wonderfully spaced for comfort, there being three inches more between each row than is usual, even in the best of theatres ... Projection of the pictures should be perfect, for the good reason that the operating booth is placed below the Circle, instead of being placed high up at the back of the theatre, which is the common practice."

The Haymarket claimed to be the second cinema – after the Leicester Square Theatre –

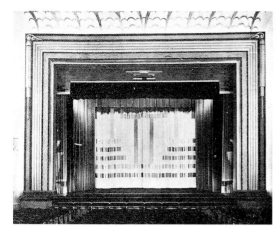

The original proscenium arch, 1933 (BLNL)

to be fitted with Western Electric "wide-range" sound. The stage "would be excellent for musical comedies and dramas not requiring a large cast, should it ever be needed for that purpose." The Haymarket Café, above the entrance foyer, seated 150 and was leased to Hunter's the Bakers. "The view from the Café windows – which extend right across an 80 feet frontage – is full of animation, as there is always something interesting happening in the Haymarket."

The cinema frontage was cement render finished in white, with much use of glass and chromium, enhanced by the lighting scheme. Interior decoration was by M. Alexander and Son and was said to have been based on a cinema in Cairo: perfectly feasible, as Dixon Scott was a frequent visitor to Egypt. Friezes of camels and palm trees were featured in the foyer. Advertised as "Newcastle's Luxury Theatre" the Haymarket was opened by comedian Tom Walls on 21 December 1933. After a programme of shorts followed by songs from the Prudhoe Gleemen, Walls' film *Just Smith* was shown.

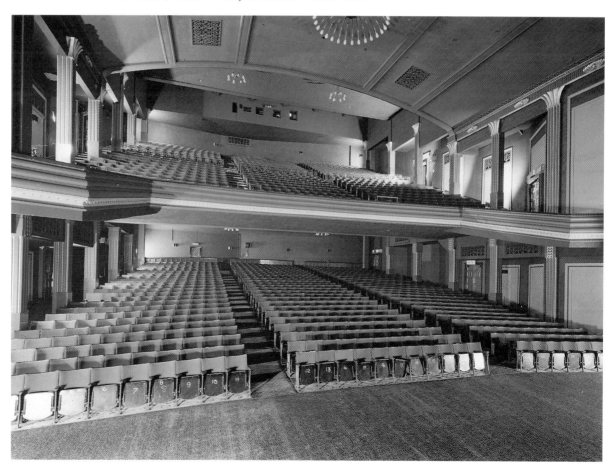

*The auditorium, October 1984
(RCHM)*

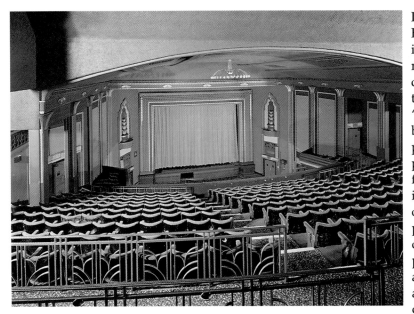
The auditorium, October 1984 (RCHM)

In the fashion of the time the Haymarket management stated its 'policy' for the future, rather modest for a major city centre cinema: "We shall not attempt to compete with the existing 'first-run' cinemas in the City, but shall show the most choice pictures from all their programmes soon after their first exhibition. In this way, and in this way only, can any cinema be certain that its programme will never disappoint its patrons ... Our programmes will run for two-and-a-half hours continuously, and our short films will be chosen with as great care for their interest and entertainment value as the 'features'. We shall not pad out time with inferior 'fill-ups', 'interludes', or cheap trimmings, and we shall have NO MIGHTY ORGAN. Good pictures will occupy the whole time of our shows, which will, wherever possible, include two full-length 'features'. In our advertisements we shall avoid 'boosting' and 'stunting'."

Following this rather obvious attack on the Paramount, there was an appeal to local patriotism: "The Haymarket theatre is the only modern cinema in the centre of Newcastle with independent management. All the other important cinemas are managed from London as units of big circuits". There was also to be a "special department" to make local newsreels – "we hope in the process of time to gather together a notable local historical record in pictures." Prices of admission were 9*d*. (stalls), 1*s*. 3*d*. (circle), 2*s*. (boxes), with reduced prices for children in the afternoon. From the outset, Haymarket programmes were of good quality.

An early success was the all-star *David Copperfield* which ran for four weeks in late 1935, a Haymarket 'exclusive'. In November 1935 the Haymarket ceased to advertise in the local press and in May 1936 closed for rebuilding.

The alterations involved extending the cinema to the rear: the facade was untouched. Plans, again by Dixon and Bell, had been approved in December 1935. The same contractors and decorators were used as in the original, though the more austere style of the additions was very evident in the circle. The new interior colour scheme was in petunia, cream and gold. 2,000 yards of carpet were laid by

Robsons. Seating was increased from 1,200 to 2,006, although advertisements often claimed 2,200. The boxes were replaced by circle slips, while the projection box was relocated at the rear of the circle and new Ross projectors installed. The café was now run by Carrick's.

The rebuilt Haymarket was opened by the Lord Mayor on 31 August 1936; the opening film was *A Night at the Opera* (The Marx Brothers). At the opening ceremony, Dixon Scott announced that the cinema had been leased for twenty-one years to Associated British Cinemas Ltd. In fact, licensing records show a transfer from Dixon Scott to Arthur Moss (for ABC) on 6 September 1935, so it was ABC which made the decision to rebuild to gain a first-run cinema in the city.

Under its new control the Haymarket had access to bigger pictures more quickly, especially the excellent Warner Brothers and MGM product of the late thirties and forties, but it was never advertised as aggressively as its size warranted. There were occasional stage shows and a personal appearance by Charles Laughton on 3 August 1938.

From October 1934 the Haymarket was used for the Sunday shows of the Tyneside Film Society.

Side-wall treatment, October 1984 (RCHM)

In the early morning of 30 April 1942 a fire was discovered in the stage area: the *Evening Chronicle* reported: "On arrival the firemen found the stage, which had a good deal of draping, ablaze and setting fire to the roof, parts of which collapsed into the pit and circle ... the fire was finally got under control after an hour as it reached the gallery end of the theatre ... The operating and film winding rooms, with the films, were saved intact. The walls of the building and the interior corridors were untouched." The cinema was of course insured, but in the middle of the war there were problems in finding materials for repairs. The Haymarket was closed for over seven months, opening on 7 December 1942 with *Mrs Miniver* (Greer Garson). Visible fire damage after the reopening was limited to the ceiling; some seats and the plush top of the front of the circle had been patched. The lower front edge of the circle had been decorated with a band of glass 'leaves' illuminated by light bulbs; these were not replaced.

The Haymarket showed the first 3-D film in the city – *House of Wax* (Vincent Price) for three weeks from 10 August 1953. Generally the best 3-D films went to the Haymarket – *Kiss Me Kate* (Howard Keel) is another example – while the rest went to the Essoldo or Stoll.

Detail of foyer plaster-work, October 1984 (RCHM)

Its first Cinemascope film was *The Command* (Guy Madison) from 10 May 1954.

In the late fifties and early sixties the Haymarket showed a sequence of British comedies – all the early *Carry On*s, for example – interspersed with routine double-bills. There was the occasional long run: *The Nun's Story* (Audrey Hepburn) ran for seven weeks from December 1959, while *King of Kings* (Jeffrey Hunter; rudely known as 'I was a teenage Jesus') for four weeks from December 1961. This latter must have been a disappointment, as there were only two performances daily, all seats were bookable, and there were 'special' (i.e. increased) prices.

In the early 1950s the Haymarket site had been bought by King's College (later Newcastle University) and leased back to ABC; some of the leases were as short as three years. There was therefore no certain future for the cinema, which remained a single screen when the city's other large cinemas were being doubled or tripled. As insurance, ABC bought the Classic (former Essoldo) on Westgate Road in 1974; this became its main outlet in Newcastle.

Demolition, 1985
(Newcastle Chronicle & Journal)

The Haymarket was used for some extended runs in the 1970s, for example the locally filmed *Get Carter* (Michael Caine), *The Sting* (Paul Newman), *Towering Inferno* (Steve McQueen) and *Superman* (Christopher Reeve), but it was usually programmed concurrently with ABC1 in Sunderland; generally the newest films went to the former Essoldo. The usefulness of a large undivided auditorium was evident during the showing in 1981 of Abel Gance's epic *Napoleon*, when the Northern Sinfonia Orchestra and a large audience were cheerfully accommodated. In May 1983 the Haymarket showed the 3-D version of *Friday the 13th, Part III*, and a bespectacled audience was seen in a cinema for the first time since the early fifties. Special lenses were fitted to the projectors and the spectacles were no longer red and green, but the show proved that there's no gimmick like an old one: one of the frighteners was a mouse on the end of a plank being thrust into the audience, first used by Audioscopiks in the 1930s.

In 1982 the beginning of the end was signalled when afternoon shows were abandoned. Thorn-EMI (formerly ABC) declined to renew the lease in September 1984: "The amount of money involved in major refurbishment is quite substantial. We would really want more than three years' security of tenure." The Haymarket closed on 20 September 1984: the last film was *Purple Rain* (Prince). The cinema was demolished in January 1985, apart from the ground floor frontage. The projectors and 1,000 seats went to the Wallaw, Blyth. A car park appeared on the site. The remains of the cinema were removed in 1987 and the car park attractively landscaped.

HEATON

North View, Heaton

November 1910

In November 1909, a local newspaper reported: "We understand that a large house near to Heaton Station, and known locally as 'Temple's Folly', has been purchased by a syndicate, and is to be adapted to the purposes of assembly and recreation rooms."

This building is presumably what became the Heaton Electric Palace which, along with a billiard hall and a ballroom (this last opened early in 1911 as a roller-skating rink, the 'Palace Rink') was owned by the Heaton Assembly Hall Company. The cinema, on the stadium plan, seated 925 (223 pit, 390 stalls,

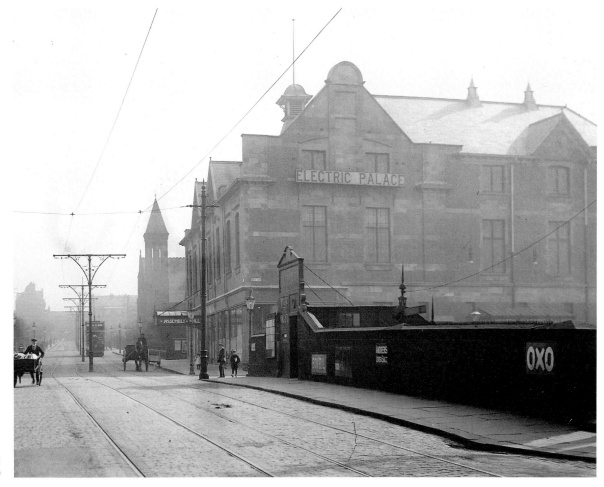

Heaton Electric Palace, 1912
(Newcastle City Libraries & Arts)

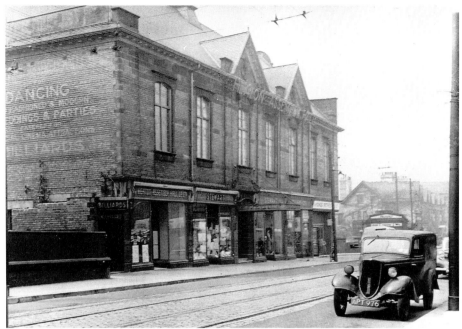

312 circle). The 6*d*. circle and 4*d*. stalls seats were plush tip-ups; the 2*d*. pit seats leather-covered tip-ups. There were also boxes, seating seven, at 5*s*.

The Electric Palace – which kept its increasingly anachronistic name until 1940 – showed the usual suburban fare of comedies, serials and the occasional English epic such as *Jane Shore*, with "refined and high-class" variety. The latter could be unusual: in

The Heaton, ca 1949 (Newcastle City Libraries & Arts)

April 1914 Martin Breedis, "the great Russian athlete", wrestled all comers, Graeco-Roman style. The "Favourite Resort of Heatonians" soon abandoned variety to concentrate on films alone. There were two changes of programme weekly with seat prices relatively high at 4*d*. to 1*s*. 3*d*. There was an unusually large orchestra of eight under W. G. Foggin. A café had been added by 1921.

Talkies came to the Heaton Electric Palace on 9 December 1930 with *Movietone Follies*. Advertising in the thirties characterised the cinema as "homely and select". The combination of cinema, dance hall and billiard hall was effective in attracting people to the complex, especially young couples. In September 1937 the Heaton closed for a week for modernisation and redecoration, reopening with *Three Smart Girls* (Deanna Durbin).

In 1946 the cinema was taken over by C. J. Shepherd, remaining independent. From the late forties until 1960 the Heaton hosted special shows for elderly people organised by the East End Old People's Treat Committee. The cinema closed on 17 June 1961. The whole building is now an attractive complex of bingo hall (in the now unrecognisable former cinema), bars and club facilities.

HIPPODROME (GINNETT'S CIRCUS)

Northumberland Road

18 May 1908

In February 1890 G. Ginnett opened a circus in a temporary building in Bath Road (later Northumberland Road). In March 1893 the building was leased by James Carnegie, refurbished and opened as a downmarket theatre. As it was put at the time: "The lessee is not aiming at a very high dramatic ideal: his purpose is to give an enjoyable evening in return for moderate prices of admission." The building was now known as the Amphitheatre.

In 1908 Harry Taft leased the building and opened it on 18 May as the Hippodrome, showing "Animated Pictures of all Nations". There was one performance nightly at 8p.m. with special family matinées on Saturdays. Prices ranged from 3*d.* to 1*s.* On Friday 12 June there was a funny faces competition. This was thin fare with which to fill a large building and it closed as a cinema on 18 June 1908, the shortest-lived in the city.

The Hippodrome was demolished in 1909 and the new Olympia built on its site.

HIPPODROME (WHITE CITY)

Northumberland Road

25 November 1912

On 4 August 1909 the city council leased a piece of waste ground on Northumberland Road to George W. Parkinson, who built a large hall known as 'The White City'. With its imposing dome, the building soon became a landmark. It was used for most of its short life as a skating rink, opening just when this pastime was entering one of its occasional periods of popularity.

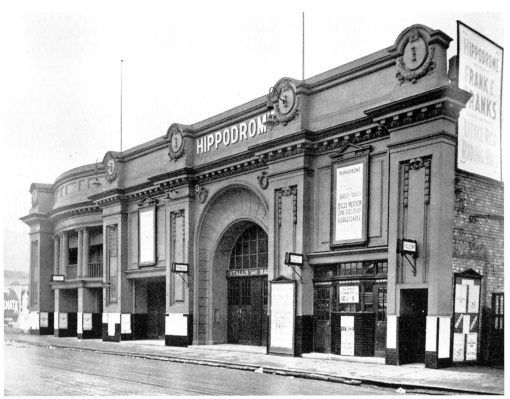

The Hippodrome, 1926
(Stephen Easten Ltd.)

This had ended by December 1910 and Parkinson attempted to open the White City as a cinema, but was seen off by Sidney Bacon of the neighbouring Olympia, who persuaded the city council that this use was against the terms of the lease. The building became the 'Dreamland Ballroom de Luxe' from 10 February until August 1912, when it was taken over by the Variety Theatres Controlling Company and partially rebuilt.

The new design, by Sunderland architects W. & T. R. Milburn, involved the removal of the White City's distinctive dome, but the retention of the ornate stucco frontage to Northumberland Road. The building, renamed the Hippodrome, was vast: in 1922 it was licensed for 2,800 and actually held 2,703 (2,453 seated and 250 standing). Seat prices ranged from 4*d.* (balcony) to 2*s.* (single box seats), the former a good way from the stage.

After an official opening by the Lord Mayor on 23 November, the Hippodrome was opened to the public two days later. It was a variety theatre, but films were shown as part of the programme until 1916. However, they were way down the bill: in the opening week, "Hippodrome Motion Pictures" were billed below Goldin, the Royal Illusionist, Herr Hagedorn's Water Fairies (who used the theatre's 30,000 gallon tank) and the "Real Rag Time 6 (In an Exposition of the Swaying Quaint Melodies that have Fascinated England)". In fact, films were shown "time permitting". The Hippodrome retained its cinema licence, perhaps as an insurance, until it closed on 20 May 1933.

IMPERIAL

127 Byker Bank

?15 August 1910

"Acknowledged to be the prettiest theatre in the district" (advertisement, 1910), the Minerva (later Imperial) was built by a company called Heaton and Byker People's Hall Ltd. It was modest in size, seating only 360. From about 1911 to 1918 it was leased to Mr E. Pirman. There were the usual two performances at 7p.m. and 9p.m.; seats being priced at 2*d.* to 9*d.*

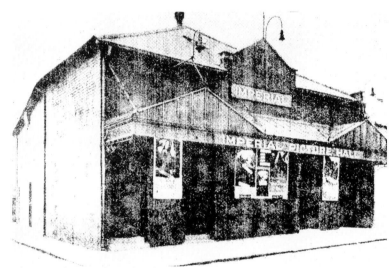

The Imperial, c1925, from a letterhead

A programme from September 1910 promised "perfection in pictures and variety" and offered "*Giovanni Medici*, an Italian Episode, *Fidelity Rewarded*, a Stirring Dramatic Picture, *Church Parade at Aldershot*, fine Military Subject, *Buffalo Hunting*, *Indo-China*, a very interesting picture, and a host of other pictures. Also Miss Flo Frazer, Dainty Comedienne and Dancer". In November 1910, the Minerva held special shows, with increased seat prices, in aid of the East End Distress Fund.

Agnes Smurthwaite, reminiscing for the *Byker Phoenix* in July 1980, remembered: "... being taken to the Minerva to see silent films in 1913. The first owner was a Mr Purman [sic], and there was a three-piece orchestra ... There would always be somebody who couldn't read who would sit beside [my] mother and ask 'What does it say?' One week a different picture was shown every night to packed houses."

On 19 September 1918 the Minerva was offered for sale and after "spirited bidding" was bought for £2,100. It was leased to J. H. Dawe of Heaton and renamed the Imperial: Stanley Dawe was resident manager. Dawe maintained that when he took over the hall it was "absolutely a white elephant"; since he had been in charge business had boomed and he had been able to buy the cinema outright. The Imperial was owned by the Dawe family until closure.

In 1920 the cinema earned an encomium from the trade journal *Northern Lights*: "The best programmes are shown by Mr. Dawe, accompanied by the best of music, Mr. J. Fenner at the grand piano and Mr. John Haley at the violin. The music is great, the pictures are great, and the audiences are great." The fare was in fact the staple of the small cinema, serials and broad comedies. BTP sound was introduced in 1931 and programmes seem to have improved by 1936, when the Imperial began to advertise in the press. Films were of good quality, but about a year old when shown there.

Early on Friday, 27 August 1937, a fire broke out backstage: "The interior was ablaze. All the walls and balcony were scorched and the talking apparatus [i.e. loudspeakers], valued at about £1,000 was destroyed. The projecting apparatus and the office, however, escaped damage. Mr. S. Dawe ... estimated the loss at about £4,000. He said that the building had been recently redecorated and fitted

with new seating accommodation."

The Imperial reopened, seating 381, on 28 February 1938 with *The Charge of the Light Brigade* (Errol Flynn). Programmes continued to be of high quality, with interesting ideas like running the *Andy Hardy* series in sequence on successive nights. So it was at the Imperial until the 1960s. There had been some vandal damage to seats and walls but, according to Ian Dawe, the cinema could still find an audience. *GI Blues* (Elvis Presley) had a particularly successful week and action movies, such as those starring Steve Reeves, were popular. The Imperial was now the only cinema in the Dawe Brothers circuit still operating as such: the others had gone over to bingo.

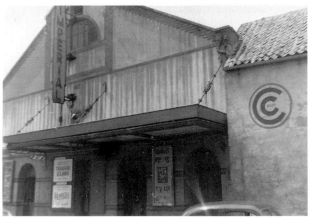

Above: Imperial, 1963 (Newcastle City Libraries & Arts) and, below, shortly before demolition (Peter Douglas)

The Imperial closed on 24 August 1963 with *The Beast of Hollow Mountain* (Guy Madison). Initially the closure was for redecoration only, but rumours of the imminent reopening of the Apollo as a cinema meant that it became permanent. It became a warehouse. In 1977 it was bought by the theatre group Bruvvers as a base but due to planned road changes in the area this idea was never realised and the building sold back to Tyne and Wear County Council. It was demolished late in 1985.

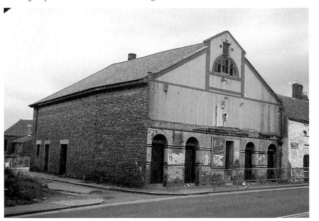

IMPERIAL

Station Road, Newburn

October 1911

The Imperial Electric Theatre was designed by Thomas R. Eltringham of Throckley Colliery for Towyn Thomas and was licensed from 18 October 1911. Seating was initially 550, but the next owner, William B. Saul, who took over in August 1912, increased this in July 1913 by the addition of a 131-seat gallery and, unusually, the removal of some of the 'select' tip-up seats in the stalls and their replacement with forms. This increased capacity to 720.

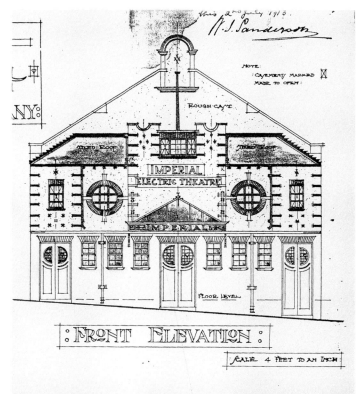

Architect's elevation of the Imperial, 1913
(Tyne & Wear Archives Service)

In January 1919 Thomas Maughan, a railway locomotive driver from Blaydon, took over the cinema; in that year *Northern Lights* reported that business was so good that people were being turned away and two shows nightly were found to be necessary.

The Imperial between the wars is remembered by Mr Finlay: "The outside was faced with vitrolite glass panels up to the canopy. The foyer was very cramped, with only a paybox and no confectionery kiosk. The cinema had an arrangement with a confectionery shop next door [Marchetti's] to supply sweets and ice cream during the interval ... The show changed every Monday, Wednesday and Friday, with [one show] on a Sunday."

Mrs Sewell recalls: "The Newburn cinema was situated at the bottom of Station Road. It was small and not very plush inside. Downstairs the front stalls were more or less wooden benches; behind these were seats – not too comfortable. It was rather spartan but we didn't know anything else ... On a Saturday you had to book your seat: there were two houses, with a children's matinée in the afternoon. On a Sunday night there was one house, after the church came out. The films shown on a Sunday were rather old, but still the cinema was always full."

By 1936 the Imperial was feeling the pressure from the recently opened Lyric at Throckley, to which

many patrons transferred their allegiance. It is possibly of this period that a client of the Grange Day Centre remembers: "It was not thought a nice place to go". In March 1936 the Imperial was taken over by Maurice Cohen (trading as Maurice Cinemas Ltd.). Performances were changed to continuous and seat prices raised to 4*d.* to 9*d.*

In mid-1937 the Imperial began to advertise in the press in a conscious effort to widen its appeal and there is a discernible improvement in the programming over the next few years from B-

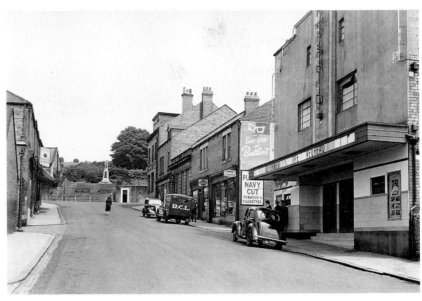

The Imperial ca 1952 (Newcastle City Libraries & Arts)

features to the occasional A. Often, the ritual mid-week change was varied by showing a weak film on Monday and Tuesday only with an A picture for the rest of the week.

The Imperial gained a new lease of life under the new management. In February 1939 the cinema closed for renovation and partial rebuilding; seating was reduced to 550, presumably by the replacement of the forms in the stalls. Newcastle architect A. J. Lamb designed a modern front elevation in cement render, with a neon display. In about September 1940 the cinema was damaged by a fire in the screen area: architect Robert Burke took the opportunity to redesign the proscenium arch and its surrounds in a more contemporary style. It reopened on 23 December 1940 but was one of the many small cinemas to fall to television. It appears to have closed on 13 May 1961 with *The Naked Maja* (Ava Gardner) and went over to bingo. The building is now used as offices by a firm of industrial designers.

IMPERIAL

Back Field Terrace, Throckley

November 1912

The Picture and Variety Palace was a temporary corrugated iron building, seventy feet long and forty-five feet wide, just off the main Newcastle to Hexham road. It was licensed from 12 November 1912 to Towyn Thomas, formerly of the Imperial, Newburn. There were several licensees before 1919, including S. O. Armstrong, who owned the Britannia, High Westwood and John Cheeseman, who later managed cinemas at Chopwell and Rowlands Gill.

No details of programmes are available, but singing competitions were held every Friday night, the winner receiving 2s. 6d. Pictures were shown once nightly, with three changes weekly. Prices (in 1919) were 3d. to 9d. Seating was about 600.

In July 1922 the hall was taken over by an ex-officer, Charles Nicholl, who (presumably) renamed it the Imperial. Unluckily for him, early on Tuesday morning, 12 December 1922, the cinema was destroyed by fire. The Imperial was a mass of flames when the Newburn Fire Brigade arrived, but they prevented the fire spreading to the nearby Throckley Co-operative Hall and other buildings in this "congested neighbourhood". The cinema's dynamo and gas engine, as well as Nicholl's personal belongings, were destroyed.

Nearly two years later in August 1924, Thomas Charlton of Sugley Villas, Lemington, submitted plans for a new cinema on the site. Designed by W. H. Burrows, this was another 'temporary' building, with side walls and roof of corrugated iron. There was a stage, two dressing rooms and a small balcony and operating room.

But was this cinema ever built? The evidence suggests that it was not: there is no record of a licence being granted and it was never listed in directories. At this time, Thomas Charlton took over the Picture Theatre at Lemington and it seems that his plans for Throckley were abandoned. The village had to await the opening of the Lyric in 1935 before it could boast a cinema again.

JESMOND

Lyndhurst Avenue, West Jesmond

2 May 1921

It is rather ironic that the Jesmond, whose early years were so fraught with problems, should have survived to become the oldest functioning cinema in the city.

The building was financed by a limited company formed in December 1919 with a capital of £20,000. Hugh Smith, a wine and spirit merchant, was chairman. The company bought a site immediately opposite West Jesmond Station and plans for the cinema were prepared by architects White and Stephenson. Although the foundations were laid in December 1919, it was not until May 1921 that the cinema opened, the delay possibly caused by a post-war shortage of materials or the government's ban on 'luxury' buildings.

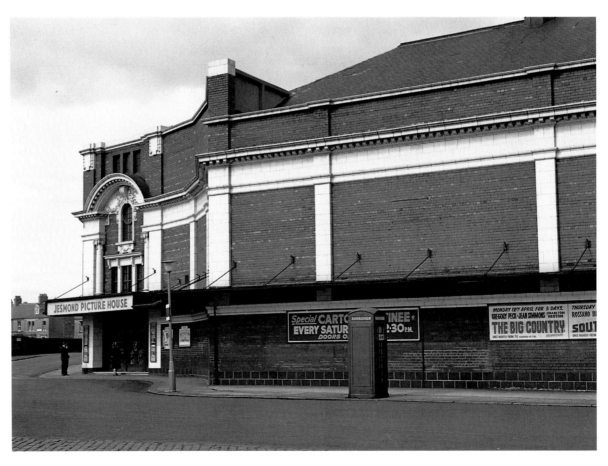

The Jesmond, 1965
(Newcastle City Libraries & Arts)

Notable features of the cinema were the reverse rake of the floor in the front stalls (or pit), "thus enabling the occupants of those seats to look at the pictures without the usual backward craning of the neck" and a concave screen which was said to give an undistorted picture from any angle. Seating was 998 (486 stalls, 269 pit, 243 circle) although 1,050 was claimed. The Newcastle artist, Gerald Dorman, was responsible for the scenic effects in the auditorium. The total cost of land and building was £34,775, an indication of the inflationary effect of the war: a pre-war cinema of similar size, the Scala, Heaton, had cost £7,000.

The Jesmond, "a cosy and comfortable house", was opened by the vice-chairman of the board, Errington Dunford, who assured the audience that it was absolutely fireproof and that it had "the largest cubic space per person of any place of entertainment in the city". At the opening, which was a matinee, local residents were the guests of the management and saw, as the main feature, *At the Mercy of Tiberius*. The first manager was John Fenwick, late of the Heaton Electric Palace.

Despite the management's grand gesture on opening day, the cinema was not a success. Was Jesmond not a suitable area for a cinema, which in 1921 was considered very much a working-class entertainment? Was the management or the programming at fault?

Whatever the reason, the Jesmond closed in late January 1922. The owning company went into liquidation and the building was offered for sale on 18 September 1922.

It was bought for £20,000 by H. P. Smith, one of the directors of the original company and sold on at the same figure to a newly formed company, the Jesmond Picture House Co. (1922) Ltd. The directors of the latter were virtually the same as for the original company but with the addition of the experienced James MacHarg.

The Jesmond was redecorated in brown and gold and reopened in the week of 4 December 1922 with two excellent programmes, *The Three Musketeers* (Douglas Fairbanks) followed by *Little Lord Fauntleroy* (Mary Pickford). There were two performances nightly with a split week. It has been suggested that the cinema was still not a success and that to attract audiences all seats were priced at 6d.; this is not borne out by *Kine Year Book*, which gives prices as 6d., 9d. and 1s.

In December 1926 the cinema began to advertise as the West Jesmond, although official sources continued to refer to it as the Jesmond. The new name certainly located it more precisely in a large suburb. (Local directory references to it as the 'Imperial Jesmond' are in error).

When the talkies came, the West Jesmond, like the Grey Street, made a virtue of its loyalty to the silent picture, advertising as "The last 'silent' house" (it wasn't), but the change was made on 10 November 1930 with *Splinters* (Sydney Howard) and *Sunny Side Up* (Janet Gaynor).

In 1933 the cinema, which had had continuous performances since reopening, went over to "two distinct houses" with all seats bookable. Programmes had to reflect the taste of local patrons (as in all good suburban cinemas): it was useless to expect Jesmond audiences to respond to the low farces, crime melodramas and westerns which were the staples in other parts of the city. Up-market material

such as literary adaptations was popular, while Jeanette MacDonald musicals went down well. For example, in 1936-37, the best weekly receipts (£260) were for *Rendezvous* (William Powell) followed by *First a Girl* (Jessie Matthews); the worst (£97) for *Sinner Take All* (Bruce Cabot) followed by *Talk of the Devil* (Ricardo Cortez).

The cinema was now booked as part of the MacHarg circuit, along with the Apollo and the Lyric, Heaton. It reverted to its old name of Jesmond during the war. While other suburban cinemas fell to television around 1960 the Jesmond kept going, supported by the vast numbers of students living in bed-sits in the area. It was also helped by its ease of access by rail and its very reasonable prices.

In December 1962 the Jesmond was taken over by Arnold Sheckman and had bingo one night per week, although it continued to be well patronised as a cinema. By 1974 it was owned by Dorlyn Entertainments, who in April proposed a change of use to "cinema and/or bingo". Petitions were organised in support of cinema use: "... there is great concern over the possible loss of an amenity which the residents, both in Jesmond and other parts of the city, value highly and most affectionately for its varied family entertainment."

Although the residents won this fight, there was concern that the defeated owners would allow the building to decay and the city council agreed to allow bingo on not more than four nights a week. In fact, the new licence was not taken up and Dorlyn sold the Jesmond to the "Perth-based bingo specialists, Top Flight Leisure" in July 1975. The battle recommenced, but from 6 October films were shown only on Tuesday, Wednesday and Sunday evenings and Saturday afternoon. Dual use did not last long. In January 1977 the Jesmond was bought by Prem Khanna, who abandoned the bingo sessions.

The Jesmond continued as a full-time cinema; in 1978 the 800-seater was attracting between 400 and 500 people each night for films showing only two weeks after the city centre and at cheaper seat prices. Apart from the building of a new proscenium arch to accommodate a Cinemascope screen in November 1954, the Jesmond is virtually unaltered. The projectors are old Westars using carbon arcs: no towers or cakestands here! At the time of writing, the Jesmond soldiers on, a last survival in the city of cinema-going as it used to be.

KING'S HALL

Marlborough Crescent

31 December 1908

Interviewed in 1931, Joseph Collins, then northern district manager for Paramount, reminisced about the King's Hall. He and his two brothers, he said, opened the King's as a cinema in 1905: "We had seen the 'pictures' showing in shops in London and had come to the conclusion that there was a big future in the business. Our prices in those days ranged from 1*d.* to 6*d.* We owned the King's Hall for five years – five happy years they were with all the fun of a new enterprise about them. We then sold out to Mr Jimmie Lowes and ourselves branched out into more ambitious enterprises."

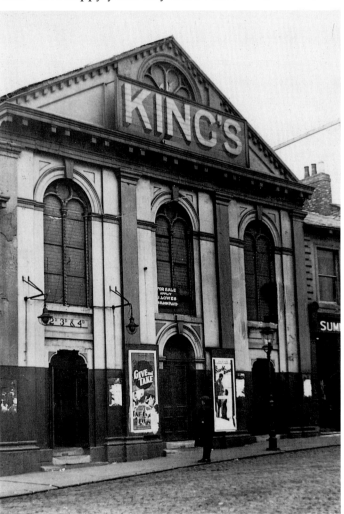

The King's, February 1930
(Newcastle Chronicle & Journal)

If Collins' memory was accurate – and I can find no positive confirmation – this makes the King's the first permanent cinema in Newcastle by a wide margin. The building had been the Drysdale Hall and in 1893 had become a Roman Catholic junior school. In December 1908 J. C. Collins submitted plans for new seating in the hall, the construction of a gallery along both side walls and the building of a brick projection box at the rear of the stalls. The gallery was reached by two iron staircases, one on each side of the paybox. Seating was to be 900.

This reference to 'new' seating might seem confirmation of Collins' claim. But, on 4 November 1908, Jimmy Lowes had submitted plans to the city council for the conversion of the hall for boxing and pictures. These were rejected, but do suggest that Collins did not have any connection with the building until December.

The King's ("The Cosiest Hall in the City") was opened on 31 December 1908,

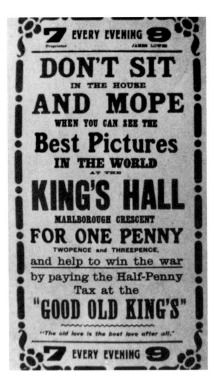

The King's handbill, ca 1915
(S. N. Wood)

"remodelled, redecorated, and reseated at enormous expense". There were two performances each evening of "superb pictures and high-class varieties" at seat prices of 2d. to 1s. There were waiting rooms for patrons and bicycles were stored free.

In its first three years under Collins, the King's advertised widely in the press, with boasts of "no intervals or weary waits" (presumably meaning a second projector had been installed) and "no vulgarity or rowdyism at the King's". There was also an obsession with alliteration: "Silent sensations and subdued symphonies in scarlet" (whatever that means), "clever comedians, aristocratic actors, topical trips and tours".

In December 1911 James Lowes took over the King's and, with his main interest in boxing promotions, the cinema's advertisements became less self-confident and finally stopped. Lowes boasted in 1912 that the King's had "no tip-up chairs". It became just another local cinema, drawing its audience from the crowded streets off Scotswood Road and Westmorland Road.

A correspondent to the *Evening Chronicle* in 1984 remembered: "At the King's a crowded house delighted in the 'comics' and the Westerns with such heroes as Hoot Gibson, Buck Jones and the greatest of all, Tom Mix and Tony. We returned again and again to follow the fortunes and fates of Pearl White or the Iron Man." From 1920 the King's had three changes weekly and seat prices were 2d. to 4d.

It is probable that the King's closed in February 1930, Lowes thinking the installation of a sound system not worth while. In October the cinema was open again, no longer owned by

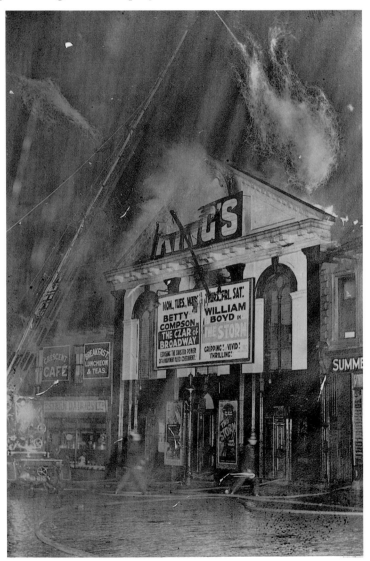

The King's ablaze, September 1931 (Newcastle Chronicle & Journal)

Lowes and having one of the cheapest sound systems, Electrocord. The balconies were now disused and seating was reduced to 342. The original screen, only fourteen feet by eleven feet, remained.

On the morning of 5 September 1931 the King's was destroyed by fire, only the recently constructed operating box surviving. The owner, Mr Gilmartin "had neglected to insure the place because the formation of a company to rebuild it is in progress." Plans for the replacement of the King's by the 'New Marlborough Cinema' were not proceeded with. After nearly sixty years the site has never been built on; the fire-blackened lower walls of the King's can still be seen.

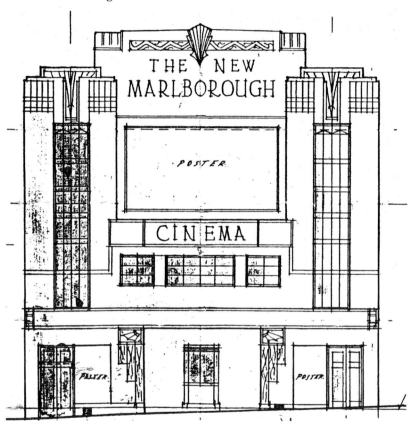

Proposed New Marlborough Cinema, 1931 (Tyne & Wear Archives Service)

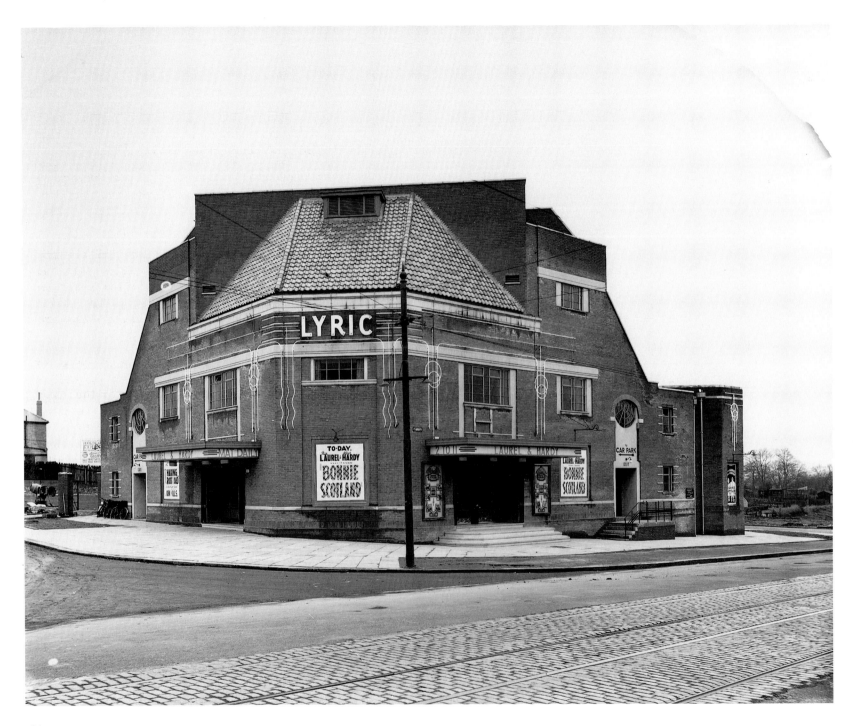

LYRIC CINEMA

Stephenson Road, Heaton

6 January 1936

"Newcastle's new corner of entertainment" was the Lyric Cinema and the Corner House Hotel, which opened two days later. The Lyric was designed by Marshall and Tweedy and built by Thomas Clements and Sons. The owners were James MacHarg of Tyne Picture Houses and John Thompson.

The cinema was designed to harmonise with the residential character of the neighbourhood. Special attention was paid to the cafe which, "... in close proximity to Jesmond Dene and Armstrong Park, will, it is hoped, form a pleasureable resting and meeting place not only for patrons of the cinema, but for members of the public generally."

In the auditorium the predominating colour of the ceiling and walls was pink. "Perhaps the most remarkable feature is the dado surrounding the walls of the stalls. This is about 12 feet high, and consists of a series of black and silver bands, giving a realistic effect of relief, as if the walls were completely cushioned all round ... The front of the circle is picked out in pink, gold bronze and bright vermilion and the walls are enlivened by perpendicular and horizontal lines in brilliant reds and browns." The exterior neon display was said to be the largest in the area.

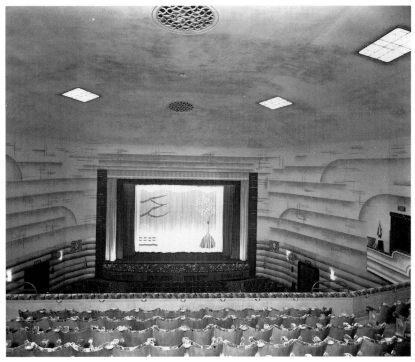

Left: The Lyric, February 1936. Right: the auditorium, 1936 (Both Newcastle City Libraries & Arts)

The Lyric was licensed for 1,594, rather than the 1,650 of press reports or the 1,700 claimed in the opening brochure. The cinema was run on similar lines to MacHarg's Apollo on Shields Road. There was a daily matinée at 2.30 p.m., continuous evening performances from 6.15 p.m. and two distinct houses on Saturday. Adult seat prices were 4*d*. to 1*s*. (afternoons) and 6*d*. to 1*s*. 6*d*. (evenings).

The Lyric opened on 6 January 1936 with *The Little Colonel* (Shirley Temple). As might be expected, the first few months brought a wealth of good things: films with

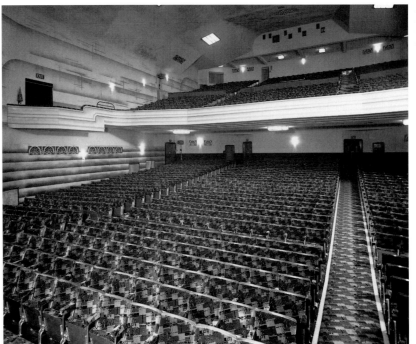

The auditorium, 1936 (Newcastle City Libraries & Arts)

Ginger Rogers, Katharine Hepburn, Richard Tauber, Greta Garbo followed in quick succession to "Heaton's Super Cinema". But before long there was an increasing number of undistinguished double-bills and split weeks. Programming improved again when MacHarg gained sole control. British Movietone News was shared with the Apollo, the cans being carried between the two cinemas by a page-boy on his bicycle.

When the Apollo was bombed in 1941, the Lyric became MacHarg's main suburban cinema and was run concurrently with the Brinkburn. By the late 1950s, when the Apollo had been rebuilt, the Lyric's concurrence with the Brinkburn continued in most weeks, but with an inferior programme to the Apollo. There was now a regular split week at the Lyric and in mid-1958 it was dropped from the *Evening Chronicle* display advertising.

In early 1959 the People's Theatre Arts Group agreed to purchase the Lyric for £27,500 for conversion to an arts centre. It closed, probably on 20 June 1959, with *The Horse's Mouth* (Alec Guinness); its cinema licence was cancelled on 18 July. The building still stands, little altered externally except for the addition of a fly-tower.

LYRIC CINEMA

Newburn Road, Throckley

15 May 1935

The village of Throckley had been without a cinema since the destruction of the Imperial by fire in 1922, but in the expansionist years of the mid-thirties and with a growing population in new housing estates, the time was right for change.

The Hinge circuit built the Lyric from designs by Percy L. Browne. The plans, which are missing, were for an 850-seat auditorium with a dance or assembly hall and seven lock-up shops. Although the design was basic for the period, with a minimum of ornamentation, the Lyric brought a new standard of luxury to cinema-going in the village.

The Lyric opened on 15 May 1935 with *The Thin Man* (William Powell): the proceeds were donated to the Newburn and District Nursing Association, the Newburn Cottage Homes and other local charities. There were continuous shows every evening Monday to Saturday and one show on Sunday.

Les Irwin remembers: "... the building of a new cinema was looked forward to very eagerly. And when it finally materialised we were not disappointed. The interior was done out in the latest concept of cinema art, the seating was luxurious – and double-seating in the back row of the ninepennies was extremely popular and cosy for couples ... [There was] a curtain which changed colours before the show started."

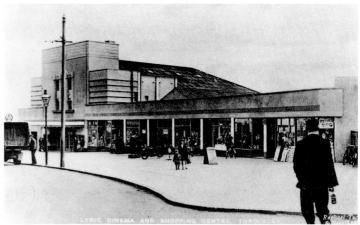

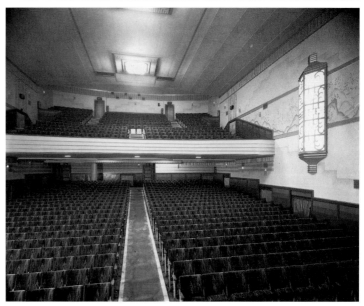

Above: The Lyric, ca 1955. Below: the auditorium, 1938 (Newcastle City Libraries & Arts)

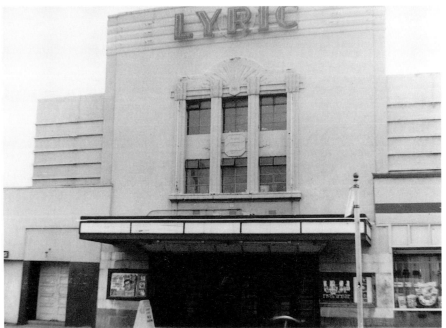

Mrs Sewell was also "… amazed at the ruched curtains [French festoons] which changed colour from orange to green to red. We who didn't actually live in Lemington changed our allegiance from the Prince of Wales to the Lyric. There was a young man dressed all in white with a white hat going around with ice cream. What bliss!"

The Lyric was popular and was considered 'posh'; it outlasted most suburban cinemas, closing in October 1966 and becoming a bingo club. When local opposition prevented the owner from installing gaming machines in the mid-seventies, it was closed. It is now a derelict and vandalised haven for glue-sniffers and others of a like mind.

Lyric, 1963 (Newcastle City Libraries & Arts)

MAJESTIC

Condercum Road, Benwell

4 August 1930

The Majestic was built for John Grantham, who owned the Grand across the road. In April 1919 he had submitted a plan, by architects Dixon and Stienlet, for a theatre to be called the Victory. Although the plans were approved by the city council, the Victory was never built, possibly due to post-war restrictions on building.

In May 1926 plans for the Majestic, on the same site but of more ambitious design, were approved. The architects were Dixon and Bell. The Majestic was built as a conventional theatre, although a projection room was incorporated. The theatre seated 1,400 in stalls and circle, with a box on each side wall at circle level.

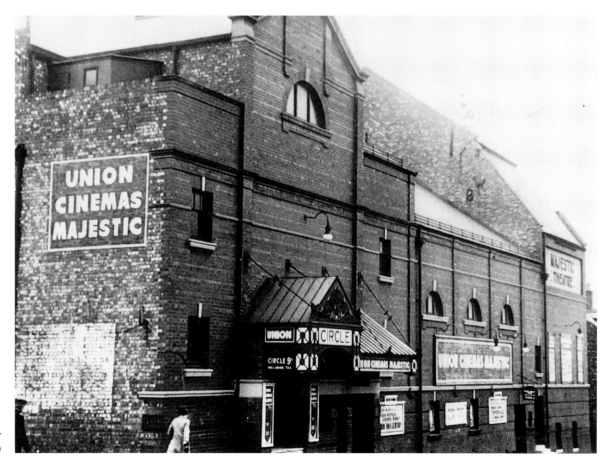

The Majestic, ca 1937
(Tony Moss)

The Majestic was opened by the Lord Mayor on 3 October 1927 with a performance of the comedy revue *Off the Dole*. In May 1928 it became the base for one of Alfred Denville's stock companies, with a series of "West End comedy, American crook plays, and standard classic dramas." The long Denville season ended in April 1930; a few weeks later the Majestic appears to have closed.

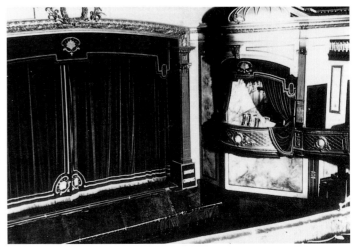

It reopened as a cinema on 4 August 1930 with the talkie *Men without Women*. Performances were initially continuous Monday to Friday with two separate houses on Saturday. Prices were 7*d.* to 1*s.* It has been suggested that by this date John Grantham had over-extended himself financially in building the Majestic, while trying to support the local dramatic society and the Denville Players. At any rate, in February 1931 the Majestic was sold to the national circuit Union Cinemas*. The Grand went two years later to Stanley Rogers Cinemas.

Under Union Cinemas, the Majestic became Benwell's premier cinema, supplanting the Grand. Prices were reduced to 5*d.* to 9*d.*, while the films were good with the backing of a large circuit. The Majestic was a Union/ABC cinema until closure, films arriving there about ten weeks after their Haymarket showing.

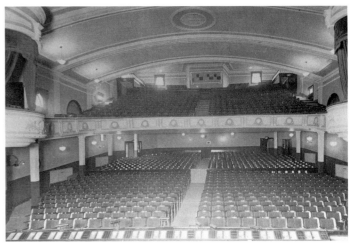

Above: The proscenium, ca 1937 (Tony Moss). Below: the auditorium, 1930 (West Newcastle Local Studies)

The Majestic closed on 20 May 1961 with *North to Alaska* (John Wayne). This was certainly going out with a bang rather than a whimper! On 7 June the building reopened as the Alpha Bingo Club. It is still a bingo club.

*Union was a badly-run circuit. Its cinemas were managed by ABC from 1937 and were taken over by this large group in November 1942, although the Union Cinemas name was used until the 1950s.

NEWS THEATRE

Pilgrim Street

1 February 1937

The news theatre concept, designed for shoppers and others with an hour or so to spare, was late in coming to Newcastle. The first news theatre in the provinces opened in Birmingham in January 1932. The idea burst suddenly on the city, three opening in 1937. (Interestingly, Dixon Scott's obituary in the *Newcastle Journal* credits him with having, *before the First World War*, "tried to persuade the North Eastern Railway to have a news theatre in the Central Station").

The News Theatre, 1963
(Newcastle City Libraries & Arts)

The News Theatre was built near the site of the Newe House, General Leven's headquarters during the Civil War. *Cinema and Theatre Construction* (March 1937) which referred to it as the "Bijou News-reel Cinema" (no-one else did) gives this description:

"Designed by Mr. George Bell, of Messrs. Dixon and Bell, the Bijou has accommodation for 252 on the stalls floor and for a further 160 patrons in the balcony, the seats ... being filled with Dunlopillo cushioning. RCA sound system has been installed, while the 'Lumaplak' screen and the projection room equipment has been supplied by Crowe & Co. Ltd. The cinema is reached from Pilgrim Street through an arcade 54 feet long, in which the mosaic and terrazzo floor and marble walls combine in the creation of a palatial atmosphere. The pay-box, which is also located in the arcade, is carried out in marble, granite and stainless steel. Generous use is made of neon tubing in the arcade, while in the cinema itself the decorative light fitting ... and the stage lighting installations by Holophane, Ltd., are most effective.

"There is a striking contrast between the decorative treatment of the vestibule and that of the auditorium, the former being treated on rich and elaborate lines and the latter with the strictest simplicity. The decoration of the former is carried out largely in fibrous plaster, the delicate mouldings and paintings being executed in ancient Persian designs."

The builder was Thomas Clements and the owner Dixon Scott, trading as Haridix Ltd. The News Theatre was opened by the Lord Mayor; the proceeds went to the Fleming Memorial Hospital.

"The programme is to last 75 minutes and will include three news reels, the latest of the cartoons, and special sport and travel films. But the great hit of the programme will be audioscopics – the new

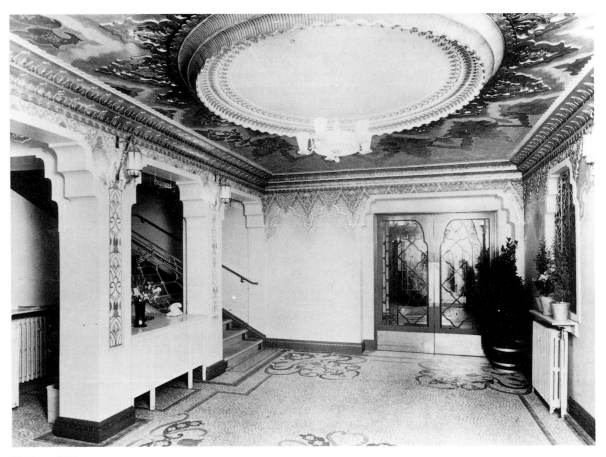

The foyer, 1937 (British Film Institute)

stereoscopic film entertainment in which people throw balls, push ladders and squirt soda right up to within an inch of your nose – or at any rate you think they do."

The local press also noted the provision in the operating box for the BBC's anticipated television transmissions to theatres. Programmes were continuous from 10.30 a.m.; admission prices were 6*d*. and 1*s*. Above the 412-seat auditorium were coffee rooms and above them, a private cinema.

Newsreels were changed every Monday and Thursday. As the three (later five) newsreels tended to contain much of the same material, Dixon Scott junior supervised the editing of them into one sequence, choosing the best items from each; the programme was rehearsed on Sunday. After the showing, the whole thing had to be disassembled and restored to the original newsreels before they were sent on – a two-hour job for the projectionists. As the same programme was repeated up to ten times each day, the boredom threshold of staff must have been high, though there were as many as ten

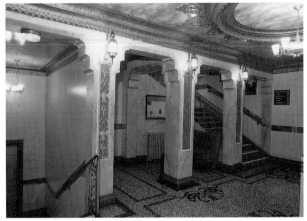

projectionists to mitigate this.

The News Theatre ran a competition for amateur films of the local Coronation celebrations in 1937 and a few weeks later announced the installation of a 16mm projector, inviting local amateurs to sell or hire their films for public showing. A mobile film service for factories and hospitals was also run from the cinema.

Like the Tatler, the News Theatre offered a venue for local film societies, normally on a Sunday; among these were The Tyneside Film Society (1949-61), the King's College Film Society (1953-54) and the Indian Association Film Society/Asian Welfare Society (1954-59). Later, societies used the private cinema upstairs.

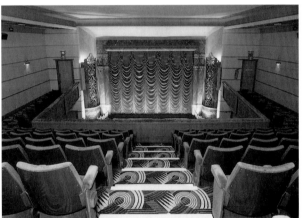

News theatres died when the product that sustained them was cut off. Cinema newsreels could not compete against television news bulletins; two folded in 1959, followed a decade later by the colour 'magazines' *Pathé Pictorial* and *Look at Life*. In March 1968 the News Theatre closed, becoming the BFI-supported Tyneside Film Theatre. It is now the Tyneside Cinema, its original decor beautifully preserved.

Above: The foyer, 1989; centre and below: the auditorium, almost unchanged as the Tyneside Cinema
(All Cityrepro)

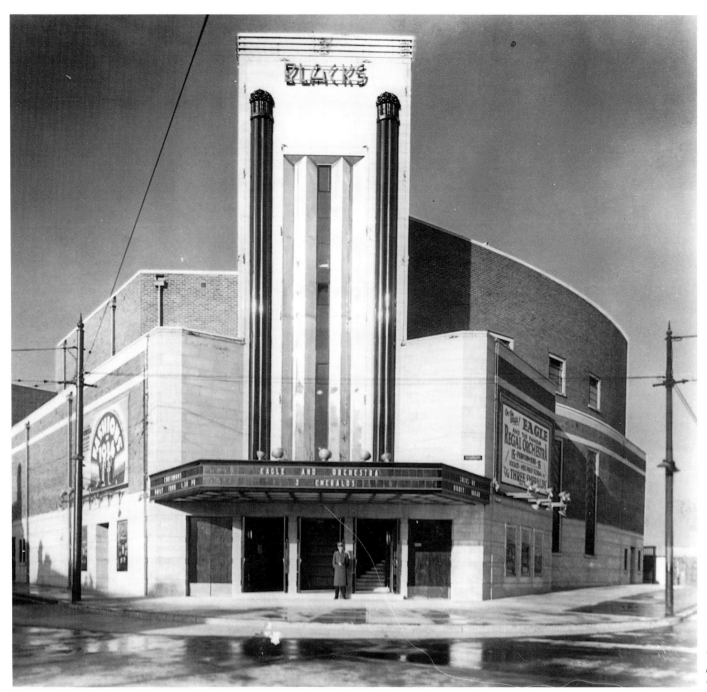

*The Regal on its opening
day, 3 September 1934
(Peter Douglas)*

ODEON (BLACK'S REGAL)

Shields Road, Byker

3 September 1934

The Regal was the second of three large cinemas, all of this name, which were built in north east towns by Alfred Black: the others were in Sunderland (1932) and Gateshead (1937). A fourth Regal, at South Shields, was converted from an existing theatre. All were among the most interesting cinemas in the area architecturally and were beautifully finished. The four Regals were never known simply as that; to the patrons of each, their name was 'Black's Regal'.

Plans for the Byker Regal were approved in June 1933; the architect was Edwin M. Lawson and the builder Henry Waller. On a prominent site at the top of Shields Road, the building's frontage was finished in white with a square tower which when illuminated at night could be seen from the other side of the city.

"Lavish foyers, panelled in walnut, and metal furnishings finished in copper are provided for both stalls and circle." The design of these foyers resembled nothing so much as a transatlantic liner of the period. Set into the terrazzo floor of the main foyer were "elephant's footprints" in black which led from the entrance towards the paybox and the auditorium. This was Alfred Black's idea, intended as a guide to patrons. Within the firm laying the terrazzo, there was some confusion over how many toes an elephant had.

The auditorium seated 1,645 (1,120 stalls, 525 circle). "The interior is spacious without being too large. The ceiling is an extraordinarily fine piece of work, and carved figures add enormously to the general effect. Throughout walnut panelling prevails, but it is more noticeable near the stage where, at either side, huge single panels contain the pipes of the mighty Compton organ. These are lit by floodlights ... The organ itself is centralised in front of the stage and rises to stage level. The famous Western Electric sound system has been installed, including the latest scientific achievement 'Wide Range'. Throughout one is struck by the quietly refined note of design and the management's obvious effort to provide patrons with the very last word in modern entertainment

The stalls foyer, 1934 (R. W. Spurs)

under the most ideal conditions".

The Regal was opened by the Lord Mayor on Monday, 3 September 1934; the opening film was *Fashions of 1934* (William Powell, Bette Davis) with a supporting programme, a stage act, the Three Emeralds (Those Amazing Dancers) and performances on the organ by J. Arnold Eagle who also conducted his Famous Regal Orchestra (from the Regal, Sunderland). There were continuous performances 1 p.m. to 11 p.m.; prices were 5*d.* to 1*s.* (afternoon) and 7*d.* to 1*s.* 6*d.* (evenings).

After the opening of Black's Regal in Gateshead in 1937, the two cinemas normally showed films concurrently. They appeared at the Byker Regal, a second-run cinema, at the end of the three-week bar imposed by the city centre cinemas. The stage shows were never a really prominent feature and the artists rarely first-rate, although the young Bob and Alf Pearson appeared there in January 1935 and again in June 1936. J. Arnold Eagle's orchestra from Sunderland returned occasionally, but he was usually billed as an organist.

The menu of the late thirties seems to have had the desired results, as the stalls were reseated in 1938, increasing capacity there to 1,247 and total capacity to 1,838.

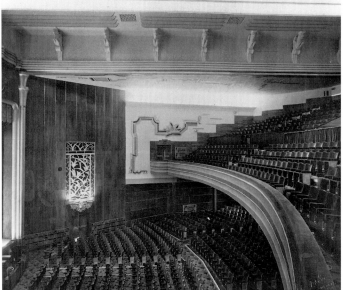

Above: The circle foyer, 1934. Below: the auditorium, 1934 (Both R. W. Spurs)

Stage shows declined after the war. Bob Spurs, manager from 1949 to 1972, thinks that "One reason was that the price of renting films was going up; artists wanted more money and you had to cut your second feature out to put a variety act in. Plus, the quality of some of the acts wasn't all that it might have been."

Through the fifties the Regal traded successfully, with audiences coming from other parts of the town to this immaculate cinema. Seats were cheap when compared with the city centre and "it was just as good entertainment; sometimes better, there was the organ, the occasional stage show, the newsreel, an interest film and the big film – sometimes a double feature. You had Byker area and Wallsend – you could say they were more or less your stalls patrons. Heaton, Jesmond, they were your circle patrons. [There were] two classes of audience, but they were both marvellous, they loved their cinema."

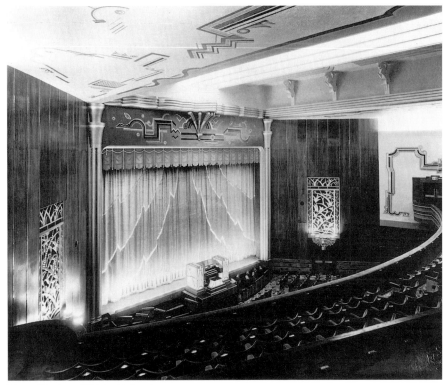

The auditorium, 1934 (R. W. Spurs)

In November 1955 the Regal was taken over by the Rank Organisation and renamed Odeon; it had been programmed by Rank for some time. In 1956 the Apollo reopened as an apparent rival, normally taking the ABC release, but "... we never found that the Apollo was a great competitor. It never seemed to make much difference unless [it had] something really outstanding. The Odeon seemed to keep its patrons. They had their own seats and the staff knew them."

In 1969, despite efforts to have it installed in a local school, the 3-manual, 6-rank Compton organ was removed to a private residence in Majorca.

The Byker Odeon closed on 11 November 1972; the last film was *How to Steal a Diamond* aka *The Hot Rock* (Robert Redford). An application for a bingo licence was refused in May 1975. A supermarket, the Byker Superstore, opened briefly in the gutted building. It was demolished early in 1987; a petrol filling station now occupies the site.

The immaculate projection room of the Regal, ca 1949 (Mrs E. Hodges)

ODEON (PARAMOUNT)

Pilgrim Street

7 September 1931

Newcastle cinema-goers were stunned by the Paramount. Not only did it have almost twice the seating capacity of any cinema yet built in the city, with opulent lounges and powder rooms, but the shows, with a first-class main feature, Wurlitzer organ, large orchestra and Tiller Girls, were the nearest Newcastle came to the legendary American super-cinemas.

The cinema was one of seven built in Britain by Paramount in major centres of population: London, Birmingham, Liverpool, Leeds, Manchester, Glasgow and Newcastle. The site chosen had been R. E.

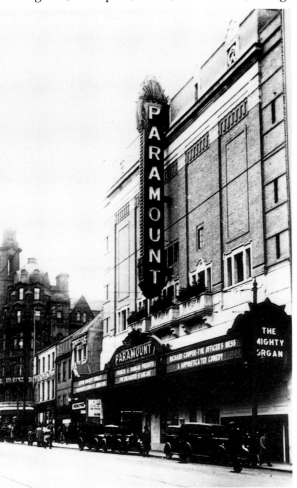

The Paramount, September 1931
(Tony Moss)

Gale's garage and before that the famous coachbuilding works of Atkinson and Philipson. The preliminary plans, by Paramount's 'house' architects Frank Verity and Samuel Beverley for a cinema to seat 2,360 were approved on 30 October 1929. At the beginning of November the local press announced that the builder would be Stanley Miller. In March 1930 the plans were amended to increase seating capacity to 2,602.

Although credited to Verity and Beverley, the cinema bore a strong family resemblance to some USA Paramounts, particularly that at Aurora, Illinois. Much of the similarity can, however, be attributed to the American interior designer of the Newcastle Paramount.

The elevation to Pilgrim Street is in brick and stone divided by pilasters and rising to a cornice. Above the cornice are two Paramount logos in metal.

When opened, the huge vertical illuminated 'Paramount' sign in 'chasing' light bulbs was a striking feature. (This, and the similar lights on the marquee, were replaced by neons in February 1938). The main entrance was on the left, leading to the stalls foyer on the right, "which, true to Paramount tradition, is kept supplied under contract with fresh flowers ..."

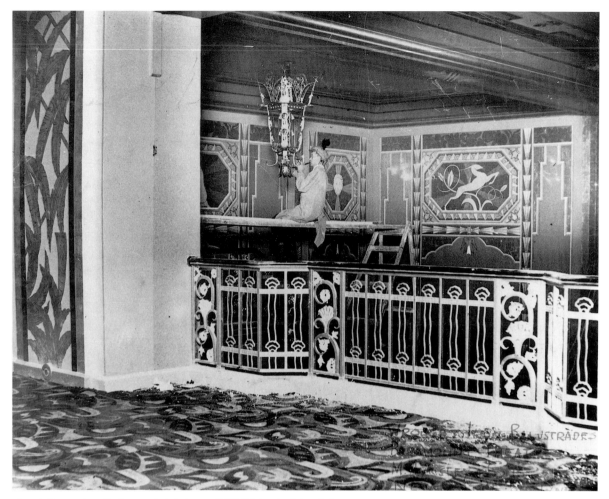

Completing work on the foyer and circle lounge, 1931 (M. Aynsley & Sons Ltd)

The hanging light fittings in the foyer were finished in 9-carat gold. At the extreme right of the foyer was a double staircase leading to the circle lounge.

The walls of this lounge were hung with oil-paintings from the Paramount Museum and Picture Gallery in the States. Off to the left was the ladies' "cosmetic room ... this being daintily furnished with mirrors, etc., and equipped with charming furniture."

"Entering the balcony one is at once struck by the decoration of the house. This is so rich and varied as to make description very difficult indeed. Charles M. Fox, art director, has carried out a scheme which is not subject slavishly to tradition; his decoration may best be termed modernised modern French.

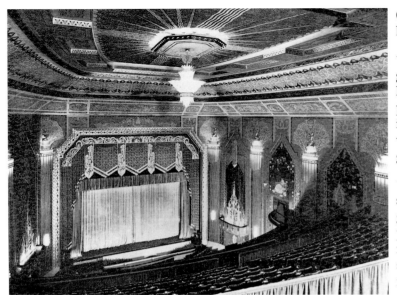

The auditorium
(Newcastle City Libraries & Arts)

(Or, as the souvenir programme put it, "a modern treatment of the Baroque period").

"Above is a ceiling fancifully resembling a night sky upon which gilded designs are seen on a dark ground, and in its centre a modern light fitting of opal glass ... The walls are divided into panels by pilasters which 'flower' into glass illumination fittings behind which, as in the ceiling fixture, coloured lamps in amber, blue and red create a very dainty result. Above them graceful figures in metal enhance the general effect.

"The panels between the pilasters are of silk, painted with figures suggesting Watteau, the colours being rich and blending with the general scheme. W. Turner Lord and Co. carried out the scheme of polychrome decoration, artists and draughtsmen working for two months to paint the details direct upon walls and ceilings. Walls and surfaces had to be minutely measured, and a full-sized drawing of each motive made. These were 500 in number ...

"The stage curtains and pelmet touch a note of real quality. Especially pleasing is the sequin-spangled net drapery which hangs in front of the organ louvres, and which, moved by the current of air, scintillates with a remarkable effect ..."

The Wurlitzer rose on a power-operated lift at the left of the stage. The orchestra pit was also on a lift and could rise independently of, or together with, the organ. The projection room was equipped with two Super-Simplex machines with a Thide automatic changeover device, two Brenkert spots and a Master Brenograph effects machine. Sound was by Western Electric.

The proscenium width was fifty-four feet. The stage was fully equipped for lavish productions; there were seven dressing rooms at circle level. The cinema restaurant was in the basement. The building was completed in ten months at a cost of £250,000.

Paramount's policy was explained in a brochure produced for opening night: "The Paramount will screen exclusively the first presentation of the famous

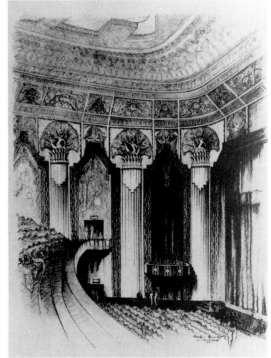

Architect's drawing of the sidewall treatment
(Newcastle City Libraries & Arts)

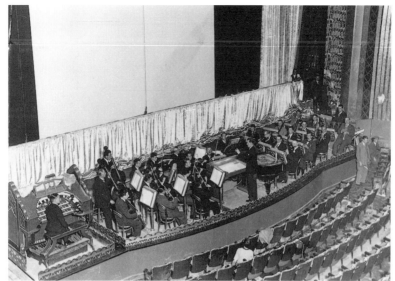

Organist and orchestra rehearse for the opening, September 1931
(Newcastle Chronicle & Journal)

Paramount Pictures in the Newcastle area, as well as other productions of outstanding merit. With few exceptions there will be a complete change of programme each Monday. In addition to the full screen programme we will present each week original stage productions, musical and scenic novelties, the Paramount orchestra and the mighty Wurlitzer organ. The stage presentations will be the famous Francis A. Mangan creations and will come direct from the Plaza Theatre, London. These stage spectacles are exclusively produced for the Paramount Theatres and cannot be seen elsewhere."

The symphony orchestra was to be conducted by Anton, late of the Opera House, Milan, the Brussels Conservatoire and the Queen's Hall, London. The organist was Vincent Trippett. The Wurlitzer was a 3-manual, 19-rank instrument, the second largest of any Paramount theatre in Europe.

The manager C. Roland Young and the house manager Patrick O'Connor were both from the Plaza, London. "The complete personnel of the theatre is composed of over two hundred people, practically all of whom are residents of Newcastle."

The Paramount planned to open at noon, with continuous performances until 11 p.m. Seat prices from 1 p.m. to 4 p.m. were 1*s.* to 2*s.* 4*d.*; in the evening 1*s.* 3*d.* to 3*s.* 6*d.* "The entire programme will be presented at all performances so that patrons visiting the theatre at noon will see exactly the same programme as the evening audiences."

The cinema was opened on 7 September 1931 by the Lord Mayor; his opening address was followed by Wagner's *Tannhauser* overture, a Paramount 'talkatoon' (talking cartoon), *Barnacle Bill*, Paramount Sound News, the stage presentation *The Ladder of Roses*, with the twenty-four Mangan Tillerettes, and the main feature *Monte Carlo* (Jack Buchanan).

The Paramount lived up to its pre-publicity. W. H. Whitehead was present on opening night: "The Paramount was the most beautiful theatre I have ever seen. It was known as 'The Cathedral of Motion Pictures' [An epithet first used by the Roxy in New York]. One minute the theatre would be all in blue, then it was all in red, then green. When it opened it created a sensation because the usherettes were

PARAMOUNT THEATRE
NEWCASTLE

— ALL NEXT WEEK —

IT'S BRILLIANT! IT'S GLAMOROUS! IT'S WICKEDLY WITTY!

FREDRIC MARCH
CLAUDETTE COLBERT

IN NOEL COWARD'S

"TONIGHT IS OURS"

FROM NOEL COWARD'S DARING ROMANCE 'THE QUEEN WAS IN THE PARLOUR'

WITH ALISON SKIPWORTH

"Let me hold you in my arms... close to my heart... let tonight belong to us!"

A 1933 programme booklet
(Newcastle City Libraries & Arts)

dressed in trousers of French grey; the reception ladies walked about with a tray with boxes of chocolates ..."

Mrs Sewell remembers that: "One of the entrancing things about the Paramount was the Powder Room. It was very big and luxurious, lined with mirrors, [and] done out in pink and beige. It was absolutely the last word!"

The promises made in the policy statement were kept, for a time at least. Anton was replaced by Vicoli as conductor of the symphony orchestra, which appeared under various guises, such as the Paramount Jazzmanians or the Syncopated Symphonic Orchestra, but all had gone by 1934. The Mangan Tiller Girls appeared less regularly in 1932 and were gone by 1933. Stage shows of other kinds were however retained until 1938: the best of these were the big-name British dance bands such as Billy Cotton, Jack Payne, Geraldo, Debroy Somers, Lew Stone, Jack Hylton, Roy Fox, Ambrose and Joe Loss. There were personal appearances by George Robey, Anna Neagle, Al Bowlly and George Formby. From its opening, the Paramount issued a weekly magazine for its patrons.

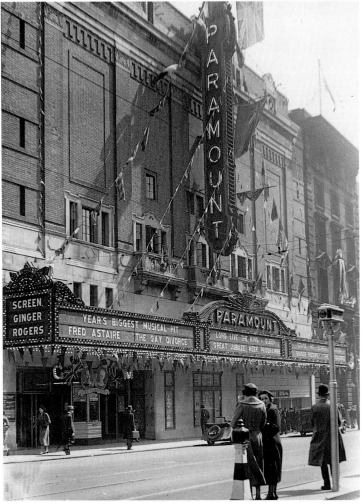

Celebration of the Silver Jubilee, 1935
(Newcastle City Libraries & Arts)

While they lasted, the stage features could be innovative: C. B. de Mille's *Cleopatra* (Claudette Colbert) was shown with a special prologue danced by Anton Dolin and Wendy Toye. The films themselves were not always of the best: there were many double-features and from time to time the stage acts were billed above the film. From May 1934 there were special reduced prices for the unemployed (as long as they got there before 1 p.m.) and in December 1936 the cinema began advertising "1000 seats at 6*d*." up to 4 p.m. and evening prices were reduced to 1*s*. to 2*s*. 6*d*. This said, however, the Paramount was undoubtedly the city's premier cinema and a visit to it was a special event.

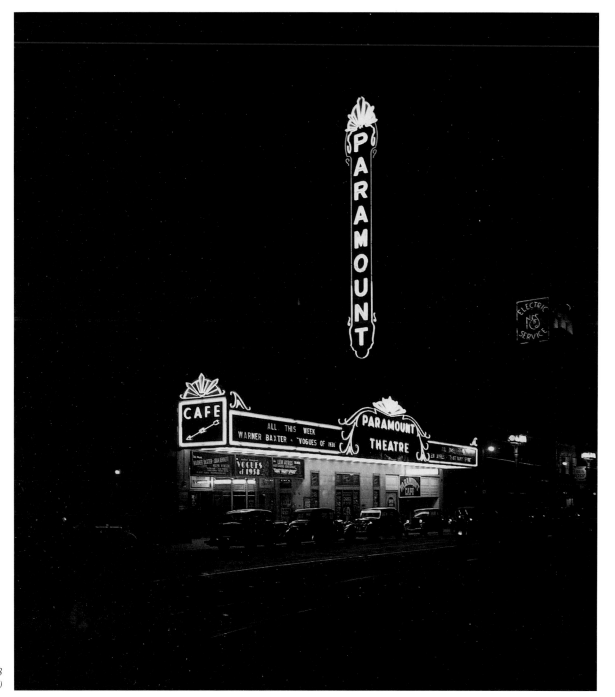

The new neon display, February 1938
(Newcastle City Libraries & Arts)

The Paramount becomes the Odeon, 1940
(J. E. Dietz)

From the cinema staff, American ideas of presentation were required. At the start of each day, all front-of-house staff were paraded in the circle foyer: hands and uniforms were inspected for cleanliness, while the usherettes had to turn round to present straight stocking seams. Any faults had to be corrected before the performance began.

On 29 July 1939 the *North Mail* revealed that the provincial Paramounts were to be sold. The buyer was Oscar Deutsch's Odeon chain, which had been negotiating for some time. The change of ownership took place on 27 November 1939; on 22 April following, the Paramount's name was changed to Odeon in its press advertising.

As the Odeon, controlled from 1941 by Rank, the cinema retained its position as the major first-run house in the city. During and after the war band concerts continued, to become an occasional feature later, like the marvellous Duke Ellington concert on 14 October 1958. The Odeon was the venue for lavishly produced northern and provincial premieres, when the stage facilities were used, additional

A group of Odeon usherettes, October 1947
(Turners Photography)

lighting being borrowed from the Theatre Royal. The 'replica' Royal Film Performance of *Where no Vultures Fly* (Anthony Steel) on 8 November 1951 saw a small galaxy of British and Hollywood stars on the Odeon stage.

The Odeon became the first city cinema to equip for Cinemascope, showing *The Robe* (Richard Burton) for five weeks from 11 January 1954. The cinema was of course firmly tied to the Rank product and not every film was of the highest class, but by and large most films of merit played the Odeon, so much so that it comes as something of a shock to find an Audie Murphy western topping the bill one week in 1958.

In 1964 the organ, acknowledged to be one of a handful of deluxe Wurlitzers in the whole of Europe, was removed to a garage showroom in Diss, Norfolk. (It now plays regularly as a central attraction in a musical entertainment centre in Nottingham).

The Odeon, May 1951 (Turners Photography)

In early 1966 the electronic Cinemation system was introduced in the projection box. Rank's Multiple Unit Management system came in late 1967; in Newcastle this meant that the Odeon and the Queen's had a single manager, both cinemas having house managers. There was also interchange of staff between the two cinemas.

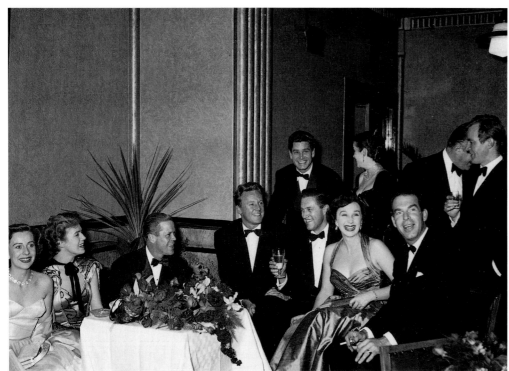

*The "replica" Royal Film Performance,
8 November 1951
(Turners Photography)*

In the late sixties the Odeon had some longer runs: *Thoroughly Modern Millie* (Julie Andrews) for eight weeks from 4 February 1968 (followed by two further weeks after some of the backlog of waiting films had been cleared) and *Battle of Britain* (Michael Caine) for eleven weeks from 4 September 1969.

By 1972 the vast 2,600-seat auditorium was seen as increasingly uneconomic and in October plans were revealed for the demolition of the Odeon and its replacement with a seven-storey block, containing shops on the basement, ground and first floor levels, with offices from the second to the seventh floors. Two cinemas, to seat 700 and 500 were to be squeezed into the first and second floors.

The problem for large auditoria like the Odeon's was explained by its manager, Fred Bower: "What would be ideal would be a cinema with walls that opened and closed. I know that when I have Bond films, I wish it were the size of my last theatre, which had 4,000 seats."

The rebuilding plan was abandoned in favour of tripling the screens in the existing building. The Odeon closed on 25 January 1975, reopening on 9 March. Screen 1 was still large – by 1975 standards – with 1,228 seats, created from the circle; it opened with *The Taking of Pelham 123* (Walter Matthau). Screens 2 and 3, beneath the circle, were much smaller with 158 and 250 seats respectively.

Screen 1 used the original projection box, equipped with two Cinemeccanica Victoria 8s; Screens 2 and 3 had a single box equipped with Victoria 9s. The whole complex

*The Odeon Restaurant, February 1955
(Turners Photography)*

was known as the Odeon Film Centre.

The next physical alteration to the Odeon was the addition of a fourth screen; this was located in the former stage area and seated 361. Odeon 4 was officially opened on 1 February 1980 by the Lord Mayor; the film was a pre-release presentation of *Rocky II* (Sylvester Stallone). The new screen opened to the public on the following day with *Breaking Away* (Dennis Quaid). The complex now had 1,997 seats, within reach of its original capacity as a single auditorium.

Concessionary £1 admission to afternoon shows on Monday and Tuesday for the unemployed was introduced in May 1984. Student concessions followed. This year was later seen to have been the low point for cinema attendances nationally.

By 1987 the upward trend of admissions was evident: at the end of January *Crocodile Dundee* (Paul Hogan) took over £28,000 in its first week at the Odeon, nearly £4,000 more than the cinema's best week in 1986. The computerised booking system C.A.T.S. was introduced in 1987.

A new challenge in that year was the opening of the 10-screen AMC complex in Gateshead Metrocentre. The Odeon fought back successfully although it was later revealed that initially at least 15% of admissions were lost. A major refurbishment over two years cost £750,000 and included a licensed bar in the old upper circle foyer, the transfer of the paybox into the main foyer and the opening of a shop selling videos, magazines and confectionery. Odeon 1 was partially reseated with pullman seats, reducing capacity slightly to 1,171.

So far, the arrival of the Warner Cinemas in

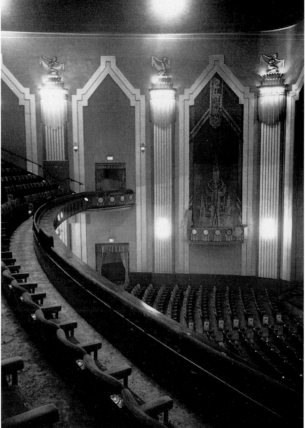

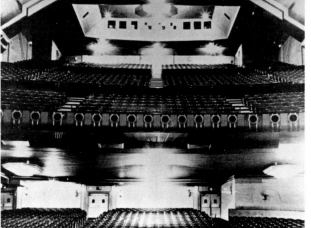

Above and below: the auditorium, 1957
(J. E Dietz)

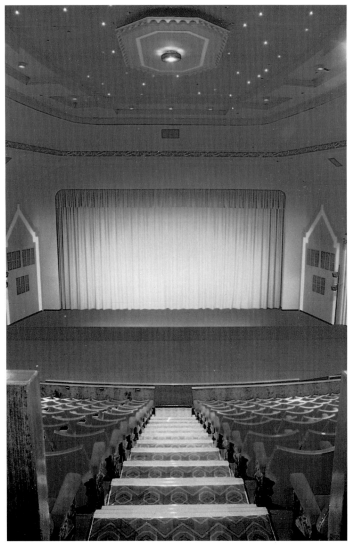

December 1989 has had no apparent effect on the Odeon. Manager Peter Talbot remarked: "I'm expecting us to be as strong now as we have ever been. We may have only four screens, but that means we are able to play the four best films available – and in the real world, commercially there are only about four films out at any one time that people want to see." Further redecoration and reseating took place in 1990.

Left: Screen 1, 1985. Above: Screen 4, 1990
(Both Neil Thompson)

OLYMPIA

Northumberland Road

20 December 1909

The opening of the new Olympia was recorded in the trade paper *The Bioscope* (30 December 1909): "By the continual addition to the list of picture halls on Tyneside, it is evident that 'living' pictures continue to maintain their popularity. What, however, will undoubtedly rank as the most attractive hall in Newcastle is the Olympia in Northumberland Road, which opened its doors as a picture hall

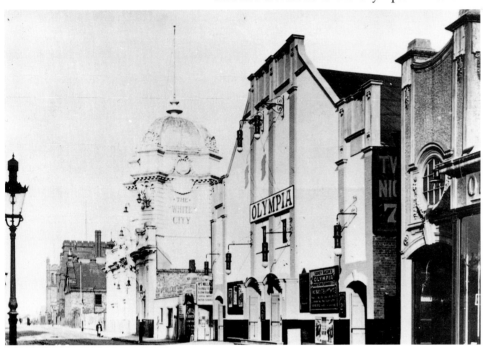

Sidney Bacon's Olympia, with the White City beyond, 1910
(Newcastle City Libraries & Arts)

last week. Built on the site of Ginnett's Circus, accommodation is provided for 1,500 persons, and a sloping floor makes it possible for everyone in the hall to see every picture and artiste with the greatest ease. Erected of red pressed bricks with stone dressings, the building is undoubtedly an architectural adornment, while the most up-to-date apparatus is employed for showing the pictures to the best advantage.

"The hall is illuminated by electricity, but gas has been installed for emergency purposes. Amber-coloured lights will serve to make darkness visible during the time the pictures are appearing on the screen. This proves a convenience to the audience. They do not, however, detract from the effect produced by the pictures. Cloak-rooms and attendants are also introduced, and tip-up seats have been installed in all parts of the hall. Olympia, which is owned by the Northern Cinematograph Company, is run on the two-shows-a-night principle."

The body of the hall was of corrugated iron (later replaced by asbestos), as was the roof (people still remember the noise during a heavy rain-storm). Inside it was lined with wood and plaster. J. Shaw was the architect, with decoration by W. T. Gibson of Gosforth and proscenium plasterwork by the Frediani Brothers of Newcastle. There were four sections of seating, with prices ranging from 4*d.* to 1*s.* The hall was 114 by seventy-five feet.

At the opening performance, encores were demanded for some of the films, while music was provided by the Lovaine Quartette. Variety acts early in 1910 included "Ada Cuffy, a coloured lady" and Little Violette, a female impersonator.

In March 1910 Sidney Bacon took over the cinema and appointed the popular lecturer Lindon Travers as manager. "It will be the scene of perfectly appointed pictorial entertainments twice nightly, with

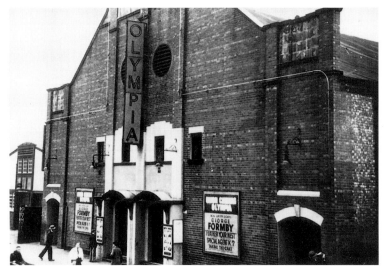

vocal and orchestral concerts at popular prices and a complete change of pictures twice a week ..." Always advertised as "Sidney Bacon's Olympia", "pictures, music, order, comfort" were promised. By December 1910, Bacon offered a show where "The Pictures are All New. Professional Orchestral Septette, Professional Management, and Auxiliary Staff of ex-Police and Military as attendants for the Comfort of Patrons."

During the war the Olympia went over to continuous performances: the programmes were liberally dosed with comedies and serials, staple suburban fare in a city centre cinema. Lindon Travers died in November 1918 and films became even less distinguished. Although talkies came on 25 November 1929 with *Broadway Melody* (Bessie Love), films often reached the Olympia after suburban showings. Seating was now 1,100 (pit 400, stalls 352, circle 348); seat prices in the twenties and thirties were 3d. to 8d., cheaper than when the cinema had opened.

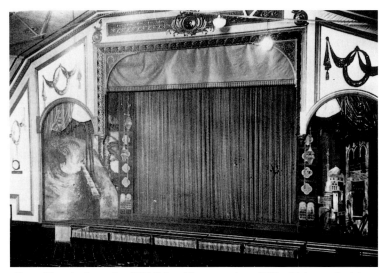

Above: Olympia, September 1937. Below: The proscenium, 1937, with 'atmospheric' touches (Both Tony Moss)

Union Cinemas took over the Olympia in 1936, but introduced no change in policy; it was later run by ABC. In September 1960 the closure of the Olympia was announced. The site was under a tenancy agreement from the city council renewable every six months. An ABC letter said, "Without security we have been unable to carry out any improvements. We have come to the conclusion that if the tenancy is likely to be terminated in the near future we may as well face the position now and close the cinema." The Olympia closed on 8 April 1961; the final film was *The Millionairess* (Peter Sellers). The building was used as a warehouse by the adjacent British Home Stores until demolition in 1971.

ORION

Stamfordham Road, Westerhope

August 1912

Samuel R. Piper was a Cornishman who began his working life as a miner and became deputy overman at Pegswood Colliery near Morpeth. In about 1898 he went as deputy to North Walbottle Colliery, where he remained until 1912, when he left a secure job for the risks of cinema ownership.

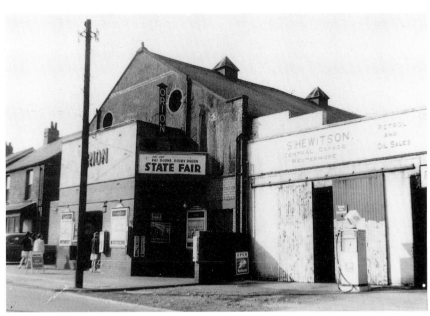

The Orion, 1963
(Newcastle City Libraries & Arts)

The Picture Palace was designed by the Lemington architect H. F. Burrows and was basic: as built it had stalls seating only, with the exception of a tiny balcony seating sixteen to the right of the projection box. The cinema seated 450 and was licensed from 14 August 1912.

When Piper died in June 1927, the cinema was taken over by one of his sons, Robert, and later by Mary Ann Piper. In 1927 the balcony was enlarged and a small shop and rewind room added on the ground floor. Percy Longhorn, a cinema sound engineer, took over in 1932 and installed an Electrocord sound system (replaced by Mellophone in 1937). There were then live 'turns' at midpoint in the show.

From about 1938, Longhorn's son Leslie took over and with his wife ran the cinema until it closed. The Longhorns devoted their lives to their village cinema. When in 1941 Westerhope was cut off by snowstorms, films were brought from Newcastle by sledge.

At about the same time the cinema was redecorated and it was decided that to celebrate this a new name should be chosen. A competition was run which produced the name 'Wavell' (for the British general then fighting in North Africa), but the name Orion was actually used.

The Orion survived when other cinemas fell to the challenge of television by cutting out the frills. Films were collected, not delivered, from Newcastle. In addition to Mr and Mrs Longhorn, there were two full-time staff, usherettes-cum-cleaners. Mr Longhorn was his own projectionist. "The rest of the usherettes and helpers, including assistants on the job of decorating the cinema, are all volunteers. 'There are five or six youths and one girl who assist, and are totally unpaid except that they get free shows. We couldn't manage without them, especially on a Saturday or Sunday'." The Orion was shut down completely two weeks each year for Mr and Mrs Longhorn's holiday.

The Orion closed as a cinema in January 1970 with *Oklahoma!* (Gordon MacRae). It is now a bingo club.

PALLADIUM

17-19 Groat Market

15 June 1908

Opened as the Royal, this was one of the earliest cinemas in the city. The building had been a shop belonging to Ismay and Sons, wholesale chemists. The owners were the Royal Biograph Animated Picture Company, controlled by John Henderson, a film renter who earlier in the year had run film shows at the Central Hall (later Gaiety). The architect for the conversion was F. M. Dryden. The hall was long (156 feet) and narrow (forty feet) with a slight dog-leg at the rear. Seating (in 1922) was 1,250.

Palladium canopy (right), 1933
(Newcastle City Libraries & Arts)

The Royal adopted two ideas from the theatre which were totally unsuited to a cinema: 'early doors' and pricing the seats nearest the screen higher than those behind. These were soon dropped. There was a continuous performance from 7.45p.m. and seat prices were 2*d*. to 1*s*. There were matinées on Wednesday and Saturday, the latter half-price for children.

In July 1908 the Royal showed a special film on the work of the Poor Children's Homes Association, which received the proceeds. In November, shows were run all day for the benefit of the large numbers of people in the city for the annual hiring of farm hands. In December 1908 an orchestra was introduced.

As in most early cinemas, variety acts were part of the bill, for example "Miss Maudie Sutton, catchy chorus singer, young and attractive" in March 1910. In February 1909 there was actuality film of the West Stanley pit disaster with a demonstration of the "Draeger rescue apparatus". Proceeds went to the disaster fund. Colour films were a feature of 1910 and the Royal appears to have been producing its own newsreel.

A raked floor was constructed in 1911 and by 1913 afternoon teas were being served to patrons. But as the years passed the Royal failed to hold its own against newer, more attractive, cinemas. Prices were progressively reduced to 2d. to 6d. in 1924.

Early in 1927 the Royal (which was occasionally referred to, unofficially, as the 'Groat Market Cinema') was taken over by Stanley Rogers Cinemas, redecorated and reopened as the Palladium on 20 June with *The Cohens and the Kellys*. In October 1929 a new projection box was built and talkies came with *Movietone Follies*. Prices were raised to 4d. to 1s.; seating reduced to 963 (305 pit, 261 stalls, 397 circle with fifty standing).

The former Palladium (left), ca 1960 (S. N. Wood)

Through the thirties the Palladium, as part of the Hinge circuit, subsisted on a meagre diet of B features. George Belshaw, who began his career as a projectionist there just before the war, remembers that most of the films were low-budget Westerns. The cinema still had gas lighting.

Before each day's show, all available staff, including usherettes, had to assemble in the cellar to pull the belt of the gas engine until it chugged into life to provide power.

The Palladium appears to have closed on 30 September 1939 with *Ambush* (Lloyd Nolan). Douglas Gibson visited it "in the course of my duties as third [operator] at the Grand. It was really decrepit and used only as a storeroom and warehouse for stage scenery." The building was for many years a store for provision merchants Walter Willson before being demolished in April 1963. Thomson House now occupies the site.

PAVILION

Westgate Road

10 December 1917

The Pavilion Theatre, which had included the bioscope as part of its programme since opening in 1903 and occasionally had special film performances like the Kinemacolour *Eruption of Mount Etna* in 1911, was in financial trouble by 1913. At a shareholders' meeting on 10 March the chairman, Councillor E. J. Wilkinson stated that: "... the company was at present in a critical position, and this had been brought about by certain financial charges they had to meet, heavy artists' salaries, and competition they had to encounter, there being in the city centre now a great many picture halls. There were no less than 24 or 26 picture halls, three theatres, and four music halls."

£10,000 was needed to clear the company of debt and the whole theatre was in need of decoration. A suggestion that the theatre should be converted into a picture hall was rejected after a long discussion. A committee was formed to seek a solution but without success, the Pavilion closing on 24 March 1913.

It reopened on 17 November, reseated and redecorated, with a programme of pictures and varieties – "a concession to the taste of the moment". The management, now the City Varieties Co. Ltd., with George Black among its directors, clearly believed that, despite all the evidence, moving pictures were a passing fad and that variety would again be supreme. By late 1914 pictures were firmly at the bottom of the bill and in 1915 were abandoned altogether. The variety and other programmes at the Pavilion were second-rate: a succession of tatty revues and musical farces. It closed on 30 June 1917.

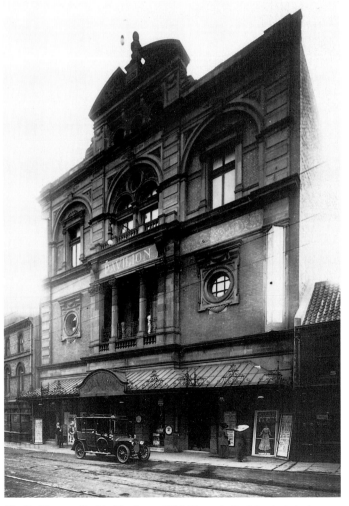

The Pavilion as a Variety Theatre, ca 1916 (Newcastle City Libraries & Arts)

When it reopened on 10 December it was as the New Pavilion, firmly devoted to films and under new management, the Scala (Newcastle) Ltd. Due to the war little alteration was made to the building, although much was promised for the future. The opening was low-key and without ceremony.

The operating box was backstage, using rear projection. Seating capacity was just over 1,600 which included, in theatre style, 134 standing and a gallery which could (at a push!) hold 600. The managing director was John Graham Cutts who left the New Pavilion in 1920 to become one of Britain's best known film directors between the wars.

The first film shown was D. W. Griffith's 208-minute epic *Intolerance*, which ran until 5 January 1918. This was an exceptional film which had opened in London at the Drury Lane Theatre. At the New Pavilion there were only two performances each day, at 2.30 p.m. and 7 p.m. and a 'symphony orchestra' was assembled to accompany the film.

This orchestra of forty players – unusually large for a cinema – was retained after *Intolerance* came off and gave promenade concerts to afternoon audiences. Moving over to continuous (2 p.m. to 10 p.m.) performances, the cinema continued to attract first-run films, accompanied by topicals and Pathé News.

In September 1919 the promised improvements were completed. The stage was cut back and the space gained used to create a "floral garden" which surrounded the orchestra. A 2-manual, 15 speaking stops Nicholson and Lord organ costing £2,000 was installed. In the auditorium the pit was eliminated and replaced with tip-up chairs and the whole redecorated and recarpeted; "... charmingly garbed courteous attendants [were] on hand to lead the way to the seat you require ..." All this was achieved without closing the cinema; it was quite coincidental, of course, that the Stoll had opened almost next door a few months earlier.

Above: Harry Davidson
Below: Francois Grandpierre

Double features (of good quality) were now the rule and and in October 1919 a fairly typical programme in "The House of Music" offered two features, *Marriages are Made* (Peggy Hyland) and *Cecilia of the Pink Roses* (Marion Davies, "the prettiest girl on the screen") *and* the Grand Orchestra playing selections from 'Cavalliera Rusticana' *and* Francois Grandpierre ("England's Foremost Cinema Violinist") *and* Harry Davidson ("England's Greatest Cinema Organist"), the latter lured from the Stoll. (Davidson later became famous for his 'Old Tyme Dance Orchestra').

In 1924 the cinema was taken over by the Thompson and Collins circuit and reverted to its original name of Pavilion. Double feature first-run programmes continued throughout the twenties. A further change of ownership, to Denman Picture Houses (later swallowed by Gaumont-British) came in 1928. In November 1929 a projection box was created from the former circle bar; as this was accessed through the ladies' lounge the potential for embarrassment was high. RCA sound was installed in February 1930, opening with *Pleasure Crazed*; the Pavilion was almost the last city centre cinema to be converted. To complement the sound films, stage shows and cabaret, accompanied by Max Swart and his Band, were retained until January 1931; this was unusual.

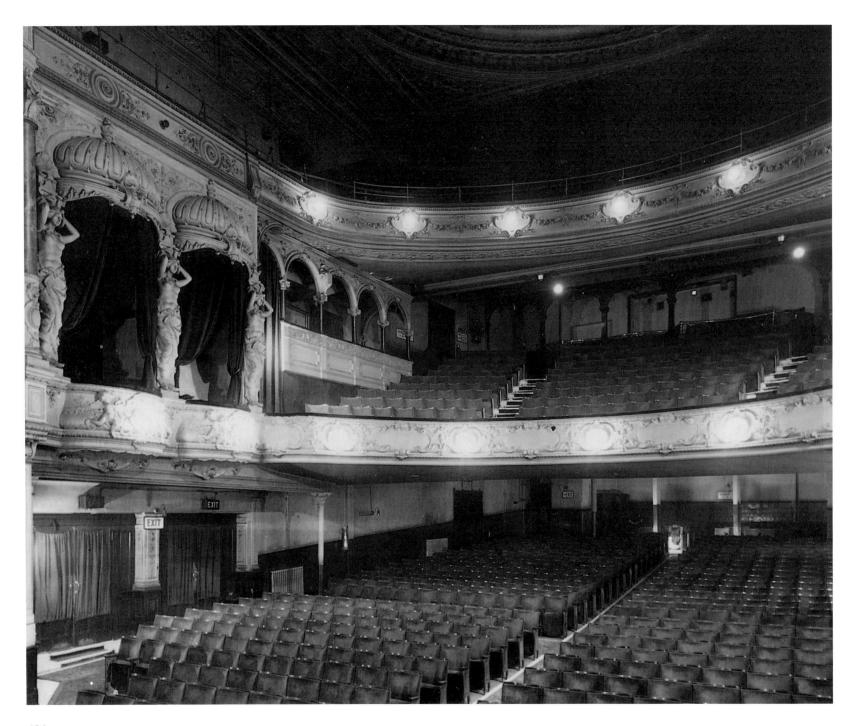

The Queen's Hall was the premier Gaumont house in the city and in the early thirties the Pavilion's programmes began to decline in quality, although from early 1933 it was occasionally used as an 'overflow' for the Queen's when a particularly good programme had been secured by Gaumont. From September in the same year the Queen's and Pavilion were run concurrently, the Pavilion taking the audience for the west end of the city.

From April 1941 Gaumont began to twin the Queen's with its other west end cinema, the Westgate, and the Pavilion was left to pick up whatever remained in the way of reissues

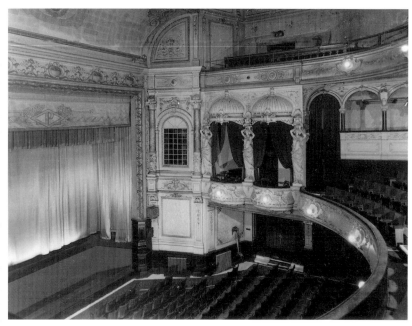

The Pavilion auditorium before alteration, December 1960 (Turners Photography)

and second runs. The gallery was closed in March 1949. With the Queen's taken up with long runs from the late 1950s, the best of the rest went to the Westgate, to whose newspaper advertisements the Pavilion programme was appended almost apologetically. When in 1958 Rank completed the Odeon/Gaumont merger, the Westgate was closed and the Pavilion occupied a similarly lowly position behind the Odeons at Newcastle and Byker.

Instead of final closure, the Pavilion was given a new lease of life by Rank in the form of modernisation. According to the manager, reported on 3 January 1961, it was to have first runs of outstanding feature films. All the Edwardian elegance of boxes and statues of naked ladies was ripped out or masked behind acoustic tiles. It was a conversion very much of its time: an effective but soulless auditorium was created. A new wide screen was installed and new lenses fitted to the projectors. The screen curtains were grey art velvet covered in sequins and illuminated by rose-pink lighting. The seats were orange.

The Pavilion reopened on 31 January 1961 with *The World of Suzie Wong* (William Holden): "Special arrangements have been made to give the Pavilion an oriental flavour to tie up with the film which is set in Hong Kong. The front entrance will be decorated in Chinese pagoda fashion with colourful lanterns. Knick-knacks and souvenirs from Hong Kong and China will be displayed in the foyer, while many of the usherettes will be dressed in Chinese style."

The cinema was now used for extended runs in a rather pale reflection of the Queen's. The longest run

The Pavilion auditorium before alteration, December 1960 (Turners Photography)

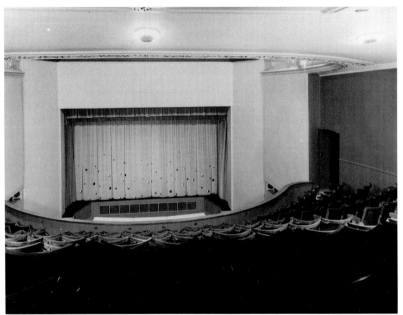

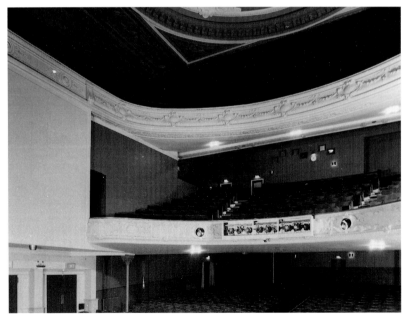

Above and below: The Pavilion after refurbishment, February 1961
(Turners Photography)

at the Pavilion was *Lawrence of Arabia* (Peter O'Toole) in 1963, which had transferred from the Queen's.

It was during this run, on 2 August, that part of the ceiling fell in on the audience, causing cuts, bruises and shock to thirty people. There were luckily no serious injuries. The ceiling fall was apparently caused by vibrations from work in an adjoining building; the cinema reopened in the following week.

On 4 March 1968 the Pavilion was again closed for modernisation, opening on 28 April as a 'showcase' cinema with *In Cold Blood* (Robert Blake). New lighting, a new screen and new seating in tangerine were installed. The old gallery was masked behind a false ceiling.

At the end of 1975 the closure of the Pavilion was announced. A spokesman for Rank explained that it had been known for some time that the future of the cinema would be suspect after the tripling of the Odeon: "At the moment we have five screens in Newcastle, and we can't always get the right sort of films to show. We are always sorry to see a cinema go, but places are always under scrutiny if they can't pay their

The Pavilion's final canopy, April 1968
(Newcastle Chronicle & Journal)

way. The Odeon in Newcastle is thriving. With the Queen's and Pavilion that makes three and you can't keep three large buildings of that order going."

Closure came on 29 November 1975 with *The Man from Hong Kong* (George Lazenby). The building then began to decay. A proposal in 1984 to convert it into a restaurant and night club came to nothing. At the time of writing, the building is to be converted into flats, with the facade retained. Demolition of the auditorium began in February 1990.

PICTUREDROME

36 Gibson Street/Buxton Street

30 July 1910

The Picturedrome was the least prepossessing of all Newcastle's cinemas. The building dated from 1878 and had been a large three-storey house with shop premises on the ground floor.

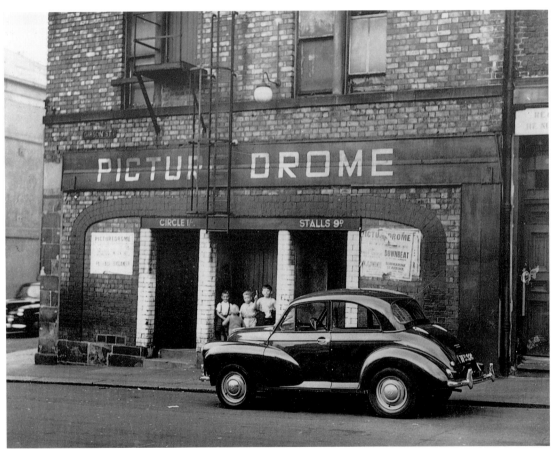

The Picturedrome in its closing week,
August 1960
(Newcastle Chronicle & Journal)

The new cinema was noticed by the trade magazine *The Bioscope* (21 July 1910): "It comprises the site originally occupied by Mr. Harrison, draper ... the new hall having seating accomodation for 450 to 500 patrons. [About 150 of these seats were in a gallery on the rear and side walls of the former first floor]. The floor has been provided with a good rake, so that a perfect view of the picture can always be obtained. Two houses per night are to be the rule, with an exhibit of first release films, with admission at 2*d*., 4*d*. and 6*d*. The necessary alterations have been carried out by Messrs. Millar and Besford, the well-known builders of Whitley Bay, and also the proprietors of the new hall. The architects are Messrs. Hope and Tasker, of Newcastle, while the decorations are in the hands of Mr. J. Thorne ... The piano is by Hopkins, whilst the projector is to be one of Kamm's latest Maltese cross machines."

The Picturedrome was owned for all of its fifty years by the Millar family. By 1930 seating had been reduced to 280 (209 stalls, seventy-one circle). A BTH sound system was installed in 1931. Between the wars seat prices were unchanged at 3*d*. to 6*d*. There was a split week.

The Picturedrome appeared in the local press only when something went wrong, as it did in September 1942. A police inspection resulted in S. C. Millar being fined £15 10*s*. with costs after Superintendent Venner "stated that during an evening performance he failed to find a responsible

person in charge. There was no competent person in charge of the operating box, a youth of 15 working the machines". The cinema's licence was withdrawn by the Watch Committee on 21 November 1942. The episode illustrates the difficulty of running a small cinema in wartime when staff were not easily available.

While closed in 1944, architect Edwin M. Lawson drew up plans for reseating the cinema, the new seats to be upholstered! Further plans of 1949 give 184 seats in the stalls and seventy-nine in the gallery – tip-up seats at the back under the projection box and forms in the side galleries. The Picturedrome's licence was renewed in November 1952 and it reopened, possibly on 8 December and hung on for a further eight years, run by part-time staff.

Closure came on 20 August 1960; the *Newcastle Journal* noted: "Tears have been shed in Newcastle this week for 'The Lop' – a cinema where seats in the stalls still cost 9*d*. and seats in the gallery 1*s*. 3*d*.

"Mr. Millar explained: '... when it was first opened there were enough people in the area to support it. But since the rehousing scheme began a lot of the regulars have been moved right out of the area. I cannot afford to run it at a loss.' Mr. Millar, whose father ran the cinema before him, can remember calling in the police to hold back the hundreds of people that formed queues outside to see the silent films. Support still continued when 'talkies' came in and some of the regulars still attending 'The Lop' are grandchildren of couples who went to matinees as youngsters 50 years ago. Tonight they are expected to turn up at a showing of an adventure film *The Buccaneer* and a Western *Paleface*." The building was demolished.

PICTUREDROME

Westmacott Street, Newburn

October 1910

The Picturedrome and Variety Palace was at the lower end of Westmacott Street at its junction with Grange Road. It was a temporary building in wood and corrugated iron, fifty-eight feet long by forty-eight feet wide. A lean-to of wood contained the tiny foyer with projection box above. There was one toilet, behind a curtain to the right of the screen! The owner was Marshall J. Rutter, a Lemington house-painter; the cinema was licensed from 5 October 1910, initially for six months only.

When Rutter moved to the new Picture Theatre at Lemington in 1911, the Picturedrome was taken over by Thomas R. Fyall, but soon closed, presumably because of overwhelming competition from the Imperial along the road.

PICTURE THEATRE

Tyne View, Lemington

18 October 1911

Marshall Rutter moved from the Picturedrome, Newburn, to open a hall in Tyne View, Lemington, between Sugley Street and Rokeby Street. He successfully applied for a licence from 18 October 1911. "The Sunday evening entertainment" he said, "would commence and finish with the singing of hymns." I have been able to trace virtually no information on this cinema, except that it was a corrugated iron building, a style much favoured in the western suburbs.

In July 1922 it was taken over by John Grantham, presumably as a temporary measure while he planned and built the Prince of Wales at the top end of Rokeby Street. After the latter cinema opened in July 1924, the Picture Theatre was run by Thomas Charlton, a local builder and funeral director. It then had one house each night with a midweek programme change. Every Thursday night there was a 'go-as-you-please'.

Renewal of the licence was refused on 2 March 1927, possibly because the cinema was in poor condition; it certainly must have wilted from the competition offered by the Prince of Wales. On 30 March, Thomas Charlton submitted plans for the reconstruction of the cinema prepared by the Newcastle architects Cackett and Burns Dick. These called for a rebuild using the existing steel roof trusses, a stage with orchestra pit and two dressing rooms and seating for 398 on forms in the pit, 286 in the stalls and 216 in the balcony.

This cinema, had it been built, would certainly have rivalled the Prince of Wales. The old building was burnt down about 1933 and the site was derelict until 1939, when air-raid shelters were built there. Part of a school now occupies the site.

PLAZA

Westgate Road/Gowland Avenue

6 February 1928

Like the Embassy, Denton, the Plaza was built to complement a housing estate. The builders, H. T. and W. A. Smelt, had had cinema interests outside the city since 1912. In the twenties, the firm built much of the Milvain Estate and the cinema was a finishing touch.

The plans, by S. J. Stephenson, were passed by the city council in April 1927. The design was of an auditorium to seat 792 in the stalls and 464 in the circle. There was an eighteen-foot deep stage with a music room and six dressing rooms beneath. Space was provided for an orchestra and an organ, the latter a 2-manual, 18 speaking stops Blackett and Howden. From the corner entrance the stalls lounge led off to the right and the pit lounge to the left; there was also a circle lounge. Two small shops were included in the frontage to the West Road.

"It is tastefully decorated in old gold paling to cream, and the curtain is a work of art. The three-

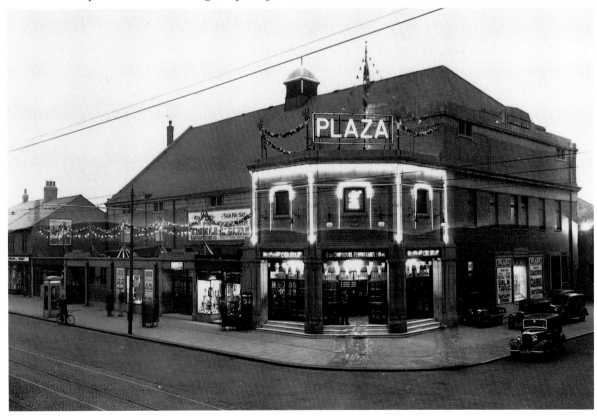

The Plaza, May 1935
(Newcastle City Libraries & Arts)

manual [sic] organ has all the latest improvements, with full orchestral effects, and is said to be the only one of its kind in the North. The stage is adapted for both pictures and vaudeville."

The Plaza was officially opened by the Sheriff of Newcastle. The opening film was *McFadden's Flats* (Chester Conklin) with an organ recital by Herby Laws of the Coliseum, Whitley Bay, and a musical interlude by the Morlais Quartette. The proceeds of the opening performance were donated to the Royal Victoria Infirmary.

Seat prices were 6*d.* and 8*d.* in the stalls and 1*s.* in the circle; performances were continuous from 6 p.m. Films arrived at the Plaza about eight weeks after their city centre showing and initially were of the best. The stage facilities were used for "variety diversions" every Friday. British Acoustic sound was installed on 10 February 1930 for *Lucky in Love* (Morton Downey). Shows were now advertised as "Talkies – organ – orchestra".

Through the thirties the Plaza maintained its high quality; supporting programmes were particularly good. The orchestra went in the early years of the decade and little is heard of the organ, except in 1934 when "interludes" were advertised. In September 1934 the Plaza was used on Sundays for interdenominational services "to attract the crowds of young people who aimlessly throng the West Road, and to whom the ordinary place of worship makes no appeal." (Presumably attendance at the cinema prevented them from aimlessly thronging on weeknights).

Douglas Gibson worked briefly at the Plaza during 1940 and 1941 and "... thought it unique in that the projection room was housed between the circle floor and the stalls ceiling and stretched right across the width of the building. It was large and quite airy but very cold during the winter months ... The entrance was via the Gents' toilet door of the circle foyer and it was not uncommon for a patron to pop in thinking it was the toilet and the look on their faces when they saw all the fantastic machinery going full blast! They still had an old 'Wurlitzer' organ housed in the orchestra pit below the stage but it was never used whilst I can remember. A novel feature of the Plaza was its waiting room to get people out of the wet nights and into the warmth. For the stalls it was a pretty big room with metal rails to place the people in a single file to pass the ticket box. The circle patrons were allowed to wait upstairs in the circle foyer and seated on long settees in comfort."

The cinema was taken over by W. J. Clavering in March 1954; by the late fifties it provided the usual double bills of a suburban cinema. The Plaza closed on 31 December 1960 with *One Foot in Hell* (Alan Ladd). Proposals for the Plaza to become a supermarket were rejected by the city council in April 1963; in August 1964, after being closed for more than three years, it was reseated, redecorated and opened for bingo. It still stands as a very well-maintained Top Rank club.

PRINCE OF WALES

Rokeby Street, Lemington

14 July 1924

The name Prince of Wales was chosen as a result of a ballot in which 5,000 local people were said to have taken part. The cinema was designed by architects W. J. Clark of Lemington and E. Jackson of Gateshead for John Grantham; the builders were Straker Bros. of Lemington.

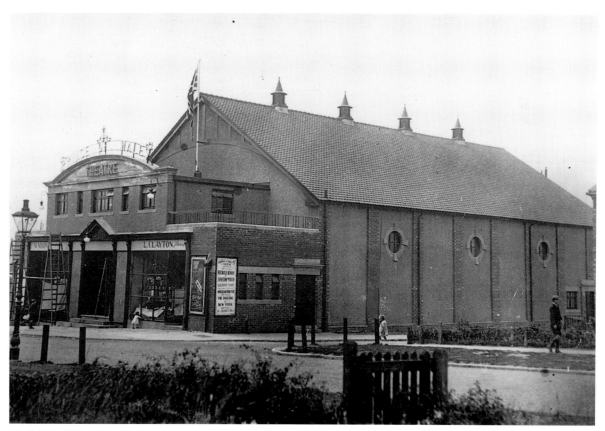

The Prince of Wales, July 1924 (Newcastle Chronicle & Journal)

The cinema was on the stadium plan, with 534 seats in the stalls and 256 in the balcony, the two being separated by a barrier. There was a small stage and an orchestra pit. Below the stage were dressing rooms. The "best of pictures" were to be supplemented by occasional weeks of variety and pantomimes.

"All the apartments are of an up-to-date character, and every precaution has been taken to guard against the danger of fire, both in the film rooms and in the hall itself. There are six exits, and in case of necessity, the whole building could be cleared in a minute." The manager was J. Lambert and the conductor of the orchestra Mr Robson. It was intended to have one performance nightly, except on Saturday when there would be two shows with, in addition, a children's matinée at 2.30 p.m. Being outside Newcastle, there was a Sunday performance at 8 p.m.

The cinema was opened by Major J. B. Rowell, chairman of Newburn UDC, who "was convinced that picture houses had assisted in bringing about less drunkenness. He hoped the people of Lemington would flock to the house and in that way support Mr. Grantham in his good work."

The opening films were *Sporting Youth* (Reginald Denny) and *The Phantom Fortune* with a song and dance act, Leeburn's Seven Stars. There were two programme changes weekly; seat prices were 4*d.* and 6*d.* (on forms) and 9*d.* (on plush tip-ups). Mr Finlay remembers the Prince of Wales in the thirties:

"The cinema had a change of programme on Monday and Thursday, and a one night show on Sunday. Though I never went to the Sunday show, I know they were very popular, as a lot of patrons came from the west end of Newcastle, as cinemas did not open there on Sunday. Later the programmes were changed Monday, Wednesday, Friday and Sunday. Sometimes if the film was a box-office winner it would be shown for six nights ... The cinema did employ some part-time staff who were not in uniform. I remember going one night at the back part of the week and it must have been the box office cashier's night off as the manager Mr Grantham issued me a ticket, then rushed out of the office to the circle entrance, halved my ticket, and showed me to the seat. He employed a bouncer with a loud voice to keep the kids quiet.

"Once a year the local Amateur Operatic Society hired the cinema for a week to put on a stage show, which was usually Gilbert and Sullivan, sometimes other musical shows. All the advertising on the screen was with coloured slides, which seemed to be hand made; a few of the local shops took advantage of this medium. There were no trailers shown, only coloured slides showing the future attractions ..."

Andy Forster remembers that there was a Saturday matinée at which seats were 1*d.* and that there was a vaudeville show on Thursday night, with singers, dancers, strongmen and local talent. Fruit, sweets and chocolate were available as refreshments.

Cinemascope was introduced in about 1956. In the fifties the now 950-seat cinema had continuous performances, still with three changes weekly. The Prince of Wales closed as a cinema in about 1960 and went over to bingo; the building still stands.

QUEEN'S

Northumberland Place

9 September 1913

In January 1909 George Laidler, a decorator and owner of the property bounded by Northumberland Street, Lisle Street, Princess Street and Northumberland Place, submitted plans to the city council for a grand concert hall on the site. The architects were Graham and Hill. The Princess Street Buildings Company, with a proposed share capital of £50,000, was floated in March 1910.

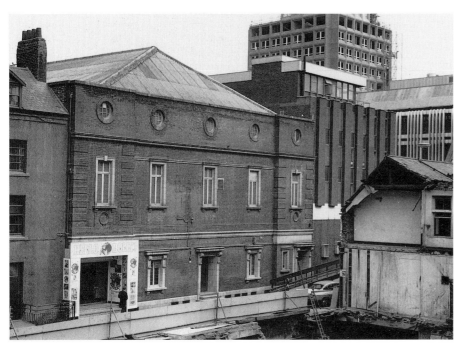

Front elevation of the Queen's, 1970
(Newcastle City Libraries & Arts)

The new building was to cover the whole site with a 130-feet by eighty-feet hall with galleries at sides and rear, a large basement and shops on the Lisle Street and Northumberland Street frontages. The main hall was designed to seat 3,500 with a potential capacity of 5,000 for meetings. The need for such a hall had been emphasised during the Newcastle Musical Festival of 1909, held in the Palace Theatre. This was agreed to be ideal as a variety theatre, but scarcely suitable as a venue for cultural events. Despite much support in the press and from local notables, by April 1910 it was clear that Laidler's plans would never see completion; apart from the company directors and their friends, only 238 £1 shares had been bought.

The grand scheme was revived in January 1911 when Philip Yorke (of London and General Electric Theatres Ltd., and the Cinematograph Finance Corporation) resubmitted the building plans. The main hall was now to seat 2,500 (4,000 for promenade concerts) with a 1,000-seater cinema and a sixteen-table billiard hall in the basement. Again, finance seems to have been a problem, though Yorke was said to own forty similar halls throughout the country. The plans were withdrawn by architects Marshall and Tweedy in March 1912.

The plans for the Queen's Hall as built do not survive, but were clearly more modest than earlier ideas for the site. The cinema was opened privately by the Lord Mayor on 8 September 1913; there was a programme of Zenith films of Lily Langtry, Seymour Hicks and Ellaline Terriss in their stage successes, the beginning of a tradition of superior programming at the Queen's Hall.

"Fare of this high quality will be seen under exceptionally comfortable circumstances. Prices are 6*d.* and 1*s.*, with a few orchestra stalls at 4*d.* From all seats, owing to the semi-circular formation, and the sloping floor, all will get an uninterrupted view, and from an armchair upholstered in red plush. The

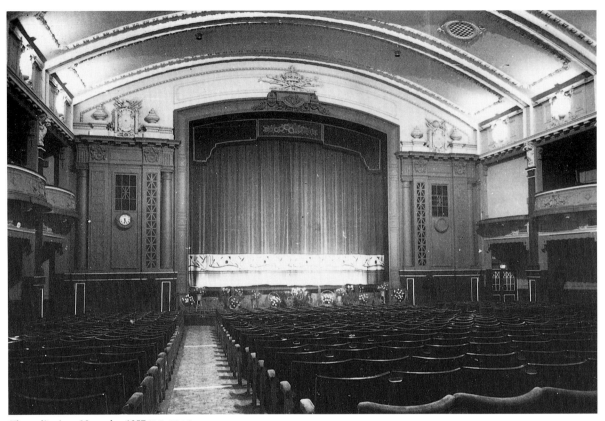

The auditorium, November 1957 (J. E. Dietz)

whole hall, which seats 1,200, is carpeted in red, [which contrasts with] the grand circle ornamentations in white fibrous plaster. [Armchairs in inlaid rosewood and red plush were specially designed for the grand circle and the private boxes on each side of the hall at circle level.] ...

"Ernamann and Gaumont projectors are installed, guaranteed safe and rock-steady. Not only is comfort assured by the seats, the wide gangways, the lounge entrances, and the elaborately fitted retiring rooms; but, if the place was filled with black smoke, it could be freed and sweet again in 12 minutes [a misprint? This seems a long time] so complete is the ventilation system. The panelling in oak, and the plentiful introduction of natural foliage, lend a delightfully furnished aspect to the whole."

The plain elevation to the narrow Northumberland Place gave no hint of the opulence within; it quite justified its claim to be "Newcastle's Finest Picture Theatre".

Musical accompaniment was by H. G. Amers' Bijou Orchestra. Access to the circle and 'first stalls' was from Northumberland Street; to the stalls from Northumberland Place and to the orchestra stalls from

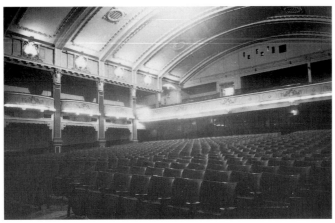

The auditorium, November 1957 (J. E. Dietz)

Lisle Street.

The Queen's Hall opened to the public on 9 September 1913. Wartime programmes included the serial The *Exploits of Elaine* (Pearl White), many Chaplin comedies and Rider Haggard's *She*. According to *Northern Lights*, much of the Queens's Hall's early success was due to its manager Fred Wolters who came to Newcastle late in 1913 and "took control of ... a young and puling business, and promptly changed what looked like being a ghastly failure into an enormous success."

In March 1920 the Queen's was bought by George Black of Sunderland; a 3-manual, 29 speaking stops Vincent organ was installed in 1921 and given its debut by David Clegg. Throughout the twenties there was a large orchestra of twelve to fourteen players. The Queen's was much used by renters for trade shows and previews; they insisted on the best. On occasion, films came with specially composed scores, such as *The Sea Beast* (John Barrymore) and the French *Les Miserables*. George Black was keen on live prologues to films: *The Sea Beast* had such a prologue in which the Lyric Quartette sang sea shanties, while showings of *Volga Boatmen* were preceded by a local male voice choir who hauled a rope across the narrow stage, all the while singing the title music – in Russian!

Con Docherty went to the Queen's as relief organist in 1926; he recalls another of George Black's initiatives: "... about 1927, this American, Lee de Forest, talked George Black into letting him come in with these original talkies lasting ten to fifteen minutes each in a sound on film system. These short sound films included a famous pianist of the day, Mark Hambourg, a famous tenor and an accordion player who argued with a 'plant' in the audience:

"*Plant*: I bet you couldn't play a request if I asked you to. *Accordionist (on screen)*: Who couldn't? *Plant*: You couldn't. *Accordionist*: Go on then, ask me. *Plant:* Play 'Flight of the Bumble Bee'."

These short revue items had been filmed at British Phonofilms' Clapham Studios, and preceded the first feature-length sound film shown in Newcastle by two and a half years, being at the Queen's as support from 10 October 1926 until January 1927.

In 1928 Black sold out to General Theatres Corporation (later Gaumont-British) and in May the trade journal *Cinema* reported that the Queen's was to be closed for redecoration with its capacity to be increased from 1,400 to over 2,000 by the addition of a balcony over the existing circle. There were to be vaudeville stars as well as films. The cinema did indeed close from 23 July to 20 August 1928 and was refurbished with new seats and carpeting, but neither the balcony nor the vaudeville stars

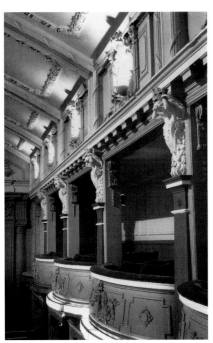

Detail of the circle 'boxes', November 1957 (J. E. Dietz)

appeared (though there were some stage acts in 1928) and seating capacity in 1930 was almost unchanged at 1,047 stalls, 366 circle with 170 standing.

The Queen's was the second city cinema to install sound equipment (Western Electric), opening on 24 June 1929 with *Show Boat* (Laura la Plante). Thirteen of the fifteen members of the orchestra were given notice, although efforts were made to place them in other cinemas in the G-B circuit. The Queen's took all the early talkie hits: *Rio Rita* (Wheeler and Woolsey), *The Love Parade* (Maurice Chevalier), *Anna Christie* (Greta Garbo). The cinema must have been adversely affected by the opening of the Paramount fifty yards away but it remained a first-run cinema, showing the best that Gaumont-British could provide. From September 1933 it was programmed in concurrency with the Pavilion, an arrangement which was maintained, with few exceptions, until 1941, when it was twinned with the Westgate.

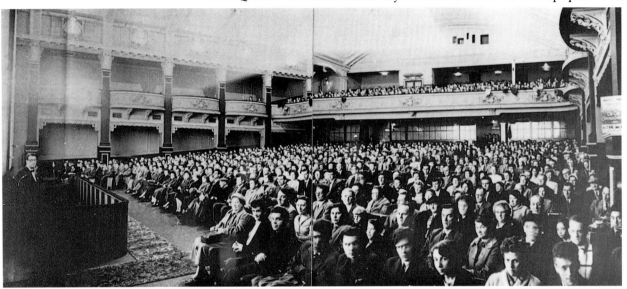

A panoramic view, 1958 (Con Docherty at left)
(Peter Douglas)

Con Docherty came back to the Queen's in 1955, after some years as house manager at the Odeon. The cinema had changed little in appearance since he had left in 1929. The association of the Queen's with spectaculars and extended runs began late in 1957 with Mike Todd's *Around the World in 80 Days* (David Niven). The original narrow proscenium arch was clearly inadequate for a wide-screen process, so a new flat screen was erected on a scaffolding framework in front of it. The old organ was sold for £25 and removed. *Around the World in 80 Days* ran from Boxing Day 1957 until 22 March 1958. All seats were bookable and prices were 3s. 6d., 5s. 6d., 7s. 6d. (stalls) and 10s. 6d. (circle). A small orchestra of seven played each day: it had been discovered that the presence of live performers meant an abatement of entertainment tax which paid for the orchestra and gave a profit besides. The orchestra was later replaced by a hired Compton Theatrone organ, played by Jack Clancy on weekdays and Con Docherty on Sundays.

After the end of this run, twinning with the Westgate recommenced (apart from a season of C. B. de Mille's *The Ten Commandments* (Charlton Heston) from May to August 1958); a new Todd-AO installation was completed in September and the number of front stalls seats reduced.

The film which made the Queen's reputation as an extended run cinema was *South Pacific* (Mitzi

Gaynor) which opened on 22 September 1958 and closed eighty-one weeks later on 9 April 1960. During this run it was rumoured that the cinema was to be converted into a dance hall, but it was contracted to Fox for the run and it was the Gaumont which met this fate.

Long runs were interspersed with single week performances until on 15 June 1963 the Queen's closed for conversion to a Cinerama Theatre. The fifty-year old cinema was gutted and internally reconstructed by main contractor Stephen Easten. With its great width, the building was ideal for conversion; the roof was removed and a new one fitted twelve feet higher to accommodate the twenty-eight feet high screen. The old projection box was removed from behind the circle, which was totally rebuilt with its own foyer. The central Cinerama projector was set into the front of the circle with the others at left and right against the side walls. "Wall decoration, seating and curtains tone in with each other, and the general level of lighting ensures that no particular surface will be highlighted, thus focusing the viewer's attention on the screen without any distraction of the eye." The cost of the operation was reported as £175,000. Seating was reduced to 972 (613 stalls, 359 circle).

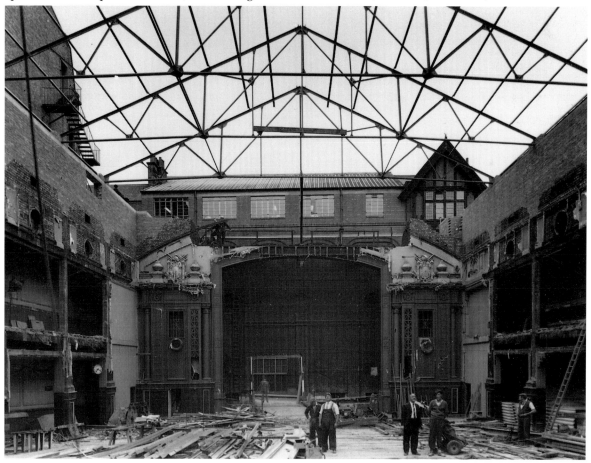

The Queen's gutted, July 1963
(Turners Photography)

The Queen's Cinerama Theatre opened on 9 November 1963 with *How the West was Won* (John Wayne). "A realistic effect was introduced in the foyer, where a small 'Hill Billy' band played lively music, and about thirty members of the Newcastle Amateur Operatic Society disguised as cowboys, Red Indians, and Western characters, sold programmes."

As the only Cinerama Theatre in the north east, the Queen's attracted coach parties from all over the region.

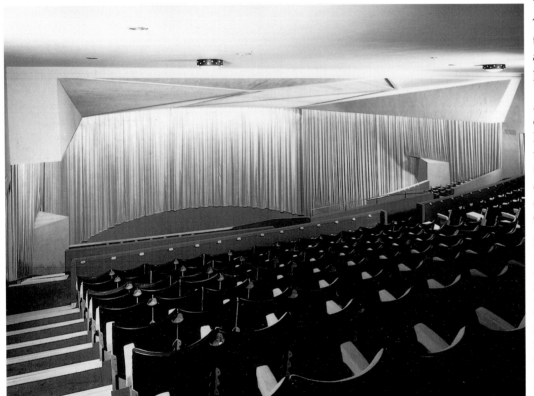

Auditorium, Queen's Cinerama Theatre, November 1963
(Turners Photography)

Three-lens Cinerama was not a great success, the opening film running until 23 May 1964 and being followed by only two others in this process, *Cinerama Holiday* and *The Wonderful World of the Brothers Grimm* (Laurence Harvey). At the end of September the cinema was closed for a week for the installation of single-lens Cinerama equipment, which was first used for *It's a Mad Mad Mad Mad World* (Spencer Tracy). It was found that this lens could show films shot in 70mm without distortion; thus paving the way for the Queen's longest run, *The Sound of Music* (Julie Andrews) from 18 April 1965 until 23 December 1967 (140 weeks).

In 1967 Rank introduced Multiple Unit Management, under which the Queen's was subsidiary to the Odeon, with interchange of staff. By 1978, with the Odeon tripled, rumours of the imminent closure of the Queen's began. Littlewoods, whose store was adjacent, planned to develop the site. In January 1979 a Rank spokesman said: "It has been obvious for some time that a lot of money would have to be spent on the cinema to bring it up to modern standards. Although it will be a shame to lose the historic building of the Queen's, we have to face the reality that the money would probably be better spent on a completely new cinema."

This took the form of the addition of a fourth screen to the Odeon complex. The Queen's closed on 16 February 1980 with *One Flew Over the Cuckoo's Nest* (Jack Nicholson). After remaining empty for a few years, the building was demolished in February 1983 and an (ultimately unsuccessful) shopping arcade named after the cinema built on the site. Plans for the conversion of this into an 'amusement' arcade and offices were rejected in July 1990.

RABY

Commercial Road/Oban Road, Byker

January 1910

The triangular plot of ground at the road junction accounted for the coffin-like shape of the Raby Hall, one of the city's earliest cinemas. The plans do not survive nor was there any press publicity when it opened. The Raby had its own gas engine power supply; seating was 823 (450 pit, 195 stalls, 178 circle) in 1930.

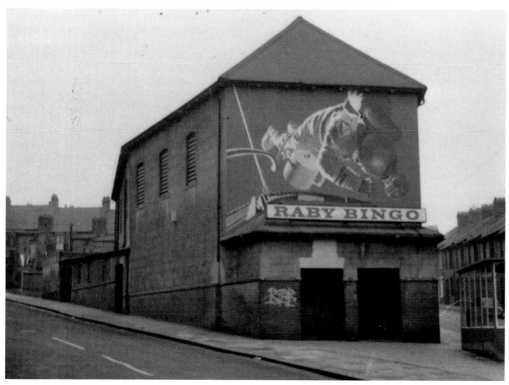

The Raby as a bingo hall, ca 1970
(Tony Moss)

From January 1911 until early in 1913 the Raby was run by Robert Scott, of "Scott's Perfect Pictures" (who also had the Imperials at Dunston and Felling) showing "best varieties and pictures" at seat prices of 2*d.* to 6*d.* In 1913 it was owned by James A. Lauder, who had managed the Tivoli nearby in its early days. In 1917 it was taken over by Joseph Broughton and William R. Marshall, later trading as the Castle Cinema Company. The Raby had a manageress, Mrs A. M. Moffatt, from 1919 to 1923; this was rare in the city.

There was the usual split week, with two shows each night; prices were 4*d.* to 6*d.* through the inter-war period. Edibell sound was installed in 1930. The cinema was often known as the 'Raby Grand'. Edward Davison, who ran the Raby as a bingo hall from 1961, contributed his picaresque memories of the cinema to the *Byker Phoenix* in 1980:

"The whole of the downstairs was fitted out with long wooden forms. You were told to shove up a bit and were eventually squeezed out and finished up on the floor ... The orchestra consisted of Johnny Carse on the piano, his wife, whom he met at the Raby, played violin, and Mr Mitchell, who worked during the day at W. H. Holmes Paintworks as a cooper, played bass fiddle ... Variety acts were introduced between films. They were very good and worked hard for their coppers. I remember the busty sopranos, tenors, ventriloquists and in particular a gentleman who played 'The Bluebells of Scotland' on ropes of bells suspended from the flies. He was a riot. Magicians on the stage didn't stand a chance. The Byker lads would tell him how the trick was done, and during his performance would whistle and shout. 'Turn round, it's on your back' – 'It's under your dickie' – and 'Hadaway and gerroff'.

"Pathé's Gazette, usually about six weeks out of date, was rushed to the 'Bamburgh' for a double showing – then back again to the Raby. Although Mick [Patton] pedalled like hell he was usually late and when he arrived the patrons were stamping their feet and shouting abuse at the manager.

"A big event at the Raby was the Great Road Race, which was filmed by a newsreel cameraman friend. Hundreds of people packed Commercial Road to see the race and be filmed. You were invited to come to the Raby and see yourself on the screen ... I believe the best business the Raby ever did during the Silent Era was '*Alf's Button*'. It was booked for three days and lasted the week. It was retained for a further week. The hall was packed twice nightly – the queues reaching as far as the Middle Club.

"The Talkies came, the cinema was redecorated, sound projectors installed and a wide perforated screen with speakers behind installed. One of the first talkies was a film called 'In Old Arizona' in which the sound effects were mainly a cowboy playing a mouth organ. From then on the Raby was a huge success, until the advent of commercial television ... Cinemascope was out of the question, the cinema was just not wide enough."

In the early 1950s the seating had been described as "very poor" and there was a slow decline through the decade. The Raby closed on 7 March 1959, reopening as a bingo club in 1961. The building was empty for some years before being demolished in mid-1989.

REGAL

Two Ball Lonnen, Fenham

8 November 1933

Between the wars, the suburb of Fenham was developing rapidly. Two Ball Lonnen, once the private carriage drive to Fenham Hall, was central to the area. The first proposal for a cinema in this expanding community, the 'Fenham Cinema', did not get past the planning stage.

Plans for the Regal, by architect J. H. Morton for Stanley Rogers, were approved in March 1933. They provided for 818 seats in the stalls, with two stalls boxes at the rear and 408 in the circle with one box at each side. (No staff or patrons can remember the stalls boxes; perhaps they were not built). There

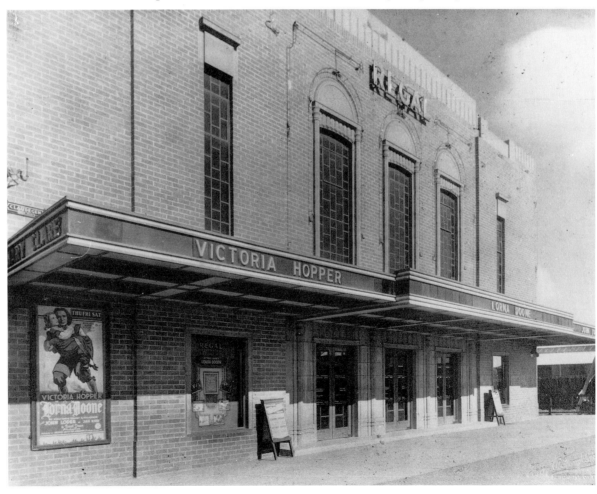

The Regal, August 1935
(M. Aynsley & Sons Ltd.)

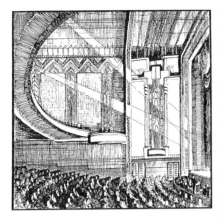

Above: Architect's drawing of the auditorium, 1933. Right: the reality was somewhat plainer (Both BLNL)

was a stage and orchestra pit. The Regal was described in *Ideal Kinema and Studio* (9 November 1933) as "... an attractive hall ... The exterior is built of smooth-faced brick in keeping with the general character of the estate in which it stands ...

"In the wall, above the main [canopy] are four [actually, three] large orange-coloured windows illuminated by lights in the circle foyer; these give a warm aspect to the front of the building. Similar windows ... are in each side of the building. At the rear of the cinema is an extensive car park, and also a specially constructed engine-house ...

"The interior of the hall is artistically shaded from red to pale blue upwards, and all the seating and overhead lighting is in keeping with the general tone effect. There are four artistically designed ventilation grilles in each of the two side walls, and at either side of the proscenium is a large decorative grille. Above the foyer is a spacious projection room in which are two Kalee projectors with B.T.P. apparatus."

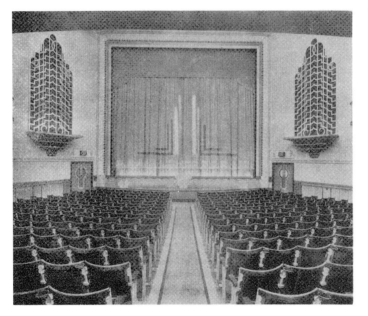

The Regal was opened by the Lord Mayor; the film at the opening performance was *If I had a Million* (Gary Cooper), provided by the Paramount Film Service: proceeds went to local charities. The normal run of the cinema began on the following day with *42nd Street* (Warner Baxter).

The owning company was Suburban Cinemas (Newcastle) Ltd.; the manager was James Siddons, a former Percy Park rugby player, who stayed at the Regal until it closed. Performances were twice nightly, becoming continuous from 1935, with a Thursday programme change.

The Regal closed on 30 April 1960: the last film was *Please Turn Over* (Jean Kent). James Siddons told the *Evening Chronicle*: "The reason for the dwindling audiences is television and in particular commercial television. Attendances dropped as soon as Tyne-Tees Television began transmitting in January last year. Another reason is housey-housey, which has been started in many of the surrounding church halls. This has taken away most of our female audience."

After being boarded up for three years, the building was converted into a Moores' supermarket opening in April 1963. It is now unoccupied.

REGAL

Church Street, Walker

? April 1910

This cinema was the first floor concert hall of the Walker Mechanics' Institute. The hall had always been available for hire; on occasion to owners of travelling cinema shows. It may have been in use as a cinema in 1907: an advertisement for "Joshua Dyson's Gipsy Choir, Dioramas and Animated Pictures" of January 1910 mentions a visit three years earlier.

Mechanics Institute, Walker. 3597

The Mechanics' Institute as "The Walker Picture House", ca 1910
(J. Airey)

In February 1910 the city council passed a plan for the addition to the hall of a "fireproof chamber" (i.e. an operating box) for the committee of the Mechanics' Institute. The hall was licensed as a cinema on 1 April 1910; the licensee was James Simpson and the name 'Favourite' was chosen.

Kinematograph and Lantern Weekly of 5 February 1911 reported: "Since taking over the fine Mechanics' Hall at Walker, which had the doubtful distinction before this of having changed hands about forty times in as many years, Mr Simpson has quite rejuvenated the place. Considerable expense was incurred in adapting and decorating the interior, but it was justified, takings improving week after week. Pictures of the best, interspersed with good turns, have had their effect, and now 'standing room only' applies almost nightly. On a recent date some 1,400 paid for admission to a charity show. Seating, however, is nominally for 850. Once nightly is the rule, except on Saturdays, then a matinée and 'twice'. The projector is an M C Chrono de Luxe, in an outside building. An excellent picture, 20ft by 18ft, is shown, the throw being 90ft."

Despite Simpson's apparent success, he did not stay much longer: *Kinematograph Weekly* (11 May 1911)

A handbill of 1910
(Newcastle City Libraries & Arts)

records that the Favourite Palace, Church Street, would be opened on 15 May by Marshall J. Rutter, of the Picturedrome, Newburn and the Palace, Horden.

In 1912, a raked floor was constructed to the plans of Edwin Liddle and in 1913 the lease was transferred to John Scott, who stayed until 1923. There were then continous performances and a split week, with seat prices at 4*d.* to 9*d.* Scott was succeeded by Baker and Roche, who already ran the Vaudeville nearby and who built a new proscenium in September 1923. The cinema was now a valuable asset to the committee of the Mechanics' Institute: hire of the hall accounted for £278 of the £564 income for 1924.

There is some doubt as to whether the cinema was open on a permanent basis in the late twenties: the trade magazine *Cinema* of 4 April 1928 says that it had been "closed for a number of years". Thomas B. Roche did not take up the licence in January 1930: probably it was thought not worth while to go to the expense of installing sound equipment and the Welbeck had recently opened as a rival.

The hall was reopened by Andrew Smith in November 1931 as the Regal; talkies seem to have arrived in 1932, while performances were now twice nightly. From 1933 the Regal was run by J. L. Davenport, who installed a new sound system and reverted to continuous performances. The final owner, from December 1942, was John G. L. Drummond, of the Hippodrome Theatre, Bishop Auckland. In February 1949 the Regal failed its annual inspection, as did the Gaiety, Nelson Street. There was said to be a danger of fire as the cinema was above a boys' club. Both cinemas closed in 1949 were on the first floor. A local petition failed to save the Regal.

REGENT

Bridge Crescent, Scotswood

1 April 1926

The Scotswood Cinema was one of the smallest in the city. In March 1926 architect F. M. Dryden submitted plans for the conversion to cinema use of the former St Margaret's Mission Church, which had latterly been a Labour Exchange and a Scout headquarters.

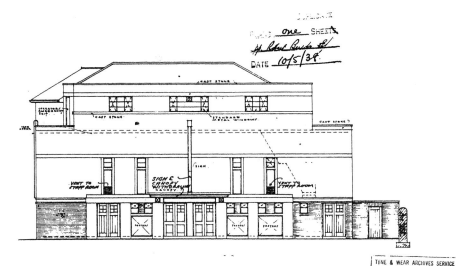

· MAIN ENTRANCE ELEVATION·

Main elevation, Regent Cinema, 1938
(Tyne & Wear Archives Service)

It was a corrugated iron building, below and to the east of the railway embankment leading to Scotswood Bridge.

Though described in the press as "roomy and comfortable", the interior was sixty-two feet long and only twenty-four feet wide, with a small stage at one end. The walls were of varnished pitch pine, a potentially appalling fire hazard; possibly because of this, although the cinema was designed for 324 seats, all on the level floor, (and claimed 350) it was licensed for only 290, with no standing permitted. The owner was John Richard Scott, who had formed the Scotswood Cinema Co. Ltd., in February 1926, with £500 in £1 shares; his partner was Thomas Charlton, of the Picture Theatre, Lemington.

Nothing is known of the programmes at this cinema, which never advertised in the press. On opening day, four free shows were given, and variety turns were promised for the future. It was one of the few cinemas in the city to which entrance could be gained on the presentation of clean jam-jars (which were sold to a jam factory along Scotswood Road). The area was quite heavily populated and the cinema was sufficiently successful for the owner to decide to rebuild.

In May 1938 architect Robert Burke drew up plans for a much larger building occupying the whole of the site. The new cinema was on the stadium plan, with 112 front stalls, 220 rear stalls and 204 in a circle which was separated from the stalls by a barrier. The new cinema, the Regent, opened in about December 1938.

The Regent ran successfully into the early fifties. In 1952 J. R. Scott retired and the cinema was taken over by Carter Crowe, who ran cinemas in Durham City and Esh Winning, but whose main business was as a cinema equipment supplier. By 1956 there were continuous performances with four changes of programme weekly.

The Regent closed on 6 July 1957, "owing to lack of business". It became a bingo hall and a rock club before being demolished in February 1964 for the approach roads to the new Scotswood bridge.

149

R E N D E Z V O U S

115 Elswick Road/corner Park Road

6 April 1911

While many early cinemas were conversions from churches, the Gem was originally a private school belonging to James Marchbanks. In February 1909 Joseph Dobson planned to open the large room as a billiard hall, but the city council refused a licence. In June of the next year plans were approved for a picture hall. Unusually, the screen was to be mounted on a long wall, with the seats radiating around it. The cinema was to seat 190 in the stalls (the floor of the room) and 229 in the 'circle' (a stepped platform at the rear). In February a bioscope room [projection box] was added.

After initial refusal of a licence because of insufficient fire appliances, this was granted on 8 March 1911. The proprietors were the Northumberland Animated Picture Company and the manager a well-known local musician, Percy Forde.

When the Gem opened, seating had been reduced from 419 to 350. There were shows twice nightly and a Saturday matinée. The projector was a Tyler Triumph and a "very fine baby grand pianoforte is presided over most ably by Miss Agnes Harvey."

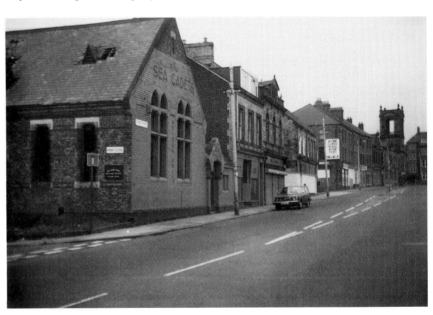

The former Rendezvous (left) shortly before demolition (West Newcastle Local Studies)

The Gem does not seem to have been a great success, despite Miss Harvey's efforts, the licensee changing twice in 1911.

On 1 November the cinema was taken over by George Tully Tomkins and it was presumably then that its name was changed to Rendezvous. As the cinema never advertised in the press, it can only be assumed that it closed some time in 1912.

The building then had a variety of uses as the Fitzgerald Hall; prior to demolition in the early 1970s it was used by the Sea Cadet Corps.

REX

Ferguson's Lane, Benwell Village

8 December 1937

The Rex was built by the small local circuit owned by H. T. Smelt; the architects were S. J. Stephenson and Gillis.

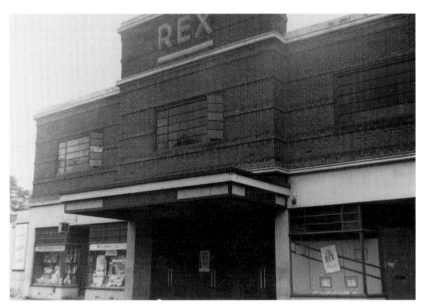

The Rex, 1963
(Newcastle City Libraries & Arts)

The facade was in sand-faced brick of two contrasting colours. An ornamental canopy with neon tubing projected eight feet over the pavement. The entrance hall and foyer walls were finished in figured walnut panelling. The auditorium was on the stadium plan and seated 1,012 (634 stalls, 378 circle).

"The simple proscenium arch, which is rectangular in design and has a span of thirty-five feet, is executed in fibrous plaster and in its very simplicity forms a most suitable surround for the elaborate curtains and draperies, in green and old gold."

Additional details of the colour schemes were given in the local press: "You pass through a softly-lit foyer panelled in walnut with black horizontal bands and strips of vermilion. The frieze and ceilings are in shell pink with tapering shadowgraphy. The walls [of the auditorium] are in shades of green and cream and the splay ceilings of light orange have a design in gold, cream and vermilion. Gold and orange grills appear at intervals ..."

The Rex had the usual café and free car park; an integral confectionery shop was described as a "novel feature". Seat prices at first were 8*d*. to 1*s*. 2*d*., dropping quickly to 6*d*. to 1*s*. As with the Rialto, programming was initially good but steadily declined.

In 1954 the Rex, like the Plaza, was sold to W. J. Clavering. With the Rialto closed from 1961, the Rex lasted much longer than most suburban cinemas, although programmes in the late fifties and early sixties were almost vintage. Owned by Consett Cinemas Ltd. from November 1963, the Rex was showing children's matinées as late as 1965. There was constant trouble with what were then known as "unruly teenagers".

The Rex closed with *Shenandoah* (James Stewart) on 10 August 1968. The building is now a social club.

The proscenium arch, 1937 (BLNL)

R I A L T O

Armstrong Road, Benwell

10 May 1937

The Rialto was built by the Hinge circuit and was very similar in design to the same company's Ritz at Forest Hall, which had opened on 9 November 1936. The architects of the Rialto were Percy L. Browne, Son and Harding.

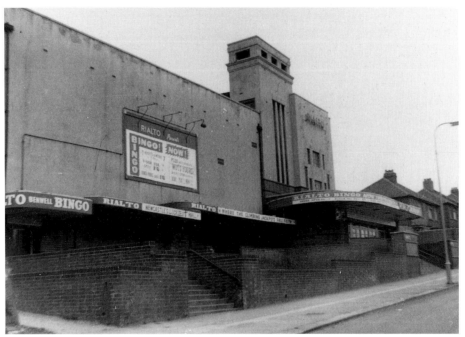

The Rialto as a bingo hall, 1963 (Newcastle City Libraries & Arts)

"The main elevation is modern in design, the principal features in a facade of brickwork and coloured cement being the lofty tower and the handsome metal canopies. Access is obtained via a vestibule, in which is accommodated the paybox, to the stalls foyer; 46ft. by 18ft., and lofty in proportion, this contributes a great deal to the favourable impression which is conveyed to the incoming patron ...

"The auditorium is decorated in red, beige and gold, the 1,026 seats, of which 358 are in the balcony, being upholstered in the same colours. Fibrous plaster has been generously used to obtain relief, being particularly effective in the proscenium arch... Beyond a handsome array of draperies, in which the colouring of the walls, carpets and seating is taken up, there is a stage with an area of 940 square feet." (*Cinema and Theatre Construction*, November 1937).

The Rialto was opened by the Lord Mayor; the first film was *Dimples* (Shirley Temple), followed in the second half of the week by *Swing Time* (Fred Astaire). Seat prices were 6d. to 1s. The Rialto, "Where everyone goes", had high-quality programming in its early years, but by the fifties this splendid medium-sized cinema was showing films anything up to four years old, although B-features turned

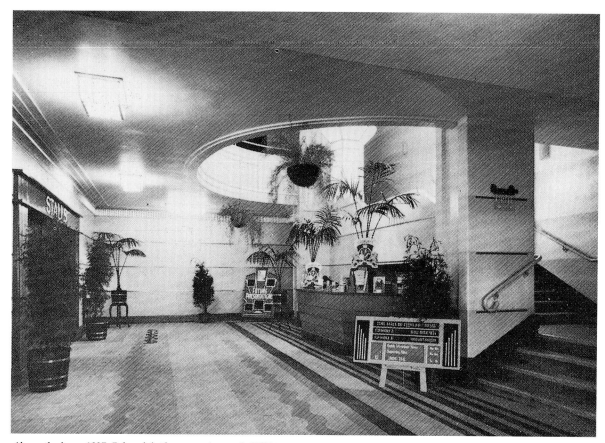

Above: the foyer, 1937. Below, left: the proscenium arch, 1937 (Both BLNL)

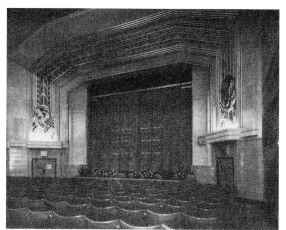

up rather sooner. In the mid-fifties it was frequently programmed concurrently with the Regal, Fenham.

The Rialto closed on 25 June 1961 with *Careless Years* (Dean Stockwell) and went over to bingo. It was demolished in July 1964; a health centre now occupies the site.

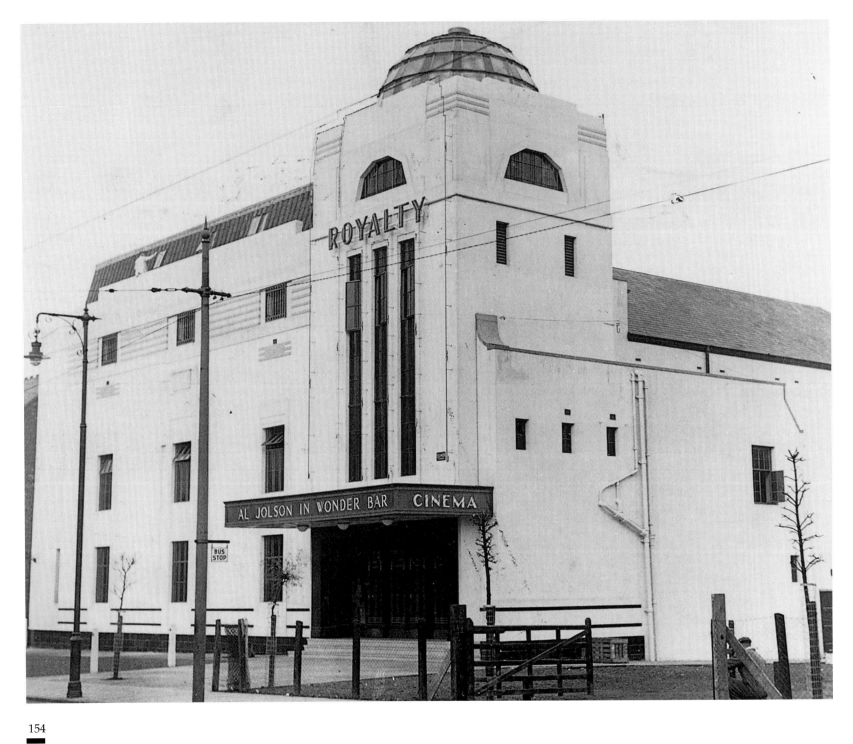

ROYALTY

High Street, Gosforth

17 October 1934

The Royalty was Gosforth's second cinema, built by a company controlled by E. J. Hinge, S. Bamford and Norman Chapman. The architects were Marshall and Tweedy; the cinema was licensed for 1,384 seats.

"Standing back from the main avenue, the Royalty has an imposing facade of snow white, which is thrown into vivid relief by a neatly bordered red gravel drive. At the side there is a large car park. Crowned by a floodlit dome, which is also lit by multi-coloured lights from inside, the Royalty greets the visitor with a dazzling neon display in scarlet, yellow, green and blue.

"The main foyer is entered through wide swinging doors, and up an imposing flight of broad steps. The attendants, liveried by a famous London house, are in simple but

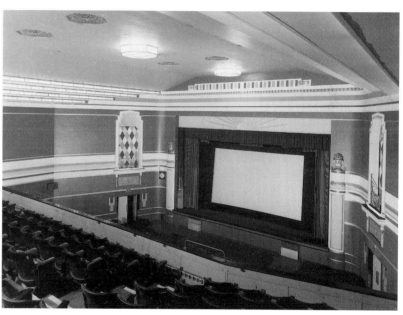

The auditorium, September 1959 (Turners Photography)

exclusive uniforms, which serve to accentuate the quiet but efficient service which is the keynote of the house. The two lounges, which are richly carpeted, are exceptionally luxurious ...

"Mural decorations are of flame fading into a delicate cream, while the fabrics are of a soft shade. This colour scheme has been adopted all over the building, with great success. Broad and easy stairs lead from the entrance foyer to the circle lounge, and thence to the circle ... The walls, in rose-pink and cream, with green and gold bases, rise in tiers to the tiered roof, where rows of rose-pink lights, let in, give a soft warm glow over the whole.

"Beautifully executed relief work, by local craftsmen, is outstanding on the wings of the stage, underneath organ lofts which have been placed in readiness for use when necessary. All the aisles in this modern super-cinema have been carpeted with thick green and orange ..."

Left: Opening week, October 1934
(Newcastle Chronicle & Journal)

The Royalty opened on 17 October 1934 with *On the Air* (Roy Fox and his Band): proceeds went to charity. The normal programme began on the following day with *Wonder Bar* (Al Jolson), which had been shown at the Paramount in the previous month.

Detail of decorative plasterwork
(Peter Douglas)

In 1937 the Royalty employed twenty-seven staff: one manager, three operators (projectionists), four daymen, three cashiers, two cleaners, twelve usherettes (formerly 'girl attendants'), two page-boys (one of whom was relief operator), one chocolate-boy and a relief manager. The usherettes and page boys were part-time. The weekly wage bill was £36.

For the next three decades the Royalty pursued its unremarkable course as a suburban cinema. Like the Jesmond, from the sixties it survived the television/bingo onslaught by showing films a few weeks after the city centre at cheaper seat prices. It also had its devoted local patrons.

By the mid-seventies, time had caught up with the Royalty. In November 1974 its owners, still the Royalty (Gosforth) Ltd., with Donald Chapman as chairman, proposed to demolish the cinema and replace it with a five-storey entertainments complex with restaurant, sports facilities, offices and a mini-cinema. This plan was rejected by the city council and in September 1975 an enquiry was held into it, along with an alternative which was to convert the ground floor into a store with a cinema retained in the circle. Both schemes were turned down by the Environment Secretary on the grounds of 'overdevelopment' of the site.

The Royalty struggled into 1977, being offered for sale for £25,000 in April. Later that year several schemes were put forward: the cinema was to become a Hindu temple, a freezer centre or a music hall with twin cinema. Finally in June 1978 the Royalty was bought by Whitley Bay Entertainments (owners of the Spanish City) who proposed the conventional solution of a bingo club. Objections came from local residents and from the owners of the Globe, which "amply supplied the need for a bingo hall in Gosforth". By October the owners had agreed to include a luxury cinema in the former circle. Opposition continued.

The Royalty, throughout all this debate, was still a cinema, although with decreasing success. A newspaper report in May 1980 logged audiences of nineteen and eleven at showings of *Rising Damp* (Leonard Rossiter): perhaps not a fair test as this film failed everywhere. Ownership had now passed to Paul Burton who managed Dexy's Midnight Runners and owned a chain of hairdressing salons.

Under temporary licences, the Royalty became a venue for occasional pop concerts but a full licence was refused by the magistrates on the grounds of noise. By October 1981, apart from school holidays, only the circle was in use. Despite an appeal, a licence was not granted and the cinema closed on 30 December 1981, with *The Incredible Journey* and *Dumbo*.

The building was put on the market at £80,000. The interior was vandalised. The site and building were bought by developers Longbarr who demolished the Royalty in May 1984 and built flats on the site.

SAVOY

Westmorland Road / Beech Grove Road

12 December 1932

In the early thirties demand for films was growing to such an extent that the earliest days of the picture halls were recalled by the conversion of two west end churches to cinema use. The first of these was the Savoy, formerly Beech Grove Congregational Church, built in 1896.

Plans were submitted to the city council in February 1932 by architect S. J. Stephenson for H. T. Smelt who already owned the Plaza on Westgate Road. The building was made less like a church by shortening two spires and masking the frontage behind stucco. But although the result resembled a cinema from the front, the building's ecclesiastical origins were revealed at the side and rear.

The original plans called for 888 seats, but this had been reduced to 791 on opening. The reduction was probably due to the realisation that some sightlines from the side galleries would be dreadful (the

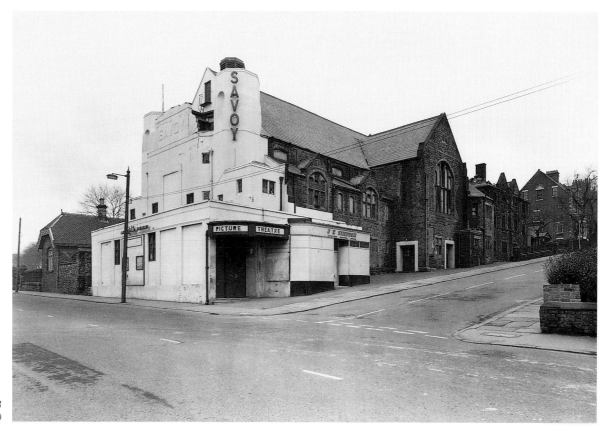

The Savoy, January 1968
(Newcastle City Libraries & Arts)

Savoy may be the only cinema with part of its seating area described in the plans as "transept"). The 'modernistic' decorative scheme by Fred A. Foster of Nottingham was in the Spanish hacienda style. It is reported that the trailing vines and bunches of grapes did not survive long.

The Savoy was opened by the Lord Mayor who praised the directors' response to "a persistent demand in the district". The opening film was *Sunny Side Up* (Janet Gaynor), already three years old: a more recent film might have been expected at the opening of a new cinema. There were two shows nightly with seat prices at 6*d.* to 1*s.*

At the rear of the cinema was a former church hall which was used as a gymnasium for boxers appearing at St James's Hall.

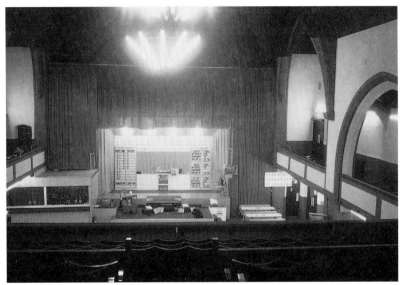

The Savoy as a bingo club (Peter Douglas)

As in all small circuits, strict economy was practised; Douglas Gibson remembers that Smelt's "used to book the 'British Movietone News' as one copy and have it carried between the three cinemas – Plaza, Rex and Savoy – to save cash. It was laughable to hear the three chiefs arguing with each other about the various times they wanted the news delivered to them. The Plaza always showed the news twice and the Savoy and Rex once if they were lucky."

In 1948 the Savoy became part of the Essoldo circuit and was allowed to decline. A visitor in 1965 noted that the auditorium was painted in orange and blue, probably years before. Silver stars stencilled on the blue ceiling could just be made out. After a freak storm damaged the roof in December 1965, it was in such a poor state of repair that its licence was temporarily revoked.

Now recognised as the worst Essoldo cinema, the Savoy was open again when, on 29 May 1966, a fire broke out in an adjoining store room. The Savoy closed and was vandalised. After much expense, Essoldo reopened it as a bingo club in October 1969.

SCALA

Chillingham Road / Tosson Terrace, Heaton

10 March 1913

Armstrong Electric Theatres Ltd. opened the Scala Electric Theatre at a time when there was much debate in the city about the growing number of cinemas. Alderman Arthur Scott, who formally opened the Scala, used the market forces argument in its support: "It was said that Newcastle had too many such places. There was a feeling that no more should be allowed to be built, or licences granted by the Corporation. To his mind it was a question of supply and demand, and so long as there was a demand for picture halls they should be built."

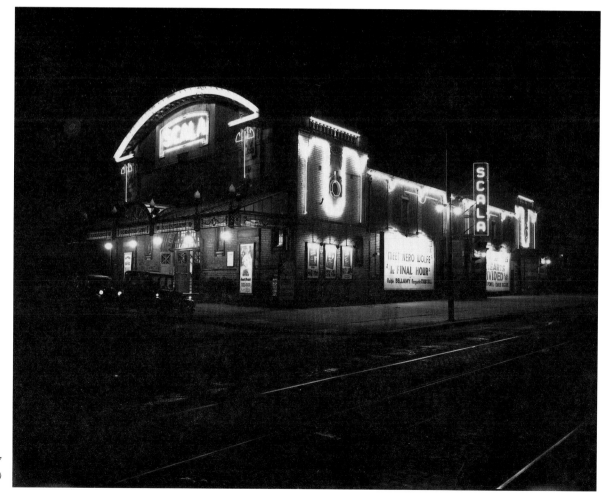

The Scala at night, February 1937
(Newcastle City Libraries & Arts)

The Scala "had a spacious tiled entrance, with marble staircases approaching the dress circle, and in the auditorium are three divisions, the pit, pit stalls and elevation. The total seating capacity, together with the four family boxes, is 1,200. The upholstering is of red plush ... The proscenium has an opening 24 feet wide and 23 feet high, and there is a large stage with the usual dressing accommodation for artists. Mr Percy L. Browne was the architect ... The machines installed are by Ernemann and Gaumont." The building was said to have cost £7,000. Reseating gradually reduced capacity to 986; in 1930 there was a miniscule "dress circle" seating sixteen. The organ was a 2-manual Vincent.

The fare at the Scala in its early years was the usual mix of pictures and variety, with continuous performances 6.30 p.m. to 10.30 p.m. Prices were 'popular' but unspecified; books of family tickets were available. The variety acts seem to have been dropped by 1914.

Throughout the twenties programmes at the Scala were superior, with "First-class music by the Scala Orchestra". From 1925 films were booked at the Queen's Hall by George Black; Scala audiences seeing the films which played at this first-run cinema after a ten week delay. In 1928 the national circuit General Theatres Corporation (later Gaumont-British) took over the Scala, installing British Acoustic sound in 1930. The first talkie was *The Street Girl* (Betty Compson) on 28 April.

Although the Scala continued to provide a good product, it was gradually surrounded by the new breed of super-cinema: the Apollo (1933), Black's Regal (1934) and the Lyric (1936), were all within reasonable travelling distance for Scala patrons. G-B disposed of this now old-fashioned cinema to Sol Sheckman in April 1936 and it was added to the growing Essoldo circuit. Revivals and B-features began to figure in the Scala's programmes, continuing in this vein for twenty years.

The Scala closed on 1 July 1961 with *Very Important Person* (James Robertson Justice). The building was demolished and replaced by a supermarket. "Rising costs and smaller audiences have forced us to close down" said an Essoldo spokesman.

STANHOPE GRAND

Worley Street/Longley Street

10 August 1908

The troubled early history of this cinema is indicated by its four changes of name and its eight managers before 1913. The cinema was opened in St Philip's Church Hall, which was hardly altered in the process.

St Philip's Church Hall, the former Stanhope Grand, in 1963
(Newcastle City Libraries & Arts)

The hall first opened as a cinema in August 1908 as the Imperial, managed by a Mr Tiplady. The seating must have been chairs or forms on the hall floor. It next appears as Prince's Picture Hall in February 1910. Later that year the hall was taken over by Carl Aarstad of the Sun Picture Hall, Byker, who opened it on 17 October as simply St Philip's Hall. There were two shows nightly at 7 p.m. and 9 p.m. and admission prices were 2*d.* and 4*d.* Travel, dramatic, historical and comic pictures were promised. In a matter of weeks it was licensed to James Eadington and in 1911 was known as the Cosy.

In May 1912 a new gallery was added, extending its depth from fifteen to twenty-eight feet. The cinema appeared in its last incarnation in 1912 as the Stanhope Grand (though most people continued to call it the Cosy, which was certainly a more accurate name for a converted church hall). It was run from March 1913 until closure by Joseph Broughton and William Revell Marshall. In June 1914 they installed a new projection box and in 1919 reseated the hall with tip-up chairs. Then the Stanhope Grand – which never advertised in the press – drops from view, except when its manager was imprisoned for one month for embezzling the takings in October 1922. Seat prices were a suitably modest 3*d.* to 6*d.*

The Stanhope Grand was last licensed in February 1930, when seating was 604 (520 stalls, eighty-four circle, forty standing). It must have closed before February 1931, because the church authorities wanted their hall back. In any case, it is unlikely that the owners would have wished to go to the expense of installing sound. The building reverted to use as a church hall, with the paybox still in situ, used as a broom cupboard. The building was demolished in about 1969.

S T O L L

Westgate Road

2 June 1919

Like its near neighbour the Pavilion, the Tyne Theatre was in difficulty in the years just before the First World War. Opened in 1867, it had for decades rivalled the Theatre Royal in the quality of its productions. By April 1913 the Tyne had been forced to accept moving pictures on occasion. A projection box of steel plates was constructed backstage: rear projection meant that the auditorium was unaltered and could easily revert to theatrical use.

Throughout the war the main fare at the Tyne continued to be provincial tours of London stage successes, visits by travelling opera companies and of course the annual pantomime. In mid-1916 it was home to an extended run of D. W. Griffith's three-hour epic *Birth of a Nation*: it was quite usual at this period for theatres to take the premier runs of major films, much to the chagrin of cinema owners. (Even the august Theatre Royal showed *Joan the Woman* (Geraldine Farrar) in July 1918). Such prestige shows certainly attracted an audience which would never go near an ordinary cinema.

On 1 March 1919 the Tyne Theatre closed and Sir

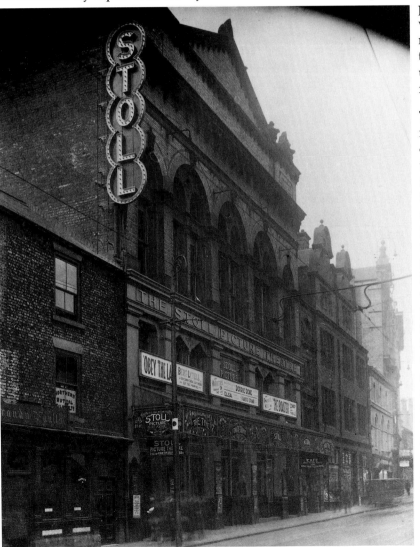

Stoll, ca 1925
(British Film Institute)

THE STOLL SENTINEL
and TYNE TATLER.

The House Organ of the Superlative
Picture Theatre of Newcastle-on-Tyne
EDITOR: KATHLEEN MASON, M.A.

No. 129. OCTOBER 9th, 1922. [COPYRIGHT

EDNA BEST and TOM REYNOLDS
in Ian Hay's Successful Stage Play " TILLY OF BLOOMSBURY."

A charming photo of Miss EDNA BEST as the incomparable " Tilly."
——— SHOWING THIS WEEK ———

Programme booklet, 1922
(Newcastle City Libraries & Arts)

Oswald Stoll acquired the lease, announcing on 12 April that he intended "giving Newcastle the very best ... The screen play will form the main feature of the entertainment, with all the instrumental, vocal, and colour effects which have made the Stoll Picture Theatre, London – formerly the London Opera House – so extremely attractive."

Stoll employed the noted theatre architect Frank Matcham to effect the transformation. To the subsequent gratification of theatre historians, his alterations were largely cosmetic: all the elaborate Victorian stage machinery was left intact. The local press described the new cinema:

"The vestibule, which will form the entrance to the dress circle and stalls, has been altered and enlarged, and made very attractive. It is now furnished with comfortable settees, and the walls and ceilings are richly decorated in panels and arches.

"The dress circle approach from the vestibule by the grand staircase is richly decorated and furnished with pile carpet. Large circular gold-framed mirrors are introduced. The whole of the dress circle and foyer, together with spacious ladies' tea-room and gentlemen's smoking lounges, have been carpeted and furnished with magnificent settees and chairs. In the dress circle will be found very comfortable tip-up chairs ... The prevailing colour of the draperies and seating is in rose du barri, and the decoration has been treated in soft grey and cream tints, with richly stencilled ornament introduced.

"The lounge of the dress circle has been converted into an elaborate winter garden cafe, with a soda fountain in green onyx, and on the balcony a ladies' orchestra will play ... The whole of the ground floor has been fitted with comfortable tip-up chairs, with wide gangways, and the whole of the floor is now carpeted. The boxes have been re-furnished and re-decorated.

"The upper circle, together with the large lounge and ladies' tea room, has been altered almost beyond recognition. The approaches to the seats have been improved. Here also the new bioscope operating chamber has been installed, a permanent structure being built entirely of concrete and steel, [with] every modern appliance for ventilation, and provision has been made for two or more complete machines, with all the requisite rewinding rooms. The gallery floor is now covered with thick carpet, and the seats are upholstered and very comfortable.

"A novelty in the matter of attendants is that at the dress-circle entrance are two young women attired in highwaymen's dress, this style of costume having been adopted at all Sir Oswald Stoll's picture houses. The rest of the female attendants wear dresses of wine gabardine which harmonises with the tone of the whole place.

"The manager of the theatre is Mr Lindon Travers, son of the late Mr Lindon Travers, who was among the pioneers of 'living' pictures in this district. Mr. Harry Davidson the musical director, has had wide experience as a conductor in London ... The prices of admission to the new Stoll house are as follows:- Boxes 10s. 6d. for three persons, extra seats 3s. 6d. each; dress circle 2s.; stalls 1s. 3d.; balcony 1s.; gallery 8d., all inclusive of the [entertainment] tax. There will be one vocalist each week to supplement the orchestral music."

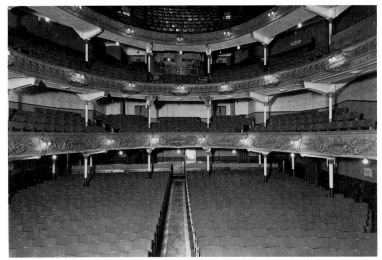

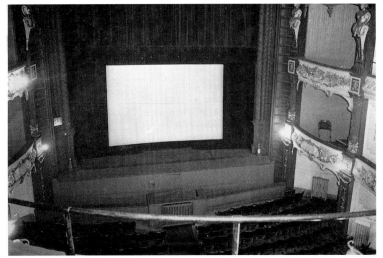

The Stoll was officially opened on 2 June 1919 by the Lord Mayor, who purchased the first ticket from Sir Oswald's aged parent, who apparently performed this service at every theatre her son opened. The first film was an exclusive presentation of *Tarzan of the Apes* (Elmo Lincoln), supported by comedies and topicals. Shows were continuous, from 2 p.m. to 10 p.m.

The Stoll was a major cinema throughout the twenties, backed by Sir Oswald's control of a major London outlet – "What the London Coliseum sees today, the Stoll, Newcastle, sees tomorrow."

The local management was also excellent: W. H. Lindon Travers was followed by Harry Samson. Travers introduced a patrons' weekly magazine, the *Stoll Sentinel and Tyne Tatler* (later the *Stoll Herald*) in February 1920, with details of current and future programmes and the stars appearing in them. Films were supported by the Stoll Symphony Orchestra, a Grand Organ, and variety acts. The organ was a 2-manual, 11 speaking stops Nicholson and Lord. (It was rebuilt in 1928 by Blackett and Howden in

Above: The auditorium, ca 1934 (Newcastle City Libraries & Arts). Below: the auditorium, 1974 (Cityrepro)

an attempt to make it sound more 'theatrical'). Always willing to experiment, in June 1922 the Stoll acquired a Vitasona sound effects machine.

The only physical alteration to the cinema appears to have been the adjustment of circle seating in 1922 to eliminate poor sightlines caused by the upper circle support pillars (though this problem was never totally solved).

The Stoll's greatest coup came in 1929. On 28 March the management announced that Western Electric

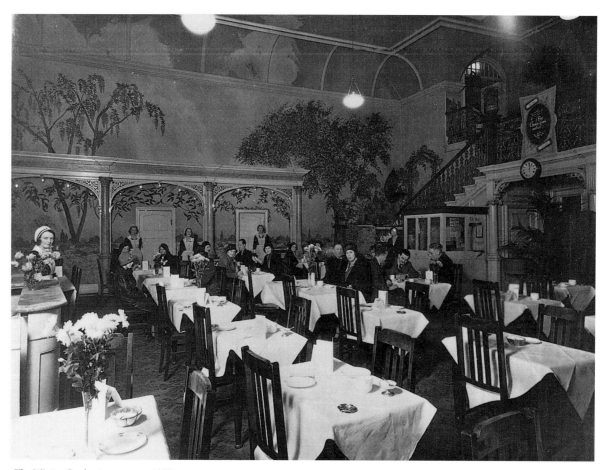

The Winter Garden tea room, ca 1933 (Newcastle City Libraries & Arts)

was wiring the cinema for sound. It "will be the first theatre in the city to present talking pictures as a principal feature in the programme. They will consist of dramas and comedies that will run for over an hour." A new steel-framed screen was installed behind which were two giant loudspeakers, fourteen feet long and slung from steel towers. The acoustical properties of this ex-theatre were said to be ideal for sound reproduction.

The first talkie, *The Singing Fool* (Al Jolson) began a ten-week run on 11 May 1929. Hours were extended to 12.30 p.m. until 11 p.m. and stage shows were abandoned, along with the symphony orchestra. The impact of this first talkie was tremendous and is still recalled sixty years later: "I remember it with bated breath, although I was very very young at the time. The vast darkness and the 'black' face on the silver screen, plus the metallic sound. It was quite an awe-inspiring occasion."

The next Stoll innovation was hardly as epoch-making: this was the introduction of the so-called 'Wonder Screen'. Invented by M. J. Coverdale and patented in 1930, this was a device using pulleys and shutters by which the size of the screen could be varied to suit the action. At the Stoll from 31 March, the inventor claimed that the problems of synchronising screen size and projector had been overcome. It was presumably used in conjunction with a Magnascope-type variable focal length lens on the projector. Although still being advertised a year later – "The wonder screen of the North: watch the picture grow" – the system was not a great success as the magnified film appeared very grainy.

Despite the constant efforts of local management and staff to publicise programmes at the Stoll with vast posters and travelling displays, as the thirties progressed it gradually declined as a first-run cinema. Lacking the booking power of the large national circuits, which now owned the neighbouring New Westgate and Pavilion, the Stoll was reduced by the end of the decade to uninspired double-bills and reissues. The only, though worthy, successes at the cinema were the series of Gracie Fields pictures and some of the excellent Alexander Korda films, although the longest run (four weeks) was of *Little Lord Fauntleroy* (Freddie Bartholomew) over Christmas 1936.

During the war the Stoll specialised in short runs of films which had appeared elsewhere in the city. *Gone with the Wind*, which had opened at the Essoldo in 1940, came to the Stoll with runs of seven weeks from 29 November 1942, two weeks in March and four weeks in July 1943. *For Whom the Bell Tolls* (Gary Cooper) ran for eight weeks from April 1944, the Stoll's only 'exclusive' of this period. The organ, now outmoded, was removed in 1942 and broken down for parts.

In the 1950s the Stoll, now almost the only cinema in a theatre circuit, had an increasingly idiosyncratic booking policy, taking films from small distributors who were usually ignored by the majors (often with good reason). Films were booked at head office in London and by the early

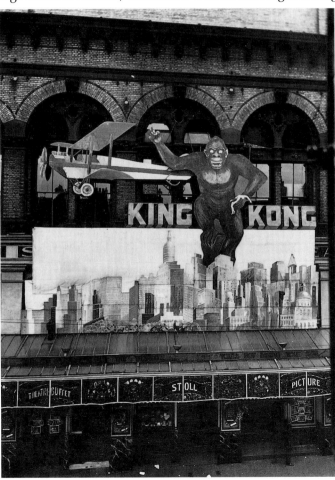

Advertising King Kong, *September 1933 (Newcastle City Libraries & Arts)*

fifties were usually of the X-certificate horror variety. Interspersed with these were British and French comedies. Later in the decade came the first of the 'sex' films for which the Stoll became notorious. As an example of this odd booking policy, take April-May 1958. *The Market in Women* (Agnes Laurent, the girl they call 'The Passion Pet') was followed by *The Duke Wore Jeans* (Tommy Steele) and *The Giant Claw*, Cert.X. Bringing most of these themes together was the "Colossal Triple Attraction" of November 1958: *Viking Women, The Mysterious Invader* and *Back to Nature* ("actually photographed in a nudist colony!").

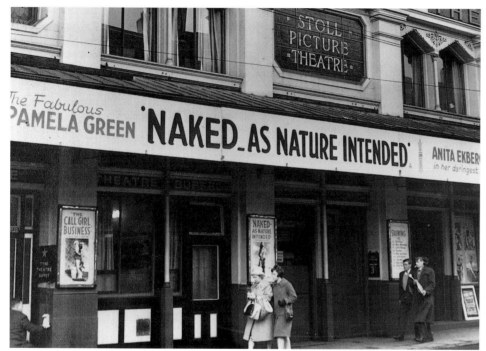

A typical Stoll programme of 1962
(Newcastle Chronicle & Journal)

All this is well-known: what is less well remembered is that in the years before the Tyneside Film Theatre, the Stoll introduced Newcastle audiences to the best in continental films of the time. No other cinema would touch films directed by Malle, Bergman, Resnais or Visconti. It would be naive to assume that the Stoll management's intention was to broaden the cinema education of its patrons, but that was the result.

Through the sixties and into the seventies, as the grip of censorship slackened, Stoll programmes became increasingly soft-porn. Closure of the cinema was announced on 30 January 1974. Stoll Theatres Corporation announced that attendances had fallen over the last year and the Stoll had been losing money for some time. The manager said that the cinema had been doing exceptionally well until a few years ago with its programmes of sex and horror films. He thought the flood of X and AA certificated films on to the market was the cause. People had not become less interested in these films, but "more cinemas were jumping on the bandwagon". In a sense, the Stoll was a victim of its own success in its particular corner of the market: more of its typical product was now on general release. The cinema was old, lacking the facilities and comfort of newer buildings like the Studios complex around the corner.

The Stoll closed on 23 March 1974 with, true to the last, two X certificated films, *World without Shame* and *Danish Bed and Board*. There was immediate concern that the 107 year old theatre should be preserved. After many problems had been overcome, the Stoll reopened as the New Tyne Theatre in April 1977. Reverting to its original name of Tyne Theatre in November 1986, it presents live shows only.

STUDIOS 1 - 2 - 3 - 4

Waterloo Street

13 December 1973

The Leeds-based Star Group of Companies specialised in the 1970s in opening entertainment complexes in major cities. The Newcastle Entertainment Centre, in part of a massive Cooperative Society block in Waterloo Street, comprised, in addition to a 4-screen cinema, a Hofbrauhaus ("bringing fun-loving Munich to Newcastle"!!) and a disco called Scamps. An almost identical set-up opened in Liverpool in October 1975.

Studios 1-4, March 1983
(Northern Echo)

The four screens were all small: 1 – 85 seats, 2 – 112, 3 – 105, 4 – 142. Although the cinemas were basic in design, all the equipment was brand-new. There was a single projection room with four Westar 5000s and four Westrex towers. Using electrically interlocked synchronous motors and a series of rollers, all auditoria could show the same film if necessary.

Opening films in cinemas 1-4 were respectively *Live and Let Die* (Roger Moore), *Cabaret* (Liza Minelli), *Butch Cassidy and the Sundance Kid* (Paul Newman) and *Sex is the Name of the Game* (?). Star policy was to show contrasting programmes in the cinemas, but soon most were occupied by either sex or horror films.

Studio 1, the smallest auditorium, opened on 30 March 1980 as the Penthouse Cine Club, showing uncensored films. (Two other 'cinemas' catered for this particular segment of the market: the Climax Cinema Club, Barrack Road, which closed in 1983 after a series of police raids and public protests and the Gallery Cinema Club in Westgate Road, seating forty in a converted corner shop).

The Studios closed on 26 March 1983 with *Pick Up Girls, Incubus, Werewolf Woman* and *Dead Men Don't Wear Plaid* (Steve Martin). Of the complex, only the former disco, now a club named Rockshots, remains.

SUN PICTURE HALL

Long Row, Byker Hill (Shields Road)

29 November 1909

All over the country cinemas were being opened in converted churches. The Sun was different; it was a converted slipper factory, built in 1902 to plans by W. Ellison Fenwick of Eldon Square. By 1909 it had closed and plans for its conversion to a cinema by Gateshead architect W. R. Storey were passed by the city council on 6 October 1909. The lessee and manager was Heaton merchant Carl Albert Aarstad. There was a small stage twelve feet deep and seating was 350 (250 stalls, 100 circle).

The Sun was formally opened on 29 November 1909: "... there was a crowded attendance. An excellent cinematograph machine has been installed, and a number of varied and interesting pictures delighted those present." The main pictures were *Leather Stocking* and *The Airship Destroyer*. There was a performance by Miss Le Clair, "the favourite vocalist".

In August 1913 Benjamin Spoor took over the Sun, made a few minor alterations and ran it until closure in 1934. It is of Mr Spoor's early years as proprietor that an evocative article appeared in *Byker Phoenix* in June 1980:

Front Elevation.

Plans of the Sun, 1908 (Tyne & Wear Archives Service)

"He was always immaculately dressed, a beautiful suit with his butterfly collar and bow tie, always a buttonhole of a carnation or rose and his button boots and spats! He always had in his hand a rolled up newspaper and would beat you over the head with it and shout 'Move along there, move along!' The seats in the cinema were only long wooden forms and we had to crouch together to make room for twice as many kids as it would hold ...

"There was a little bit of a stage below the screen, on which there was a piano and a gentlemen called Mr Varley used to play this piano and watch the film at the same time ... He had the right tune for the action depicted and everybody got worked up into the spirit of things. He had various other gadgets at his side to give the effect of thunder, heavy rain, gun shots, storms, ghosts, etc. ...

"One thing that always sticks in my mind was a cowboy thriller, when Buck Jones (the fastest and toughest gun in the west – we thought!) lost his friend over a cliff. He landed badly hurt on a ledge and when our hero Buck found him, he tied his lariat to his horse and lowered himself over the cliff to his friend. He tied himself and friend together and called to his faithful horse to haul away and gee-up! The excitement was intense and silence reigned, but the poor horse couldn't make any progress. All of a sudden, in the intense silence and excitement, a voice from behind us shouted 'Gee up, ye wooden bugger!' Mr Varley started bashing on his piano and I think the horse must have heard as he suddenly started dragging the two unfortunates up the cliff."

The Sun occupied a warm place in many hearts: more recollections were given in a letter to the *Evening Chronicle* in August 1970: "[Entrance ticket numbers were flashed on the screen and] if your number came up your prize was 1lb of sausages or a packet of Tip Top peas. Both of my brothers won these prizes and my father sent me back to the next performance to try for the potatoes and believe it or not I won them and we had our dinner for the next day." Bill Taylor and Ken Brown have independently told me that admittance to Saturday matinées could be gained for a couple of jam jars.

Actual admission prices declined from 4*d*. and 7*d*. in 1920 to 2*d*. and 4*d*. in 1933. There were two shows nightly and a split week. Unlike most other cinemas, occasional variety shows were given right to the end. The Sun never installed sound and by 1934 must have been having difficulty in finding new silent films to screen – in that year only two such were submitted to the British Board of Film Censors. The Sun was last licensed on 2 February 1934 and closed later in the year. The building was demolished; the site is now occupied by a funeral director's premises.

TATLER

147-149 Northumberland Street

16 December 1937

The Tatler News Cinema was originally a café owned by Louis Bertorelli; the premises ran through the block and had an additional entrance in the Haymarket opposite the bus station. In March 1936 architect J. Newton Fatkin submitted plans for the alteration of the premises to include a 488-seat newsreel cinema with café above. By the time the Tatler opened, control had passed to E. J. Hinge.

The Tatler, 1938
(Newcastle City Libraries & Arts)

The cinema was on a single floor and was decorated by Fred A. Foster of Nottingham "on lines of carefully restrained modernism".

"The side walls, above a dado of deep rose and silver, are in horizontal widths of cream, silver, orange and two shades of old rose, a wealth of colouring being introduced in the rectangular panels of abstract painting between the vertical, corrugated pilasters [carefully restrained?]. In the ceiling, a central panel of rose and cream is flanked on either side by moulded plaster coves finished in silver. Lighting is on to the latter from the summits of the mural pilasters and on to the two ante-proscenium grilles from concealed fittings above the exit doors. The curtains ... are of cream satin, with border and legs of rich gold satin." In the café above, with a separate entrance, the decorations were cream, grey and stippled silver, with carpet and curtains of black and red.

On its opening, the cinema was licensed for 437. A "steady stream of patrons" saw a Lowell Thomas travelogue about Jamaica, a short on Salisbury Cathedral, comprehensive news coverage and one of the *Stranger than Fiction* series. All seats were priced at 6*d.*, cheaper than the two existing news theatres. Programmes were continous from 12.30 p.m.

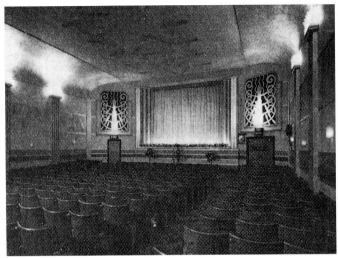

The auditorium, 1937 (BLNL)

Its central location, small size and availability on Sundays made the Tatler ideal for the various film societies which began after the war. In the 1950s the Tatler tried to run a programme which was different from the rival News Theatre, with a greater emphasis on cartoons like the *Tom and Jerry* series. In July 1964 it was bought by Classic Cinemas Ltd. who fitted a new cinemascope screen, installed a Projectomatic system and redecorated the café. In November 1969 the news theatre era ended in the city; by then the Tatler was one of only four or five left in the country. Classic announced that from 9 November the Tatler – now renamed Classic – would begin an extended run of Peter Fonda's *Easy Rider*. Newcastle citizens were not to be alarmed: "we have had very large audiences of hippies [at the Classic, Piccadilly] and, personally, I have found them very charming people, and they have caused no trouble."

From 20 September 1970 the Classic began a new life as a cinema club for members only, apart from a Saturday morning family show and late-night shows (which had begun in July 1969). Seating was re-spaced and reduced to

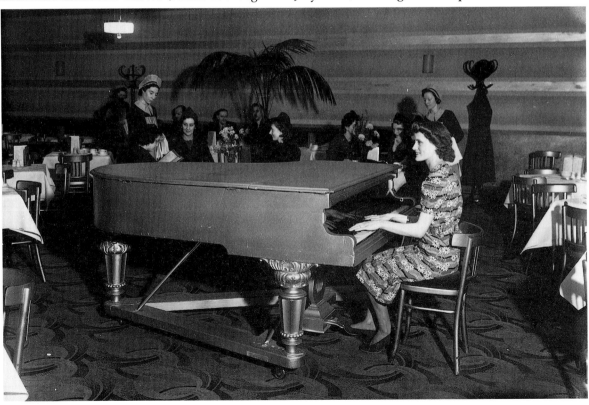

The café, ca 1944 (Newcastle City Libraries & Arts)

The Haymarket entrance, ca 1970 (E. Moorhouse)

418. Again, people were reassured: "If someone wants to see three hours of pornography they will be disappointed. All the films come well within the law". On its first anniversary, the club claimed 6,000 members and from November 1971 there was to be a monthly striptease presentation.

Striptease was hardly new to the north-east, but the fact that it was taking place in a cinema aroused press interest. A reporter found the cinema packed for the stripper: the films were *Double Initiation* and *The Nude and the Prude*. Perhaps in protest, the cinema heating had failed that morning. The cinema was renamed the Tatler Cinema Club in February 1972.

By 1975, although club membership was said to be 10,000, interest was falling. A reporter visited a performance at which the audience for lunchtime striptease was about fifty – "the cinema seemed empty and strangely silent." The reporter's attempt to interview patrons ended when one told him to "... off".

In October 1975 and again in 1978 plans were announced to convert the cinema to shops, but it plodded on. In July 1979, after the Classic chain had been taken over by Lord Grade, there was a feeling that the club shows might cease, as had happened in Leeds, but "We won't be playing the [A and AA certificated films] at the Newcastle Tatler because too many cinemas there would get them before us. There's no money in that."

But the change did indeed occur when on 4 November 1979 the cinema opened to the general public as the Classic. It was not saved, however, closing on 24 August 1980. Shops and a bank now occupy the site.

TIVOLI PICTURE HALL

Walker Road/Raby Street

July 1908

The Tivoli was on Walker Road, about twenty yards west from the foot of Raby Street. It was the third picture hall to open in the city, having been converted from a United Methodist Chapel and schoolroom. Opening prior to 18 July 1908, shows were twice nightly at 7 p.m. and 9 p.m. and seat prices were 2*d*. to 4*d*. At each performance in the opening weeks, a "Hot Porridge Competition" was held. This was apparently an eating competition: the results may be imagined!

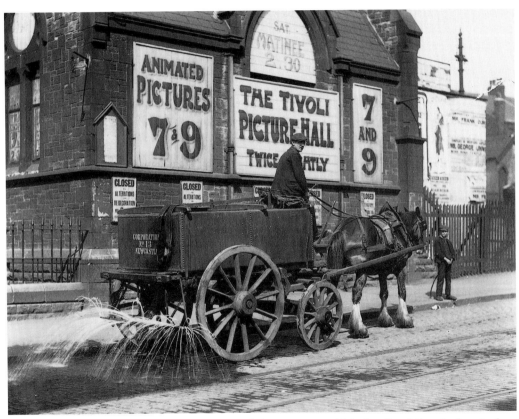

The Tivoli, August 1910
(Newcastle City Libraries & Arts)

The first owner was J. A. Lauder, a stage conjuror; when he left to manage the New Empire (formerly Albert Hall) in Jarrow, the Tivoli had a succession of owners and managers. Matters were not helped by a fire on 15 April 1910 which damaged the stage area and destroyed the pianoforte.

The Tivoli was closed until early 1911; in the interim, architect J. J. Hill drew up plans to include a small stage and seating for about 250-300, with 3*d*. forms at the front and 2*d*. forms at the rear. In February 1911 the cinema was being leased by a local company, grandly titled the British Canadian Animated Picture Co., with offices in Station Chambers, Neville Street and which also ran the Star, Easington Lane and the Central, Swalwell.

Edward Davison recalled the Tivoli at this period: "For a while we [at the Raby] had a competitor called the Tivoli. It was an old building containing a large room. At the front was slung a white sheet and in the centre was a projector on a small wooden platform. The sheet would move with the draught and would often reveal the owner and his family sitting in front of an old kitchen range eating fish and chips."

It was probably the success of the Raby which forced the closure of the Tivoli sometime in 1912. The building became part of a factory for Numol in 1919.

VAUDEVILLE

Church Street, Walker

17 October 1910

The Vaudeville Picture Palace was a conversion from a Primitive Methodist Chapel in a row of terraced houses. Plans for a theatre for W. Campbell-Maxwell of Wallsend by architects White and Stephenson were rejected by the city council in February 1908 but amended plans for T. Proctor were passed in May 1910.

Vaudeville plan, 1910
(Tyne & Wear Archives Service)

Seating was a modest 360, all on the floor of the hall, with a small stage and space for a pianist or 'orchestra'. "The finest hall in the district" opened on 17 October 1910 with two performances nightly and seat prices of 2*d.* to 6*d.* "The world's finest pictures" were supplemented by two variety acts, the "3 Royal Temples, Harmony Extraordinary" and "Tiny Aston, the Wonderful Boy Actor/Vocalist".

In June 1911 new owner T. M. Miller increased the cinema's capacity to 390 by adding a small balcony reached by six steps from the floor of the hall. Ownership changed to William Baker in May 1912; he already ran the Gaiety, Newcastle, the Coliseum, Whitley Bay and the Empire, Wheatley Hill. In about 1919 he was joined by his cousin Thomas Roche (of the Imperial, Tyne Dock). The Vaudeville was owned by the Baker family until closure.

A BTH sound system was installed in 1931, but seat prices were unchanged at 4*d.* to 6*d.* until the war. There were occasional variety shows in the thirties. From 1933 continuous performances were introduced; the split week continued. The newsreel, Universal, was shared with the Regal and was three weeks out of date.

The proscenium arch was outlined in multicoloured light bulbs and had a 'pelmet' with an embroidered crown at its centre; on either side were illuminated double-crown posters advertising future programmes. In the projection box were two Kalee 8s.

In the thirties, the Vaudeville, like the Gem, was run on a day-to-day basis by a family who lived next door – the Cowens – members of which were manager, projectionist, usherettes and cleaners.

The 'Vaudie' was a little community cinema. Special matinées were held for the unemployed on Tuesdays and Thursdays, admission 2*d.* There were special prices for pensioners and as in most local cinemas there were regulars who took the same seats week after week. Staff remember that there was never any 'trouble'. The most popular films were westerns and comedies – love stories were not acceptable.

The Vaudeville was one of the earliest cinemas to close, on 2 August 1958: the end came so abruptly that staff were unable to retrieve personal possessions from the building.

WARNER CINEMAS

Manors

8 December 1989

The American multi-cinema concept came to Tyneside on 14 October 1987 with the opening of the 2,470-seat, ten-screen AMC (now UCI) complex in the Metrocentre, Gateshead.

Warner Cinemas, 1990
(Cityrepro)

The first proposal for a multiplex in Newcastle was made in May 1988 as part of a leisure park scheme by local entrepreneur Joe Robertson. His chosen site was at Manors, just east of the city centre but separated from it by a motorway. The northern part of the site had formerly been the London and North Eastern Railway's Manors Goods Station, destroyed by enemy action in 1941 and latterly used as a car park. It belonged to the city council and had been on offer for development for some time. It was for this eight-acre site that Robertson proposed a sixteen-screen cinema with car park. To the south across New Bridge Street, around Manors Metro Station, were to be a roller rink, a ten-pin bowl, an American diner and other facilities.

The recently-formed Tyne and Wear Development Corporation, which was the planning authority, had selected these precise sites for development as a science park. Here was a potential conflict, with the city council determined to oppose TWDC's vesting of its land. The Corporation began compulsory purchase proceedings for the council's site and bought the remainder from British Rail.

By early June Joe Robertson had disappeared from the scene and the cinema was to be built and operated by Warner Brothers, who were proposing a twelve-screen, 3,200-seat cinema. The city council sold the goods station site to Warners for a reported £1.25m. TWDC accepted a compromise plan for a smaller science park on the south side of New Bridge Street.

Construction of the Warner Cinema at Manors began on 14 February 1989, with a ground-breaking ceremony by actor Charles Dance. Warner Brothers' first U.K. multiplex cinema, near Bury, Greater Manchester, was then under construction. It opened in July 1989, with twelve screens and 4,000 seats.

As with the Paramount nearly sixty years before, an American company introduced the latest ideas in cinema design to the city. The architects were American, Ira Stiegler, Howard and Unick, with local structural engineers Derek H. Bell Associates. The main contractor was P. Whelan Ltd.

The main elevation, with its tall central atrium in metal and glass in the Warner Brothers colours of blue and yellow is a rather startling addition to the cityscape. Within this is a large concourse containing the C.A.T.S. ticketing system and booking facilities. In the centre is a large concessions stand; on the left the Warner Brothers Studio Store and on the right a video games room.

The nine auditoria are to left and right from the rear of the concourse and are numbered clockwise from the left. The reduction in the number of screens from twelve to nine has meant that some are larger than is normal in multi-screen complexes. Actual seating is 3,386, made up of: 1, 404; 2, 398; 3, 236; 4, 244; 5, 290; 6, 659; 7, 509; 8, 398 and 9, 248. When compared with the main concourse, the auditorium design is surprisingly traditional. The first impression is of height and space, unusual in a multiplex. The smaller auditoria have festoon screen curtains, while the largest even has a slight reverse rake for the front rows of seats, first seen in Newcastle at the Jesmond in 1921! Side walls are tastefully decorated.

Sightlines from all seats are excellent; the larger auditoria each have a 'Cry Room' where fractious children can be taken out of the hearing of others while still able to see the film. For the hard of hearing, there is an infra-red transmission system using headsets. (Reminiscent of the thirties, when the Essoldo, Westgate and Queen's advertised their 'Ardente' deaf aids).

Above the auditoria is a single long projection suite, serving all screens. "Your theatre has also been fitted with the most advanced projection and sound equipment available: the ORC [Optical Radiation Corporation, formerly Westrex] Projection console, installed with its own computer which controls and monitors all functions. One basic function is to monitor all projectors within the complex for mechanical or film faults, warn the projectionists and stop the programme concerned ... These projectors are also fitted as standard with a newly developed light source which is capable of projecting onto the screen with an almost flicker-free effect, with the light beaming for perfect accuracy. This, The Century Projector, has been chosen for its craftsmanship and proven quality of projection ..." The sound system is capable of replaying all systems including Dolby Stereo Spectral Sound.

The total cost of the building was £4.5m; there were forty-three staff (reduced by fifteen in August 1990 as a result of rationalisation). After a formal ceremony on the morning of 6 December 1989 there was an open day; regular programmes began two days later. The poor quality of films then available resulted in lower than expected admissions in the first week, but these were reported to be well ahead of projected levels by 1990. Children's Saturday matinées were introduced in January 1991.

Above: Warner Cinemas foyer, 1990. Below: Screen 7, Warner Cinemas, 1990. (Both David Lawson Commercial Photography)

WELBECK

Scrogg Road/Byker Street

4 November 1929

The Welbeck Cinema and Playhouse was the last cinema of the silent era to be opened in the city. It was built by a company formed in December 1928 with a capital of £14,000 in £1 shares of which the chairman was William Crocker, a Wallsend fruit merchant and managing director of the Albion Cinema, North Shields.

Plans by J. Newton Fatkin were approved by the city council on 12 December 1928 and provided for 688 seats in the stalls and 312 in the circle. There was a large thirty feet deep stage, with dressing rooms below and an orchestra pit. Seating was claimed to be 1,100, but was actually 965.

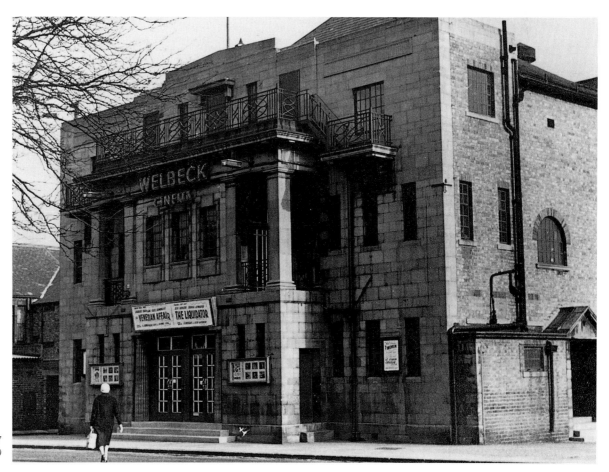

The Welbeck, 1967
(Newcastle City Libraries & Arts)

The cinema was opened by the Lord Mayor-elect. The first performance was by invitation and programmes in the first few weeks were not advertised. There were twice nightly shows with seat prices of 4d. to 1s.; seats could be booked. From 16 December 1929 there was a "grand variety week" with a singer, a comedian and a trapeze act, in addition to the films.

But stage acts, despite 'Playhouse' in the cinema's name, were infrequent. Even before the Welbeck opened three of the dressing rooms were converted for storage. However 'turns' appeared occasionally up to the war.

An RCA sound system was installed a few months after the cinema opened; the first sound film was *The Singing Fool* (Al Jolson) from 30 January 1930; there were two matinée performances of this and some other early talkies. 'Playhouse' was dropped from the name in January 1933, although a theatre licence was retained until 1939.

The Welbeck was several cuts above the other Walker cinemas in terms of style and comfort in the thirties: it is remembered as "first class" and a "beautiful cinema, it was one of the few small cinemas which had a lot of money spent on it". The decorating was always done by professionals, not the local handymen as was often the case. In the late thirties there was a staff of about fifteen, including three projectionists and three cashiers – the Welbeck had separate payboxes for pit, stalls and circle.

Continous performances were begun in 1940; in the same year the circle was reseated. The stalls were reseated in 1949, reducing capacity there to 567. Two Super-Simplex projectors were installed in about 1943; at the same time new screen curtains of "gorgeous" silver festoons were fitted.

In January 1954, when Cinemascope was introduced at the Odeon, the Welbeck advertised films on a "panoramic wide screen". This was presumably achieved by fitting a larger screen, with masking top and bottom, accompanied by a corresponding aperture plate in the projector and must have led to the loss of some of the picture; certainly the films advertised during the few weeks of the experiment were in the conventional 4:3 ratio. Showing a mixture of Rank and ABC releases, the Welbeck outlasted most suburban cinemas. There were the usual sixties problems with vandalism, a steel bar being hurled through the screen one night in May 1964. A bingo licence was refused in May 1966 but allowed the following year and the Welbeck was last licensed as a cinema on 6 December 1968. It became a full-time bingo club run by the Noble Organisation, its attractive tiled facade masked behind Classic-type metal cladding. In 1989 it was taken over by Granada Leisure and renamed Essoldo.

CINEMAS THAT MIGHT HAVE BEEN

CINEMAS THAT MIGHT HAVE BEEN

From the earliest days of the cinema in the city, picture halls were planned but never built. Some were turned down by the city council, others foundered through lack of finance or a change of idea by their promoters, struggling to keep pace with public taste.

Before the First World War, cinemas were proposed for: Waterloo Street and Sunderland Street corner, with the conversion of St John's National School; Avison Street, New Mills; the conversion of the Cooperative Hall on Scotswood Road; and the conversion of the old Presbyterian Chapel in Carliol Street from a warehouse to a cinema. Picture halls were also planned for Heaton Road, the Bigg Market and Algernon Road, Heaton. In the absence of plans for these projects it is impossible to give further details.

The first cinema proposal for which details survive is the Princess, to be built in Back Lane (later Heber Street) off Gallowgate. The Princess was promoted in 1915 by Joseph Cowper, an insurance manager of Dean Street; the architect was Henry Gibson of North Shields. The plan was for a hemispherical auditorium with 650 seats in the stalls and 600 in the circle. There was also to be a ten-table billiard hall. These plans were abandoned in 1919 in favour of a stadium on the same site, designed by Dixon and Stienlet. This was never built; as with many post-war plans, lack of materials was probably the cause.

Two further proposals of 1919 presumably fell victim to lack of funds. The Clayton Picture House Company, with £100,000 proposed capital, was formed in August 1919 to build a 1,200 seater cinema with café on Fenkle Street between Clayton Street and Cross Street; the leading light was Alfred Bedson, who ran the Heaton Electric Palace. In November a group of businessmen paid £50,000 for property on Newgate Street just west of the Albion Inn with the intention of building a cinema; it did not materialise.

The next proposal was a major scheme for a prime city centre site in New Bridge Street. City Amusements was formed in April 1921 with a proposed capital of £250,000. The chosen site was 49

ELEVATION TO NEW BRIDGE STREET.

The Oxford, 1921
(Tyne & Wear Archives Service)

New Bridge Street and the plans, by London architects Adamson and Kinns, called for the demolition of the nineteenth century architect John Dobson's house. The picture hall was to be called the Oxford, with a dance hall, a restaurant, a billiard saloon and tea rooms.

"The front of the building is intended to be in cream terracotta with Corinthian pillars. On entering from the street, the visitor will find himself or herself in a spacious vestibule, tastefully decorated and leading to a semi-circular foyer for the theatre immediately beyond. Leading from the vestibule will be staircases ... to the billiard room and restaurant, which will be situated in the basement, and from the vestibule there will also be the up-to-date feature of lifts to the balconies of the theatre.

"Coming to the central attraction, the picture theatre, it may be mentioned that it is designed to accomodate in the stalls (every seat throughout the theatre will be separate with ample room in which to move), 967; in the lower balcony 540; and in the upper balcony 405."

Almost 2,000 seats was vast for 1921; in addition the restaurant was to seat 800 and the dance floor to hold 800, with a further 1,500 in its balcony. Although the city council approved the plan on 27 April 1921, it was withdrawn by the promoters. Raising the money is likely to have been the obstacle; in 1923 City Amusements was recapitalised at a more modest £75,000 and the Oxford Galleries dance hall was the result.

A similar grand scheme was proposed in January 1926 for a site at the corner of Jesmond Road and Portland Terrace. The cinema was to hold 1,500 with a stage large enough for concert parties. There was to be a dance hall to hold 1,400, with indoor tennis courts (and possibly additional courts on the flat roof). This scheme was promoted by a London syndicate but again it seems that cost (£250,000) was the problem. The United bus garage was built on the site.

The next scheme to appear was a return to the city centre, to the Singleton House site at the southern corner of Northumberland Street and Northumberland Road, which in 1929 was occupied by single-storey shops. In November of that year the local press reported that among prospective lessees of the site was "a cinema combine, who own picture theatres in many provincial towns". This may have referred to ABC, which was expanding rapidly at this time. The site was taken by British Home Stores, which opened in September 1932.

Back to the suburbs, this time to Fenham, where in December 1929 Mrs E. A. Bruce submitted plans by architect F. M. Dryden for a site on West Road near its junction with Two Ball Lonnen. The 'Fenham Cinema' was to seat 1,230 (870 stalls, 360 circle) and was designed in a 'rustic' style. Although the plans were submitted and withdrawn in a saga which ran until July 1935, the cinema was never built.

Newcastle almost had one of the glamorous art-deco Odeons designed by the Harry Weedon

Partnership which adorned so many towns and cities in the late thirties. In June 1936 Odeon Theatres Ltd. asked the city council for a lease of land on the south side of City Road at its junction with Pilgrim Street. Although the council had doubts, based on the increase of traffic which a large cinema would generate at an already busy junction, the lease was granted in September.

Odeon, 1937
(Newcastle City Libraries & Arts)

In January 1937 plans were prepared for a cinema to seat 2,042 (1,352 stalls, 690 circle) with lock-up shops; the exterior was to be finished in faience tiling. This cinema disappears from local records later in 1937. I am therefore grateful to Robert Bullivant, who joined the Weedon Partnership in 1935, for his recollections:

"Between 1935 and 1939 [Oscar] Deutsch decided that his organisation could operate profitably in a large number of towns and cities and once a location had been chosen a site was quickly acquired and the Odeon was designed, built and opened to the public usually in less than twelve months. Odeons were built in over 95% of the towns Deutsch had selected.

"The reasons why the odd 5% were never built are complex. In a few towns other circuits or developers had already made a planning application and those involved 'did a deal' with Deutsch. In other towns existing cinemas were so fearful of the Odeon threat that they were prepared to sell out to Deutsch who thus acquired a cinema as a going concern and at less than the cost of building a new one.

"In some locations plans to build an Odeon were abandoned after Deutsch had taken over or agreed to manage another circuit which already operated a cinema in the town in question. The decision not to proceed with an Odeon on the City Road and Pilgrim Street site ... fell into this category. Deutsch was already negotiating to manage the Paramount chain and he eventually took them over and subsequently most of them were renamed Odeon."

This was a wise decision for another reason. The site was in a decaying part of the city and a cinema there would have been isolated from the main shopping thoroughfares.

It was not until the late 1960s that further schemes were proposed. Early plans for the Eldon Square development in 1969 incorporated a cinema centre for ABC, but this was abandoned as too costly. In mid-1971 Lord Grade's Galaxy chain was said to be considering a luxury 350-seat cinema on part of the old Town Hall site; no more was heard of this. A partnership between Thorn-EMI and the Tyneside Cinema was reported in September 1985. The proposal was for a three-screen cinema to be run by the Tyneside, with a further unspecified number of commercial screens to be operated by Thorn-EMI (which had recently lost the Haymarket). The site for this complex was thought to be either the Quayside or Gallowgate; again, there were no further developments.

CIRCUITS

CIRCUITS

In the cinema's earliest days before the First World War, most halls were small, with a seating capacity of a few hundred and tended to be owned and run as family businesses. Even then, however, the more forward-looking owners saw the advantages of forming a group of cinemas, or circuit, under their control. These advantages were mainly economic: a circuit gave greater power in the eternal struggle against renters and distributors; staff and films could be exchanged between cinemas; while profits from small halls could be used to expand the circuit with larger and, it was hoped, more profitable cinemas.

Nationally in 1914 there were 109 cinema circuits, although only thirteen of these were of ten or more cinemas. Two of the thirteen were based in the north east: Thomas Thompson of Middlesbrough and Black's Theatres of Sunderland.

Thompson ventured into Tyneside in partnership with J. R. Collins, a film renter who had founded the Newcastle Film Supply Company. By 1916 Thompson and Collins owned the Grainger, Newcastle and the Globe, Gosforth, as well as the Howard Hall, North Shields, the King George, Cramlington, the Palace, Prudhoe and the Shipcote, Gateshead. In 1919, when the Grand, Byker was taken over from George Black, there were fourteen cinemas in the Thompson and Collins circuit. In 1924 the New Pavilion was added. This was the peak of expansion and in the late twenties the circuit was broken up. Collins' film supply company was merged in the Famous-Lasky (later Paramount) Film Service; some of the cinemas went to the Ostrer brothers.

The Black family was from Sunderland, where George Black I (1858-1910) opened the former Bonnersfield Presbyterian Chapel as the Monkwearmouth Picture Hall in May 1906. From this modest beginning the Black circuit expanded rapidly under George Black II (1891-1945) who took over at the age of nineteen. To the Palace, West Hartlepool, the Borough, North Shields, the Palace, Gateshead (owned), the Tivoli, South Shields and the Picture Hall, West Hartlepool (leased), George II added the Borough, Wallsend, the Theatre Royal, Blyth and, his first in Newcastle, the Grand, Byker. A major first-run cinema in Newcastle, the Queen's Hall, followed in 1920 (although the Grand had then been

sold). By 1927 Black Brothers also owned the Grainger, Grey Street, Scala and Globe, Gosforth.

In early March 1928, Black's Newcastle cinemas (except the Grainger) were sold to financier F. A. Szarvasy, presumably acting as a front man, as only two weeks later they turned up among the assets of the newly reorganised General Theatres Corporation. George Black was a director and general manager of GTC and moved to London. GTC was taken over by Gaumont-British later in 1928. George's younger brother Alfred returned to the north east, building the series of magnificent Black's Regals between 1932 and 1937.

Sidney Bacon (1878-1927) was a Newcastle theatre manager who by 1904 was running the Grand, Byker, the Olympia, Newcastle and the Metropole, Gateshead; he was also joint lessee, with Richard Thornton, of Olympia. He left Newcastle to enter the cinema business in London and began to build a nation-wide circuit. In Newcastle he took over the new Olympia in 1910 and the Star in 1911. But his circuit expanded away from Newcastle, in Carlisle, York, London and the south coast. By 1919 there were seven cinemas, by 1930, thirty-one. The circuit was based in London and was run after Bacon's death by Thomas France. All the former Bacon halls went to Union Cinemas in 1936 (or October 1935; sources differ).

Other circuits were more local in scope. The largest of these was founded by Stanley Rogers (1858-1933). Although his obituary states that he "came to Tyneside shortly after the end of the Great War", he is to be found managing the Empire, Blaydon, in 1914. With E. J. (Teddy) Hinge as general manager, Stanley Rogers Cinemas expanded rapidly in the 1920s, both in the north east and on the Cumbrian coast. The company acquired small, run-down halls and by careful management restored them to profitability. In Newcastle, examples were the Gaiety and the Palladium. Rogers died in October 1933, shortly before the completion of what was probably the first cinema to be built by the company as new, the Regal, Fenham.

The company (actually an interlocking network of companies) was then run by Teddy Hinge (1888-1961), eventually becoming Hinge Circuit Cinemas. In the thirties, income from the smaller cinemas was used to build several medium-sized but attractive new halls, sometimes in partnership with others. In Newcastle, these were the Royalty, Gosforth, the Lyric, Throckley and the Rialto, Benwell. At the same time, older cinemas were added to the circuit: the Grand, Benwell, the Globe, Gosforth and the Grand Theatre, Byker. By the end of the decade, there were fifteen cinemas and theatres in the circuit.

The business was run, as were all small circuits, with extreme care. One of Hinge's projectionists remembers: "... all stores had to be used extremely sparingly to save cash. Carbons used in the arc lamps had to be used till they were a mere two and a half inches short as stubs: we were supplied with metal holders to enable this saving to be carried out. All light bulbs had to be accounted for when replaced or your supply was not renewed ... We were even encouraged to clean the bayonet caps with metal polish to make them look brand new and not used. These were collected from time to time and sent back to Crompton Parkinson Ltd. as duds and refunds claimed."

Like many cinema pioneers, Teddy Hinge had begun his show business career as an actor; the theatre remained his first love. Profits from the cinema circuit were poured into two "dying theatres", the Grand, Byker and the Hippodrome, Darlington, in a vain attempt to keep variety alive. What remained of the cinema circuit was dismantled in the early sixties.

James MacHarg was a Wallsend builder whose first venture into cinema ownership was in his home town with the Tyne and the Royal. His first and for many years his only cinema in Newcastle was the Brinkburn, Byker. In 1922 he formed a new company, Tyne Picture Houses Ltd., with a capital of £10,000. This company built the super-cinema, the Apollo, in 1933. A further group of cinemas was managed but not wholly owned by MacHarg. These were the Lyric, Heaton, the Jesmond and the Grainger in Newcastle, along with the Shipcote, Gateshead, the Lyric, Howdon and the Howard Hall, North Shields. All the cinemas were however run as a circuit, with interchange of relief staff and all films centrally booked. By 1961 only the Apollo and the Jesmond remained and these were sold to Arnold Sheckman in 1962-64.

A circuit of some eleven cinemas, all of them small halls, was that run by Sidney Dawe and J. H. Dawe as DB Cinemas. Although based in Newcastle, the brothers had only one cinema in the city, which they leased and then bought in 1919, the Imperial, Byker. Other cinemas in the circuit at various times were the Apollo and the Theatre Royal, Birtley, the Rex and the Theatre Royal, Hebburn, the Empire and the Theatre Royal, Jarrow, the Empress and the Palladium, Gateshead, the Regal, Wheatley Hill, the Palace, Wingate and the Hippodrome, Thornley. Later the Carlton, Tynemouth was added. Most of these cinemas were converted to bingo halls. Linked to DB Cinemas was DRC Cinemas, the 'R' being Leslie Renwick of the Bamborough and the 'C' Carter Crowe.

Like James MacHarg, H. T. and W. A. Smelt, who later traded as Northern Cinemas, were builders. Their first involvement with the cinema was with the King's, Annfield Plain, in 1912. The circuit owned three cinemas in Chester-le-Street in the late thirties. In Newcastle they owned the Plaza, the Savoy and the Rex. The circuit was broken up in about 1953, most of the cinemas going to Essoldo, although the Plaza and the Rex were taken over by W. J. Clavering.

Almost too small to be considered a circuit were the six cinemas owned by Joseph Broughton and William R. Marshall. In Newcastle they owned the Stanhope Grand and the Raby Grand. Elsewhere were the Picture House, Forest Hall, the Queen's, Wallsend, the Crown, Tyne Dock and George Black's old hall at Monkwearmouth, which they named the Bromarsh after themselves.

The third largest cinema circuit in the country, after Rank and ABC, was Essoldo, based in Newcastle. Owning 196 cinemas at its peak, this empire was latterly run from offices in City Chambers, Grey Street, although there was a London office responsible for film booking.

Sol Sheckman (1893-1963) was said to have bought his first cinema, the Gaiety in Sunderland, when he left school at 15. This would have been in 1908, but unfortunately for this story, the Gaiety did not open until 1913. Sheckman began as a boxing promoter in Blyth in the mid-twenties, moving on to St James's Hall, Newcastle. His cinema career seems to have begun in 1925, when he ran the

Hippodrome, Crook, the Co-op Hall and the Palace, High Spen and the Empire, Tudhoe. The company name was North Eastern Theatres, later North East Coast Cinemas.

He founded a second company, S.S. Blyth Kinemas Ltd. in 1930, which began with the former Black Brothers' Theatre Royal, Blyth. Both circuits expanded and were merged into Essoldo (formed in 1931), a name derived from the first names of his wife, Esther, himself, and his daughter, Dorothy. Essoldo cinemas were broadly of two types, the large modern super-cinema (such as the Essoldo, Newcastle) and the smaller, older halls which were acquired cheaply and given the benefits of a large circuit. In Newcastle, examples of the latter were the Crown, Savoy and Scala. In the sixties many of the small cinemas were closed or turned over to bingo; the flagship Essoldos were sold to Classic in 1972.

ACKNOWLEDGEMENTS

I would like to record my thanks to all those who have helped in the writing of this book, by agreeing to be interviewed, by writing to me with information following a letter in the *Evening Chronicle* and in many other ways. The greatest pleasure of the work for me has been the enthusiasm and unstinting help of all those now or formerly in the business. Any errors or faulty interpretations in the book are my responsibility.

John Airey, M. Aynsley and Sons Ltd., Tom Bainbridge, John Barnes, George Belshaw, Brian Bennison, Douglas Bond, the British Film Institute, the British Library Newspaper Library, Jill Brown, Ken Brown, John Browne, Douglas Buglass, Robert Bullivant, Robert A. Burke, Eric Caller, Terry Charnock, the Cinema Theatre Association, Cityrepro Photographic Department, Cityworks, Newcastle upon Tyne, City Engineers, Newcastle upon Tyne (for permission to reproduce plans of cinemas), Gordon Clark, Tom Clark, Christopher Clavering, Thomas Clements and Sons Ltd., Mrs L. Coulson, Ian M. Dawe, Edward Dietz, Tom Dixon, Con Docherty, Peter Douglas, K. Douglass, Stephen Easten Ltd. (Mr Sutherland), Alfred E. Finlay, Andy Forster, Douglas Gibson, Joe Ging, clients of the Grange Day Centre, Throckley, Glyn Hall, Margaret Hall, Noel Hanson, the late Percy Harding, David Hinge, Elizabeth Hodges, John Hodgson, Geoff Hornsby, Maria Hoy, Mrs W. Huggins, Robert Hutton, Les Irwin, Doris Johnson, Mr Johnson, Dr A. Jones, Pat Jones, David Lawson, Mrs Lear, G. A. Lewins, Michael Long, Joan Lowery, John McMahon, Joe Marsh, Geoff Mellor, Mr Miller, Bob Milner, Mannie Moorhouse, Tony Moss, Paul Mustard, Newcastle Chronicle and Journal, Ltd., Fred Norris, Ethel Oakley, Audrey Patterson, Keith Proctor, Promotions and Arts Unit, Newcastle upon Tyne City Libraries & Arts, the Rank Organisation (Percy Aruliah), Bill Rosser, Royal Commission on the Historical Monuments of England, Elizabeth Sewell, John Sharp, Trish Sheldon, Bob Spurs, Bill Stewart, Vincente Stienlet, Sunderland Central Library (Local Studies), L. G. Tagg, Peter Talbot, Bill Taylor, Mike Thomas, Neil Thompson, Bill Travers, Turners Photography, Tyne and Wear Archives Service, Des Walton, Warner Cinemas, West Newcastle Local Studies, W. H. Whitehead, Mr and Mrs G. W. Wilkinson, Dave Wilmore, S. N. Wood.

A NOTE ON SOURCES

Research on Newcastle cinemas has been bedevilled by the disappearance of many vital written sources of information. Despite extensive enquiries and the assistance of many people, I have been unable to trace any cinema licensing records for Newcastle prior to 1930. These records give reliable details of the changing ownership of cinemas, their seating capacities and any special events for which the consent of the licensing authorities was required. Some information was found in the minutes of the Town Improvement Committee.

Deposited plans for public buildings in Newcastle (including new cinemas) were filed in a separate sequence from the turn of the century; all those prior to 1914 are lost. Plans of cinemas converted from other buildings survive. Of the thousands of plans of buildings approved by Newburn UDC, only a few are missing; needless to say, among these few are the plans for the Lyric at Throckley.

Descriptions of cinemas in the city are based on several sources. National trade journals, such as *The Bioscope, Kinematograph and Lantern Weekly, The Cinema, Cinema Construction* and *The Ideal Kinema* often give reports on local cinemas, particularly in the 1930s. The most heavily used source has been the local press; for the 1930s the *Sunday Sun* is particularly good.

INDEX OF CINEMAS AND THEATRES

GENERAL INDEX